The Portrait
in Eighteenth-Century
America

The American Arts Series/University of Delaware Press Books

The Portrait
in Eighteenth-Century
America

Edited by
Ellen G. Miles

DELAWARE

Newark: University of Delaware Press
London and Toronto: Associated University Presses

Associated University Presses
440 Forsgate Drive
Cranbury, NJ 08512

Associated University Presses
25 Sicilian Avenue
London WC1A 2QH, England

Associated University Presses
P.O. Box 39, Clarkson Pstl. Stn.
Mississauga, Ontario,
L5J 3X9 Canada

The paper used in this publication meets the requirements
of the American National Standard for Permanence of Paper
for Printed Library Materials Z39.48-1984.

Library of Congress Cataloging-in-Publication Data

The Portrait in eighteenth-century America / edited by Ellen G. Miles.
 p. cm.
 Includes index.
 ISBN 0-87413-437-4
 1. Portrait painting, American. 2. Portrait painting—18th
century—United States. 3. United States—Biography—Portraits.
I. Miles, Ellen Gross, 1941– .
ND1311.1.P67 1993
757'.0974'09033—dc20 90-50995
 CIP

PRINTED IN THE UNITED STATES OF AMERICA

Contents

Foreword

In 1987, when the National Portrait Gallery mounted its exhibition, American Colonial Portraits: 1700–1776, it had been more than fifty years since the last major exhibition concentrating on portraiture in the American colonies. During that half-century our knowledge of individual artists of the colonial period increased dramatically, as did our understanding of life and society in the New World. But for the most part, specialists in these fields tended to "cultivate their own gardens," remaining at arm's reach from one another. It was our thought that the Portrait Gallery exhibition would bring people from these diverse areas together for new thinking about these old pictures, just as the exhibition brought together portraits that had never before been studied in juxtaposition.

If these are portraits of the members of a society on the edge of a new political order, they are also paintings by artists who (many of them, at least) were in transition spiritually and aesthetically. The Europeans who came here had few painted or sculpted portraits with which to shape their own artistic practice. The artists who emerged on this side of the Atlantic often had to experience the European tradition through copies, engravings, or written discussions—mere shadows of the originals, as those who later managed to get to London, Paris, and Rome discovered. What were the consequences of this newly configured society and this austere artistic environment for portraiture? Why, indeed, did people take the trouble to have portraits made at all, given the many other distractions of life in the New World? These and dozens of other questions arose when the exhibition and its learned catalogue came together, and the essays in this volume reflect some of the responses of our scholarly colleagues.

In organizing this symposium, the National Portrait Gallery was honored to be joined by the Institute of Early American History and Culture of Williamsburg. Both institutions appreciate the substantial support provided for the conference by The Barra Foundation Inc. and the Smithsonian Special Exhibition Fund. Ellen Miles, editor of this volume, was joined by Lillian B. Miller, historian of American culture and editor of the Peale Family Papers at the National Portrait Gallery, and Thad W. Tate, who at the time was director of the Institute of Early American History and Culture, in the planning of the conference. Many organizational details were dealt with admirably by Dr. Brandon Brame Fortune of the Portrait Gallery and Mrs. Sondra Walker of the Institute. Later Dr. Miller and Dr. Tate assisted in the editing of the proceedings, and Susan Cross helped prepare the manuscript for publication. Most of all we are grateful to the authors of these papers for their contributions that, we hope, will inspire generations in the future to view the art of eighteenth-century America in new ways.

ALAN FERN
Director, National Portrait Gallery

Introduction

ELLEN G. MILES

Portraits dominated the visual arts of the British colonies in North America before the American Revolution. They appeared as paintings, engravings, watercolor miniatures, and stone or wood carvings. They celebrated the sitter's social or political status, marriage and family ties, and at times also memorialized the sitter after death. This preference for portraits continued to be characteristic of American art in the Federal era and the first decades of the nineteenth century. All of this has been recognized by writers on American art since the 1820s. In much modern scholarship, however, colonial portraits have developed split personalities. They have been collected and discussed in an art historical context as examples of the work of early American artists, and at the same time were collected by historical societies or illustrated in American histories because of the identity of the sitters, with two results. First, the context became primarily biographical, and broader cultural questions, as well as those concerning the art of portraiture itself, were largely ignored. Second, because both approaches had a strong nationalistic focus, American artists and their patrons were separated from their European counterparts.

This split has resulted in a limited view of American colonial portraits. The conference entitled "The Portrait in Eighteenth-Century America" and the exhibition "American Colonial Portraits: 1700–1776," held at the National Portrait Gallery in the fall of 1987, sought to change this emphasis. The planners of the conference brought together a group of historians and art historians of eighteenth-century American and English culture who are known for their unusual approaches to the art or history of the colonial era. The goal of the conference was to broaden the possibilities of interpretation of colonial portraits, to make these images available to a wider audience of historians and art historians, and to provoke new questions about the images and their cultural context. The papers that resulted offer a number of new directions for research in colonial and late-eighteenth-century American art. They also add to our understanding of the collecting of historical American art in the first decades of the twentieth century. At the same time, they raise significant questions of methodologies useful for interpreting cultural objects.

At the conference the keynote address offered a broad introduction to the issues of portraiture in England in the eighteenth century. Next, two sessions brought together an historian and an art historian who focused their remarks on the broad topics of the artist or the sitter. The final session offered papers about the impact of colonial American portraiture in later periods of American culture. In each session two papers were followed by a short commentary. As a group the papers and commentaries discuss such topics as gentility; the portrait as a symbol of social status; portraits as consumer items; the attitude toward the artist and the portrait in colo-

nial society; likeness as a goal of portraiture; and the interpretation of imagery in colonial American portraits.

In the section on the European background of American colonial portraits, John Hayes discusses "The Theory and Practice of British Eighteenth-Century Portaiture." Hayes outlines the broad topic of English portraiture in the second half of the eighteenth century, focusing on the views of Sir Joshua Reynolds, "the pivotal artistic figure of his age in Britain." He discusses likeness, realism, and demonstrations of social status as the traditional goals of portrait painters, comparing these with Reynolds's idealization of the sitter. Hayes points out that not all English painters followed Reynolds's lead. Instead they continued the traditional approach of providing an adequate image of the sitters for themselves, family, and friends, using the timeworn tricks of borrowing poses, costume, and attributes from earlier portraits. In his paper Hayes touches on many of the issues of portraiture in the period 1750–1800, notably the uses of a drapery assistant, the idealized image, and the search for a way to give a more timeless meaning to portraits. While the social world of aristocratic portraiture, with its public exhibitions, did not exist in colonial America, its values did affect a number of American painters, including Gilbert Stuart, as Dorinda Evans discusses in her paper, "Survival and Transformation: The Colonial Portrait in the Federal Era."

In the section titled "The Artist in American Colonial Culture," Timothy Breen, in "The Meaning of "Likeness": Portrait Painting in an Eighteenth-Century Consumer Society," proposes that the portraits be seen as expressions of the new consumerism that affected both America and England after the 1740s. This theory helps explain one impetus for a portrait, imitation of English taste. The aristocratic English country house usually included some family portraits. About four times as many portraits were painted in the colonies between 1750 and 1776 than in the first fifty years of the century. The rise in the demand for portraits after the 1740s thus appears to coincide with the rise in American wealth and in the importation of British consumer goods such as china, fabrics, glassware, pipes, and certain foods.

Further addressing the issue of "The Artist," Dr. Poesch's essay " 'In just Lines to trace'—The Colonial Artist, 1700–1776," outlines the careers of painters in colonial America. She then introduces contemporary ideas about artists and their work as expressed in poetry, thus revealing an untapped source of colonial American attitudes about the arts. The poetry expressed several significant ideas, including an awareness of the artistic traditions of the past, feelings of humility coupled with pride in achievement, and the role of painting in preserving images of individuals for future viewers.

Graham Hood's commentary, "Soul or Style?: Questions about Early American Portraits," notes that these two papers contain clues about what portraits meant: in addition to a reflection of consumerism, the portraits indicate an emotional need for a sense of permanence. He also notes that these papers suggest that our idea of likeness and that of the eighteenth-century viewer are not the same. The verses show that eighteenth-century emotions ran high at the sight of portraits, but exactly what moved the viewers is less clear to us today. We often see little difference between portrait faces, and yet the poetry quoted by Dr. Poesch testifies that contemporaries saw true likenesses.

The section called "The Colonial Sitters and Their Self-Image" directs attention to the cultural and social values of colonial Americans and to the ways in which they are expressed in these portraits. Stephanie Wolf, in "Rarer than Riches: Gentility in Eighteenth-Century America," discusses the concept of gentility, giving examples to define the American view of being a gentleman. She points out that for the English gentleman, the acceptable occupation was the management of his estates. In America, instead, status followed the making of wealth through a trade. Those who saw themselves as gentry imitated their English counterparts in manner, dress, and social behavior, as well as in their choices of architecture and the decision to have a portrait painted.

Dr. Craven in his paper "Colonial American Portraiture: Iconography and Methodology" investigates the individual portrait for clues about the sitter's values. Dr. Craven's methodology is based on the belief that "nothing is included in a portrait by chance or accident." He notes the visual elements of the portraits: face, costume, wig, attributes, background, and outlines his method, emphasizing both the visual characteristics of the portrait and the facts of the sitter's biography. He warns of false assumptions and

suggests sources such as courtesy manuals that are often overlooked as helpful for interpreting portraits. He lists five categories in recreating the biography of the sitter: socioeconomic status and goals, religious affiliation, political allegiance, cultural concerns, and personal interests. He proposes that even artistic style is often arrived at through service to these categories.

Robert A. Gross's commentary, "Gentlemen Prefer Swords: Style and Status in the Eighteenth-Century Portrait," notes that in postrevolutionary America portraits were regarded as not merely signs but also acts of gentility, a "crucial value in the social order." He asks whether the art of portraiture underwent the change that political rhetoric did, "as the potential audience for portraits widened from city to countryside." He finds it interesting that there is only a crude woodcut of Daniel Shays. This portrait was engraved to illustrate a contemporary account of the rebellion Shays led in 1787. Several years earlier Shays had rejected the trappings of gentility when he sold the sword given to him by General Lafayette. In sharp contrast, the men who were Shays's political enemies, including James Bowdoin II, frequently are represented in fine paintings.

The final section considers "Colonial Portraiture in Later American Culture." In "Survival and Transformation: The Colonial Portrait in the Federal Era," Dorinda Evans discusses portraiture in America after the Revolution. She describes two coexisting attitudes toward portraiture, one emphasizing a "high standard of resemblance" and the other the "aesthetic merit of a portrait as a picture." Dr. Evans notes that the first attitude was a holdover from the colonial era. The new attitude was accompanied by two other changes in portraiture in the Federal era: the introduction of new portrait sizes and an idealization of the image. Dr. Evans discusses the idealization of Washington by Stuart in the well-known series of Vaughan, Atheneum, and Lansdowne heads, painted in the 1790s.

Richard Saunders's paper entitled "The Eighteenth-Century Portrait in American Culture of the Nineteenth and Twentieth Centuries" presents a brief survey of the fate of colonial portraits from the postrevolutionary period to the late nineteenth century. He notes the predominantly historical impetus for collecting and writing about these images in the nineteenth century and then discusses a group of early-

twentieth-century collectors and dealers as they sought to fill a rising demand for historical portraiture. The eagerness among some collectors and institutions for portraits of major colonial personalities led to misrepresentations of paintings, even to the point of adding false signatures to European pictures. The falsification of colonial portraits affected the scholarship on American art in the years between the first and second world wars.

In her commentary Karal Ann Marling deftly salutes the transformation of the portrait into an icon. Dr. Marling's familiarity with portraits of George Washington brings the discussion to the subject of historical fantasy; both the first President and his painter, Stuart, were portrayed in later images by C. H. Schmolze (1858) and Grant Wood (1939). The famous portrait of Washington became more than an historical image of an individual.

The conference "The Portrait in Eighteenth-Century America" was held at the time of the exhibition American Colonial Portraits: 1700–1776. Copies of the page proofs of the catalogue were made available to the speakers as they prepared their talks, and many refer in their papers to portraits and other objects in the exhibition. Thus the conference papers can be considered as part of a dialogue begun by the exhibition, planned to address the topic of portraiture in the American colonies from 1700 to 1776. Because portraits dominated colonial American art, the exhibition also became a study of American artists during those early years. Equally important, however, was a trans-Atlantic emphasis: paintings made in Europe were included, as were books and prints.

The catalogue for the exhibition, American Colonial Portraits: 1700–1776, by Richard H. Saunders and Ellen Miles (Washington, D.C.: Smithsonian Institution Press, 1987), builds on the traditional art historical, object-oriented method of catalogue essays that discusses each object in the exhibition. Elemental data includes the identification of the artist and the sitter, as well as the date the portrait was made. The entry was then broadened to include information about the sitter's life, possible reason for having a portrait made, attitudes toward portraits, level of taste, or other clues that would explain the content of the portrait, including its size, the pose of the figure, the clothing worn, the background or

other attributes. The authors also investigated the artist's life, including his or her training, the visual characteristics this portrait shared with others by the same artist, and the region or regions of the country the artist came from or traveled to. Sitters included as wide a range of social levels as were represented in portraits, keeping in mind that most sitters were from the upper economic levels of the population. Works were included by each of the women artists of the period whose works have survived, as well as an engraving after a lost portrait attributed to the only recorded African-American painter. The objects in the exhibition were thus chosen to address many issues about portraits, issues that were summarized and reiterated in the two introductory essays by the coauthors. These essays discussed the reasons portraits were made, the traditional sizes, compositional choices, and uses for portraits, as well as recounting the numbers of artists in various locations throughout the colonies.

From the conference and the exhibition came a clear idea of the question to be asked about American colonial portraiture. Studies of a single artist's works are still valuable; they form the core of information on which interpretations are based. Most important in this area of research is the contribution of conservators in revealing the methods and materials used by these artists. Careful conservation reports, based on x-radiography, infrared reflectography, and tests of pigments, also help to separate the artist's work from the additions and changes to the portraits since they were created. But the chance of finding new documentation on which to base attributions is slim. Instead, for research on individual pictures, a more fruitful direction is to investigate the sitters, about whom often the basic information is unknown. Determination of age at the time of the portrait, level of education, membership in certain social or political groups, and religion and marital status is often difficult. This approach has at times led to new material on the artist, as Elizabeth Kornhauser has so dramatically proved in her work on the artist Ralph Earl.

There is also a clear impetus to go beyond the level of identification to one of interpretation. The most interesting group of questions concerns the imaging process itself. Elements of the portrait that attract the modern viewer are clothing, pose, personal objects, and background views. Some of these visual references are easily identified and understood. Books with titles, desks with pens and paper, views of ships at sea or battle scenes clearly refer to professional accomplishments, and appear most frequently in portraits of men. But some objects, such as flowers, bowls of fruit, fountains and gardens, are included because of their allusions to the character or personal interests of the sitter, especially in portraits of women. Are we sure that these are symbols? How are they to be interpreted?

Another aspect of imaging is the pose of the figure. Studies of the concept of gentility suggest the hidden (to us) content of the frequently repeated formal poses used by painters. Studies of dance manuals and manner books are now recognized as a helpful direction for understanding the poses of figures in portraits. Other poses are derived from portraits by much-admired English painters, including Peter Lely, Godfrey Kneller, and Joshua Reynolds. Was the sitter conscious of these imitations? Was he, or she, flattered by them?

Clothing is clearly a major element of the imaging process. Was the clothing in the portraits actually owned by the sitters? Is it real, or invented for the portrait by the painter? Historians of clothing now tend to believe that many if not most eighteenth-century portrait painters invented the clothing in their paintings. At times this consisted only of giving the sitter a more elegant suit or dress than he or she really owned. In other instances, especially with portraits of women, the artists often created a new type of clothing specifically for the portrait. This is significant for a discussion of the issues raised in Dr. Breen's paper on portraiture and consumerism since it is now believed that the three Copley sitters who appear in the exact same dress, in different colors, probably did not have such a dress, which had been copied by the artist from a mezzotint. The possibility that the clothing represented in many portraits was not clothing actually owned and worn by the sitter does not negate his theory that the sitter's clothing was a significant element in the painting. As he points out, even the faces in the portraits may not have been close, careful representations of the literal truth. Eighteenth-century portraits, in other words, are not photographs. Their concept of representation differed from the modern notion of realism and pictorial truth.

Another major area of interest is that of the

painter's "style" in a portrait. Does the term *style* include composition and color as well as technique? What social or historical meaning does the style of a particular portrait have? Samuel Green addressed this question in 1971, in a paper entitled "The English Origins of Seventeenth-Century Painting in New England." He sought to prove his theory that "seventeenth-century portraiture in New England reflected the style favored by the Puritan or Parliamentarian groups in Great Britain."[1] He found instead that "there was no consistency in the patronage of fashionable artists by Royalists or Cavaliers, or of *retardataire* artists by Parliamentarians or Puritans."

In this discussion there is room for a better understanding of the technique of the colonial artist who was trained in America, as compared to that of the English-trained artists like Joseph Blackburn or John Smibert. It is also important not to follow a compulsion to identify only one colonial American style. For example, the style of Henry Benbridge, who painted in Italy in the 1760s, is very different from that of Charles Willson Peale or John Singleton Copley. No single colonial artist of this group should be considered the typical, or most representative, colonial artist. The danger of assuming one colonial style is shown in Richard Saunders's paper: in the 1920s a number of eighteenth-century English portraits were falsely identified and collected as colonial American portraits.

Portraiture as a business enterprise also attracts researchers: how did painters learn, how did they get materials? Were the sizes of the canvases and proportions and positions of the figures predetermined? Was the similarity of images disturbing to the customers? What were the sitter's expectations? What was his or her role in determining the final look of the portrait? What effect did competition have on groups of artists? What was the local impact of a talented visitor? What did a less successful painter do to earn a living?

The broad social and cultural context for the portrait also merits further investigation. Less than one percent of the population was seen in portraits. Can we assume that other, undepicted individuals share the values of these sitters? Why were they not painted? Was it an economic choice or the absence of an artist? Why do some families value portraits, commissioning them in several generations, while others had no interest? Is the portrait an expression of personal values? of the importance of the individual in society? Is it more important in mercantile, Protestant societies?

The study of colonial portraiture offers many surprises. Among them is a closer look at how people viewed themselves and what they valued in images of themselves. The concept of the portrait as a bearer of individual and shared values was established in American culture by the time of the Revolution. After the birth of the new nation, portraiture became the first visual form to receive wide public and private patronage.

Notes

1. The article is included in *American Painting to 1776: A Reappraisal*, ed. Ian M. G. Quimby (Charlottesville, Va.: Winterthur Conference Report for 1971, 1971), 16.

The Portrait
in Eighteenth-Century
America

Part 1
The European
Background

The Theory and Practice of British Eighteenth-Century Portraiture

JOHN HAYES

American eighteenth-century portraiture was almost inevitably heavily dependent upon British example.[1] Engravings of British portraits gave American practitioners their cue as to style, pose, design, and iconography. Several early-eighteenth-century British portrait painters, such as John Smibert and John Wollaston, settled, or worked for some time, in the American colonies. Conversely, and chiefly in the second half of the century, young American portraitists visited and worked in Britain; three of the most promising of them, Benjamin West, John Singleton Copley, and Gilbert Stuart, remained in that country (although Stuart eventually returned to practice in America). West, who welcomed his fellow Americans into his family circle, had early become the favorite painter of George III and in 1792 succeeded Sir Joshua Reynolds as the president of the Royal Academy.

There is no doubt that Reynolds, "the modern Raffaelle,"[2] was the pivotal artistic figure of his age in Britain. Given the fact that London was also the principal European center for portraiture, we could not do much better than to examine the portraiture of the period through his eyes. Born in 1723, he studied under the

leading portraitist of his day, Thomas Hudson, and spent three years in Italy. By the 1760s, with William Hogarth ill (he died in 1764), Reynolds had become the undisputed leader of British painting and thus the most obvious candidate for the presidency of the new Royal Academy, founded in 1768. He dominated the academy over the next two decades by the impress of his personality, with his major exhibited pictures— many of them seminal works—and with his justly celebrated discourses to the academy students. He was influential, too, upon the next generation, none more so, especially in the field of portraiture, and he was revered by the greatest artist of the new age, Joseph Mallord William Turner.

Ambitious, organized, unbelievably hard-working, highly cultivated, at the center of social and intellectual life in London, Reynolds had very clear views regarding the position of the artist in society and the place of painting among the liberal arts. When he returned from Italy in 1752 he painted a full-length portrait of the youthful but already distinguished naval commander, Augustus Keppel, who had taken him there in 1749 (fig. 1). What was he trying to tell

19

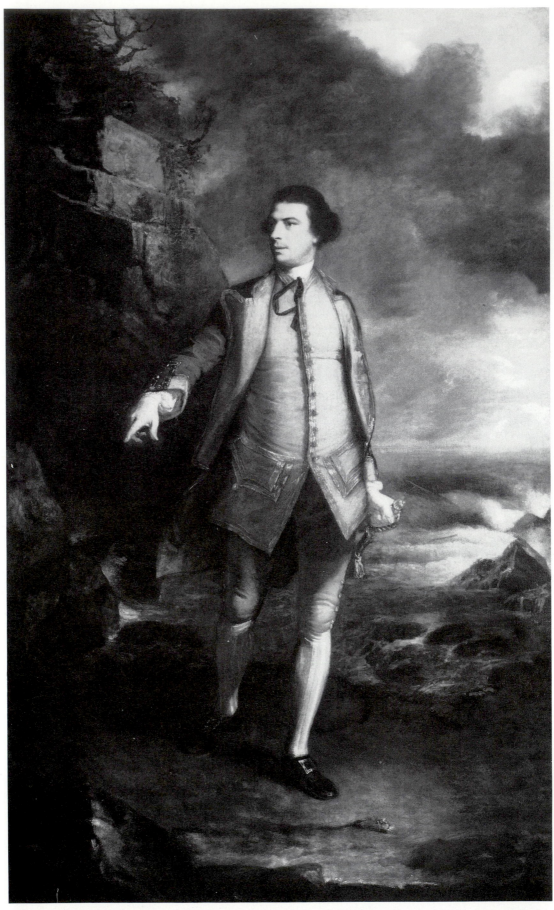

Fig. 1. Sir Joshua Reynolds, *Commodore Augustus Keppel*, 1752, oil on canvas, 94⅛ × 57⅞ in. (238 × 147 cm). The National Maritime Museum, Greenwich, London.

his public with this very unusual portrait?

On the lowest level it was an advertisement. Artists' studios were a kind of promenade, open to the whole of the *beau monde*. Reynolds hung the portrait of Keppel, with its pose derived from the Apollo Belvedere and its lighting scheme from Tintoretto, in his public rooms for the world to admire; and it did. Commissions flowed in. As an investment in future patronage, in 1761 he bought "a handsome house on the west side of [Leicester Fields]; to which he added a splendid gallery for the exhibition of his works, and a commodious and elegant room for his sitters," spending far more than he could afford and opening the gallery with a ball.[3]

Thomas Gainsborough, later to be one of Reynolds's main rivals, had a far less ostentatious studio when he first set up in Bath in 1759, but he, too, found it essential to have public rooms. His style could be as daring as Reynolds's, but at its most original it offended against decorum, as Mrs. Delany found when she went with Lady Westmoreland to see his pictures in 1760: "There I saw Miss Ford's picture, a whole length with a guitar, a most extraordinary figure, handsome and bold; but I should be very sorry to have any one I loved set forth in such a manner" (fig. 2).[4] Twenty years earlier she might have made a similar remark about Hogarth's aggressively unconventional full-length of *Captain Coram* (1740; Thomas Coram Foundation for Children, London). When in 1795 George III "started back with disgust"[5] at the unblushed romanticism of Thomas Lawrence's *Lord Mountstuart* (exhibited at the Royal Academy in 1795; private collection, Scotland), it was the spectator rather than the artist who was out of step.

Most portrait painters deferred to their clients and especially to rank, but Gainsborough was quite prepared to rebuke no less a person than the prime minister, William Pitt, when he sat to him inattentively, and "maintained an importance with his sitters, such as neither Beechy (sic) or Hoppner can preserve."[6] "Now damn Gentlemen," he declared,

there is not such a set of Enemies, to a real Artist, in the world as they are, if not kept at a proper distance. *They* think (& so may you for a while) they reward your merit by their Company & notice; but I . . . know that they have but one part worth looking at, and that is their Purse. . . . If any Gentleman comes to my House, my Man asks

them if they want me (provided they don't seem satisfied with seeing the Pictures) and then he asks *what* they would please to want with me; if they say a Picture sir please to walk this way and my Master will speak to you; but if they only want me to bow & compliment Sir my Master is walk'd out.[7]

Nonetheless, when for health reasons he moved a little way outside Bath, onto Lansdown, he was careful to keep in touch with the social world of the rich and idle taking the waters: "I have . . . let off all my House in the smoake except my Painting Room and best parlour to show Pictures in."[8]

Reynolds was concerned, second, in demonstrating that portraiture was an art that could aspire to a higher position in the academic hierarchy. I "would rather be an apothecary than an *ordinary* painter,"[9] he had told his father as a youngster. Later he was to observe that it was according to the "mental labour employed in it" that "our profession becomes either a liberal art, or a mechanical trade."[10] He sought to rise above the "phizmongering" of the day, which catered for a demand for likeness, accuracy, realism, finery of costume, and emblems of rank. The demonstration of social status or aspiration to it, the suggestion of broad acres and power in local affairs, could, he believed, be achieved by nobler and more sophisticated means. Position attained through the rough-and-tumble of trade and commerce, as so much was, was not to be celebrated too overtly, as many years later Lawrence was to discover when the sons of the banker Sir Francis Baring refused to let a print be published of that artist's well-known triple portrait (*Sir Francis Baring, John Baring and Charles Wall*, R.A. 1807; private collection, England), because they did not like "to have their Father exhibited with a *Ledger* before Him."[11]

Third, Reynolds was determined to sweep away every remnant of the frivolous world of the rococo, a style he continued to belabor in his discourses: "all trifling or artful play of little lights, or an attention to a variety of tints is to be avoided."[12] The rococo style, whose chief protagonist was the ubiquitous Hogarth (and in which Gainsborough was brought up), had dominated the avant-garde of English painting since the death of Sir Godfrey Kneller. This avant-garde was associated with the then opposition party, which congregated round the court of that distinguished connoisseur, Frederick, Prince of

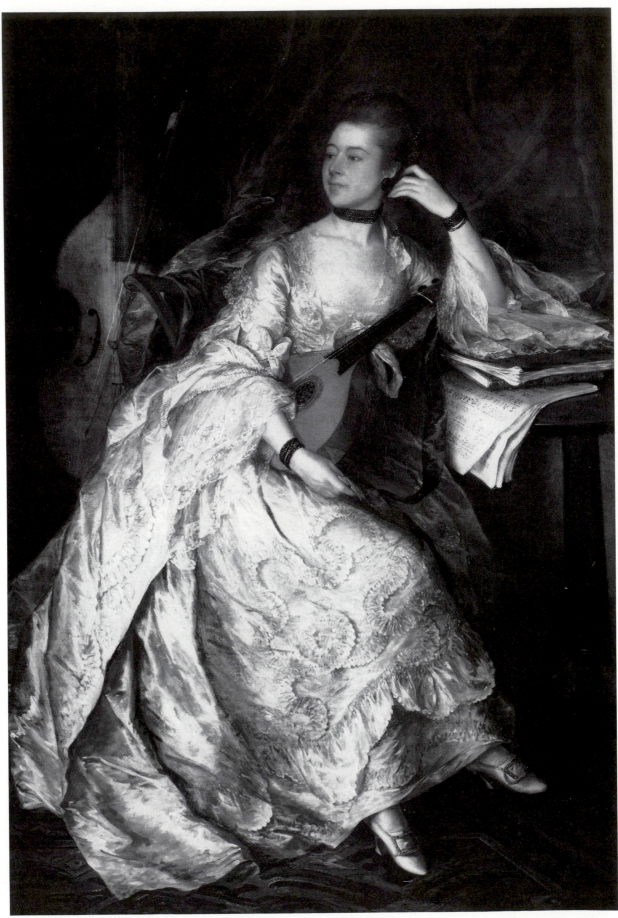

Fig. 2. Thomas Gainsborough, *Miss Ann Ford, later Mrs. Philip Thicknesse,* 1760, oil on canvas, 77⅝ × 53⅛ in. (197.1 × 135 cm). Cincinnati Art Museum; bequest of Mary M. Emery.

Wales. It was Philip Mercier, who came to England in the mid-1720s and worked for the prince, who introduced the sensuous colors and facture of French art and also its informality, notably by way of the conversation piece. This was a genre quickly taken up by Hogarth; the fashion was all the rage for a few years, then as suddenly dropped by the aristocracy, and left to middle-class sitters who were unprepared to pay for large-scale portraiture. The leading practitioner was Arthur Devis, who charged five guineas a figure in the 1740s and turned out work in a broadly similar style for a quarter of a century, until, in the 1760s he was supplanted by an infinitely more sophisticated artist, Johann Zoffany, who was patronized by George III.

Fourth, Reynolds wanted to sweep away—or to transform through a wholly new resonance—the outworn conventions that had been the stock-in-trade of British portraiture since the seventeenth century. These had been handed down from the age of Sir Anthony Van Dyck and Sir Peter Lely, whose careers centered around the life and pomp of courts, respectively of Charles I and Charles II. In 1752 these conventions, which the engravings and mezzotints after Sir Godfrey Kneller had disseminated in the American colonies, were the currency of Hudson, to whom, as I have noted, Reynolds himself had been apprenticed. Even the rococo painters had been bound by the rubric of contemporary etiquette and the postures of polite society, but court art had embalmed portraiture in conventional poses that were largely of stylistic origin.

Just as Devis painted his sitters in settings of his own devising, which reflected a status often superior to their own and were sometimes repetitious, so Hudson portrayed women in identical poses and costumes and jewelry. We must suppose that these sitters never caught sight of their alter egos on the walls of the house for which they were destined. Portraiture had veered to the mechanical, almost as though it were nothing more than a furnishing fabric. Postures might be painted ready for heads to be inserted; Sir John Medina, for example, is recorded as taking with him in 1693 or 1694 to Scotland canvases with ready-made postures and backgrounds: "Medina has 2 [men] bussie [sic] at work doeing the drapery of some pictors [sic] to take along with him."[13] Kneller was more conscientious, as Alexander Pope reported: "I find he thinks it absolutely necessary to draw the Face first, which he says can never be set right on the figure of the Drapery & the Posture finished before."[14]

Drapery painting brought its own rewards. As Gainsborough said, "There is a branch of Pai[nting] next in Profit to Portrait. . . . which is Drapery & Landskip backgrounds. perhaps you don't know that whilst a Face painter is harras'd to death, the drapery painter sits and earns 5 or 6 hundred a year, and laughs all the while."[15] Hudson and Allan Ramsay shared the services of Joseph van Aken; Reynolds and Francis Cotes, those of Peter Toms.

Fifth, Reynolds wanted to display *his* sense of the past in a deeper, more considered way, one which reflected the veneration for classical antiquity that underlay contemporary architecture and the values of eighteenth-century society in general. In Italy he had done none of those things that young British artists were wont to do: copying for British noblemen on the Grand Tour, acting as a cicerone, buying and selling antiquities. He had concentrated his whole attention on his future career, for which he prepared himself by the study of antique sculpture and of the most admired masters of the High Renaissance and the Bolognese school, and indeed of any works in the galleries, palaces, and churches of Italy that attracted his vigilant and receptive eye for their mastery of design, pose, color, or chiaroscuro. He filled his sketchbooks—of which ten survive—with ideas for future use. As he said: "It is by being conversant with the inventions of others, that we learn to invent. . . . Nothing can come of nothing."[16] If we examine a few of his later works we shall see what he meant. We shall also understand something of the extent to which his high seriousness and career sense were intertwined.

Reynolds was careful to send to the first public exhibition of pictures ever held in London, that of the Society of Artists in 1760, a portrait of one of the most celebrated beauties of the day, Elizabeth Gunning, Duchess of Hamilton and Argyll (fig. 3). Nine years earlier Francis Cotes had established his reputation with his pastels of the Gunning sisters (1751; Duke of Argyll, Inveraray Castle, Argyllshire, and National Portrait Gallery, London). The fame, status, or beauty of the sitter was always to be a significant factor—perhaps the most significant factor—in the public acclaim of an exhibited portrait. The concept of the Duchess leaning against a sculptured plinth

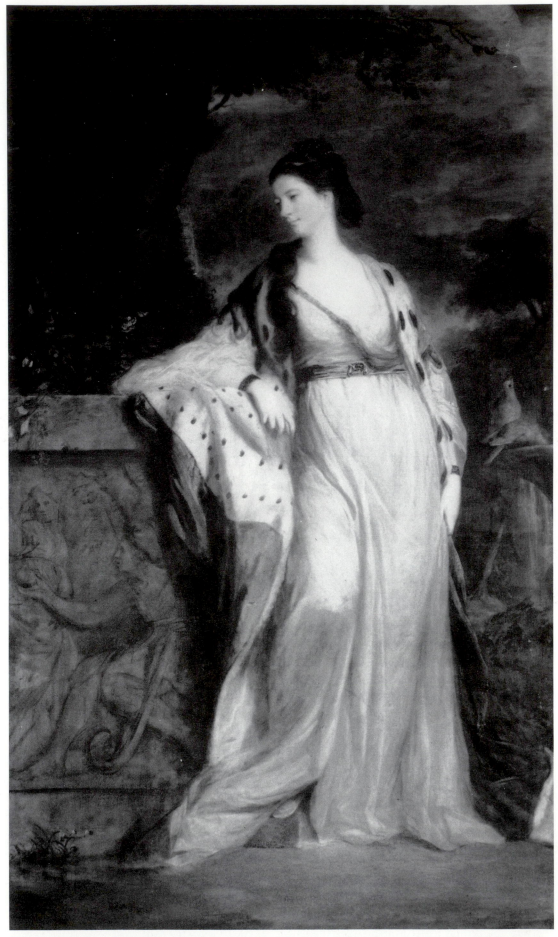

Fig. 3. Sir Joshua Reynolds, *Elizabeth Gunning, Duchess of Hamilton and Argyll;* exhibited at the Society of Artists in 1760; oil on canvas, 94 × 58 in. (238.5 × 147.5 cm). Trustees of the National Museums and Galleries on Merseyside (Lady Lever Art Gallery, Port Sunlight).

was derived, suitably enough, from Kneller's famous "Hampton Court Beauties", but Reynolds's invention has a majesty, serenity, and breadth of light and shade rarely found in Kneller's work. The elegant curving pose derives from one of Tintoretto's *Virtues* in the Church of the Madonna dell'Orto in Venice, which Reynolds had sketched. The sculptural drapery is classical in inspiration, and the sitter is identified with the goddess Venus from the representation of the shepherd Paris on the plinth and the presence on the right of the doves, her attribute. The power of the image derives not only from its grace but from its intellectual as well as formal coherence.

Similarly, in the engagement portrait of Anne Dashwood (1764; Metropolitan Museum of Art, New York), Reynolds used the convention, familiar in early-eighteenth-century portraiture, of depicting the sitter as a shepherdess, but gave the image a gravity it had never possessed before by means of the reflective seriousness of the expression. The plinth shows an appropriate relief, of Psyche being awakened by Cupid's arrow.

Peter Ludlow (fig. 4) was depicted in a Hungarian hussar's uniform, a popular masquerade dress in the mid-eighteenth century (Devis had a doll fitted out in this costume in his studio wardrobe). Even Reynolds had to descend from his lofty pedestal to please his clients, for there were at least five sittings for the dog in this picture. But the design was based on Van Dyck's great full-length of Thomas Wentworth, first Earl of Strafford (1636; Trustees of the Rt. Hon. Olive, Countess Fitzwilliam's Chattels Settlement, England), and suggests, both in grandeur and in the treatment of the background, of Titian, whose portrait of Charles V holding a hound by the collar (1533; Museo del Prado, Madrid) when in the Royal Collection had originally influenced Van Dyck.

In spite of his desire to transform British portraiture, Reynolds was very conscious of the importance of the Van Dyck tradition, and especially so in the mid-1750s when, after his return from Italy, he was trying to establish himself with an aristocratic clientele. After all, many of these people had portraits by Van Dyck hanging on their walls. He was not above cribbing from that artist's poses in much the same way that Hudson did; his portrait of Lord Cardoss in Van Dyck dress (1764; National Gallery of South Africa, Cape Town) is an example. He defended

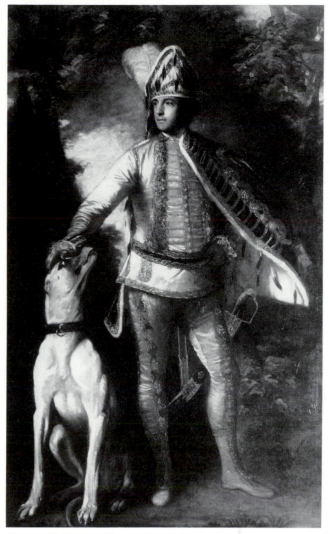

Fig. 4. Sir Joshua Reynolds, *Peter Ludlow, later 1st Earl of Ludlow,* **1755, oil on canvas, 91 × 57⅞ in. (231 × 147 cm). By kind permission of the Marquess of Tavistock and the trustees of the Bedford Estates, Woburn Abbey, Bedfordshire.**

his actions in his sixth Discourse (1775): "an artist . . . should enter into a competition with his original, and endeavour to improve what he is appropriating to his own work. Such imitation is so far from having any thing in it of the servility of plagiarism, that it is a perpetual exercise of the mind, a continual invention."[17] As it happens, Gainsborough satisfied Reynolds's theory, as it applied to direct borrowings, even more remarkably than Reynolds himself. In his portrait of the Hon. Mrs. Thomas Graham, also in Van Dyck dress, exhibited at the Royal Academy in 1777 (National Gallery of Scotland, Edinburgh), the motifs of the drooping right arm and the hand fingering the satin folds are culled from Van Dyck. But the artist's love of feminine beauty and brilliant impressionistic handling give the canvas

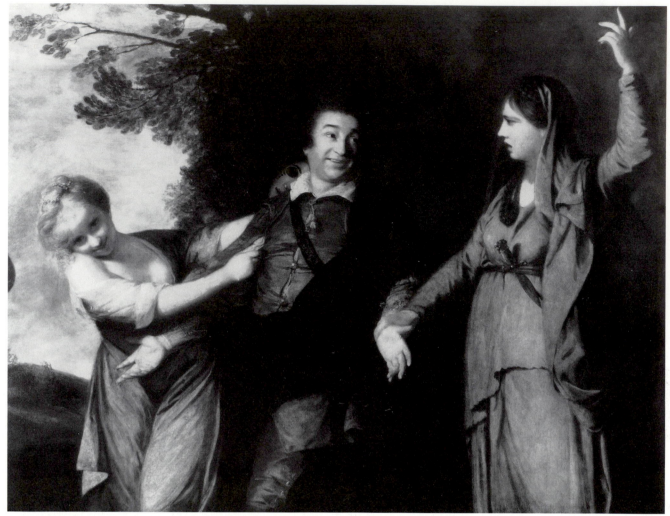

Fig. 5. Sir Joshua Reynolds, *David Garrick between Tragedy and Comedy;* exhibited at the Society of Artists in 1762; oil on canvas, 58¼ × 72 in. (148 × 183 cm). Private collection; photography courtesy of the Royal Academy of Arts, London.

a magic and glamour entirely his own.

Reynolds's invention and learning went further in his *Garrick between Tragedy and Comedy* (fig. 5), derived from the familiar subject of the Choice of Hercules. Here the two Muses are painted in distinct but appropriate styles, Tragedy in the manner of Guido Reni, representative of the "Great Style," and Comedy in that of Correggio, whose style was "founded upon modern grace and elegance."[18] Gesture in eighteenth-century portraiture was often derived from the example of the stage—from the declamatory style of acting then in vogue—and this inspiration is clearly apparent in the figure of Tragedy.

But Reynolds's portraiture most obviously approximated to the "Great Style" and to the compositions of the history painter in his *Three Ladies Adorning a Term of Hymen* (fig. 6). The patron, Luke Gardiner, wanted to have a portrait of his fiancée, Elizabeth Montgomery, in the company

of her two beautiful sisters, one just married (to Viscount Townshend) and the other destined to marry a year later. "I wish", he wrote to Reynolds, "to have their portraits together at full length, representing some emblematical or historical subject; the idea of which, and the attitudes which will best suit their forms, cannot be so well imagined as by one who has so eminently distinguished himself by his genius and poetic invention."[19] A few weeks later Reynolds responded with his choice of subject: "the adorning a Term of Hymen with festoons of flowers. This affords sufficient employment to the figures, and gives an opportunity of introducing a variety of graceful historical attitudes. I have every inducement to exert myself on this occasion."[20]

Reynolds's chosen subject was taken from Poussin, and the three "graceful historical" attitudes that elevated the group portrait into an

historical composition—improving a lower genre in the artistic hierarchy "by borrowing from the grand"[21]—derive, in the case of the figure of Lady Townshend, on the left, from a drawing in one of his Italian sketchbooks, and, in the case of the two standing figures, from Poussin's *Bacchanal* (Musée des Beaux Arts, Reims). The sitters are differentiated but the likenesses are generalized, and all accord with the ideal of classical beauty. As Reynolds wrote: "It is very difficult to ennoble the character of a countenance but at the expense of the likeness, which is what is most generally required by such as sit to the painter."[22] He also advised the portrait painter, "let him not forget continually to examine, whether in finishing the parts he is not destroying the general effect. . . . The great end of the art is to strike the imagination."[23] He himself avoided detail and particularization and kept the overall effect constantly in mind, nowhere more so than in this group.

Reynolds's portrait of the Montgomery sisters brings us to his final purpose in painting the portrait of Keppel: to demonstrate his unique ability to idealize and exalt his sitters. In this purpose he was at his best with men, with admirals, military commanders, bishops, and writers. He devised poses, gestures, and associations appropriate to each, and in addition, "Each person," he pronounced, "should also have that expression which men of his rank generally exhibit."[24] Cotes, who was his principal rival in the 1760s, watered down this ideal, taking up Reynolds's style and poses but adapting them to his own decorative or sentimental intentions. Gainsborough, by contrast, saw his sitters, even if they were generals or grandees, first and foremost as individuals, and painted them as they

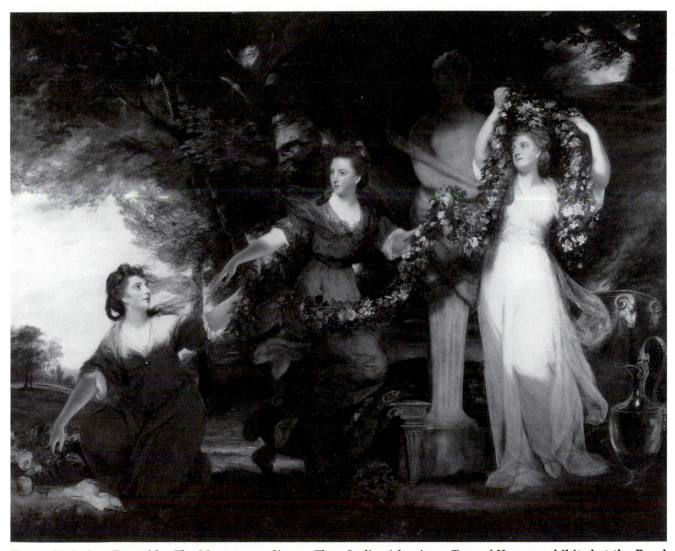

Fig. 6. Sir Joshua Reynolds, *The Montgomery Sisters: Three Ladies Adorning a Term of Hymen;* exhibited at the Royal Academy in 1774; oil on canvas, 92 × 114½ in. (233.7 × 290.8 cm). Tate Gallery, London/Art Resource, New York.

were in everyday life, setting them against his customary landscape background.

Reynolds idealized women rather differently. In the first place he eschewed fashionable dress and invented garments suggesting classical drapery but based on the informal wrapping gown of the day. With such material he could deploy elaborate drapery patterns and sophisticated patterns of light and shade. Most painters had lay figures on which to dispose drapery, and the ideal portraitist, he wrote, "dresses his figure something with the general air of the antique for the sake of dignity, and preserves something of the modern for the sake of likeness."[25] George Romney and John Hoppner followed his lead, though Gainsborough, who delighted in painting the silks and satins of contemporary costume and regarded likeness as "the principal beauty & intention of a portrait," described such draperies as "a fictitious bundle of trumpery."[26]

Second, as with French portraitists of the period such as François Boucher or Jean-Marc Nattier, Reynolds associated his women sitters with the world of mythology; in short, he turned them into goddesses. However, as Edgar Wind has pointed out, he did this as a compliment to some appropriate female quality or accomplishment, not to invest them with divinity.[27] The portrait of Lady Blake, for example, one of the works he sent to the first Royal Academy exhibition in 1769 (present location unknown), is depicted as Juno, dressed in classical robes and standing on a cloud receiving the cestus (girdle), a symbol of chastity, from Venus, as a variation on the mythological theme, Reynolds associated some of his sitters with a mood such as melancholy or contemplation, an example followed by Romney, notably in his countless portraits of Lady Hamilton.

Reynolds was fortunate in being able to mold the public exhibition as a forum for his most personal style. He consistently showed his strength, originality, and variety in his exhibited portraits, and the annual Royal Academy exhibition, frequented by patrons as well as by critics and a throng of increasingly well-informed visitors, became the testing-ground for portraiture in the late eighteenth and early nineteenth centuries. Careers depended upon public performance. Few leading portraitists disdained to exhibit, though Romney was one. It is less known how much reputation depended upon criticism. Although far less analytical than in France, reviews were more particularized than they are today and were often embellished with flattery or malice, according to the pamphleteer concerned or the bias of the newspaper publishing it. Gainsborough, for one, was acutely conscious of adverse criticism.

Gainsborough's style was, in any case, less suited to public exhibition than that of Reynolds. Pictures had to be forced in tone for the glare and competition of a public showing on crowded walls. Thus we find Gainsborough writing to one of his sitters, probably in 1772: "I think we could still finish a little higher, to great advantage, if it would not be intruding too much upon your good nature, to bestow one more little sitting of about half an hour. . . . I am fired with the thoughts of Mrs. Pulteney's giving me leave to send you to the Royal Exhibition, and of making a good Portrait of you"[28] ([Sir] William Johnstone-Pulteney, Bart., probably exhibited at the Royal Academy in 1772; Yale Center for British Art, New Haven). But Gainsborough was increasingly put out by the hanging of his full-lengths at too great a height. The rule was that full-lengths should be hung with the lower edges of their frames eight or nine feet from the floor, level with the height of the doorways. This prevented any appreciation of the delicacy of his technique. In 1784 Gainsborough made a final but unsuccessful complaint to the hanging committee and withdrew from the exhibition: "he has painted this Picture of the Princesses in so tender a light, that notwithstanding he approves very much of the established Line for Strong Effects, he cannot possibly consent to have it placed higher than five feet & a half, because the likenesses & Work of the Picture will not be seen any higher; therefore at a Word, he will not trouble the Gentlemen against their Inclination, but will beg the rest of his Pictures back again"[29] (The Princesses Charlotte Augusta, Augusta Sophia, and Elizabeth, 1783, Royal Collection, Windsor Castle). Henceforth he exhibited annually in his own studio, setting a precedent that, from time to time, was followed by others. It was not until 1821 that the "Line" was lowered a foot so that full-lengths could be "brought nearer the eye."[30]

Rivalry was greatly increased by public exhibition. We owe it to that indefatigable diarist of the art world, Joseph Farington, that the competition for favor, in the 1790s and 1800s, between Lawrence, John Hoppner and Sir William Beechey is recorded in such detail. Lawrence, only twenty-

one, had made a splash at the academy in 1790 and was commended by Reynolds himself.[31] But in 1794 Lawrence was generally regarded as inferior to Hoppner,[32] who was patronized by the Prince of Wales. In the following year George III declared that Beechey was first and Hoppner second.[33] In 1796, seeking to restore his position at a time when his reputation was rising again, Lawrence reduced his prices to those of Beechey (thirty guineas for a head and shoulders).[34] In 1799 we find Beechey complaining that Lawrence was painting on a scale larger than life in order to get center place.[35] In spite of this some rated both Beechey and Hoppner higher than Lawrence in 1800.[36] Three years later Lawrence was contemplating giving the academy exhibition a miss, as "He had many small pictures to finish," but Farington was adamant that he must keep his name before the public.[37]

By 1807 the tables were turned as far as Hoppner was concerned. The triple portrait Lawrence showed that year—of Sir Francis Baring, John Baring and Charles Wall (private collection, England)—was widely acclaimed. Farington told West it "would not be *rivalled*," and West agreed: "that picture, & His Circular one exhibited last year, puts them all at a distance."[38] Now, as West reported, "Lawrence was studying His art with energy, and was adopting the true method of proceeding viz: to begin & finish . . . instead of filling His House with dead Coloured pictures."[39] (One of the major faults of his practice was that, for financial reasons, Lawrence took on too much work; he received the customary half-payment at the first sitting, and started but failed to finish his portraits.) In July Farington advised him to raise his prices: "I told him it appeared to me decidedly that Hoppner's mode of painting is so much more slight than his, that Hoppner could paint at least 3 pictures in the time that he could paint two."[40] Lawrence did so, and he raised them again after Hoppner's death in 1810. Only a few years later he was knighted and had begun for George III his celebrated portraits of the victors of the Napoleonic Wars (now in the Waterloo Chamber at Windsor Castle). Farington discussed the situation with Thomas Phillips, a reputable follower of Lawrence: "On my mentioning the great difference between the Prices of Sir Thos. Lawrence and Himself and other Painters, He [Phillips] said that *Owen*, *Shee* & Himself had 50 guineas for a three quarter portrait, & 200 guineas for a whole length, & that He wd. not

raise His price, having, He said, only business enough to keep Him employed. He added that *Owen* had more business than He had, that 50 guineas for a Head was a large price & that He had lost many sitters on that account."[41]

Phillips's words remind us that portraiture was a business and a livelihood before it was an art form, and that, in sheer quantity, simple, unpretentious face painting predominated. As Marcia Pointon writes, "The virtuoso performance of a Reynolds or a Gainsborough launched by a sensational display at a Royal Academy exhibition was the exception rather than the rule."[42] Gainsborough, in his impecunious younger days, apologized to a friend for not traveling over to visit him because "business comes in, and being chiefly in the Face way I'm afraid to put people off when they are in the mind to sit."[43] At almost exactly the same time Reynolds was putting up his prices to stop the flow of sitters.[44] In those busy days, to expedite business, he kept in his studio a portfolio of prints of his previous portraits from which sitters could select an attitude.[45] Reynolds certainly ran his studio as a business—his pupils complained about it—and he was astute in generating for himself publicity and profit through the publication of superb mezzotints of his works. He never let up, and if he really believed what he said when he expressed the view that the size of London's population was insufficient to support more than eight painters,[46] perhaps he had good reason. There were well over a hundred portrait painters jostling for place in the capital in the 1780s;[47] and Hogarth had spoken long since of the "misery among the unsuccessfull how often have they wished they had been brought up cobblers."[48] Marcia Pointon, in one of the most illuminating and down-to-earth essays ever written about British portraiture, describes the bevy of colormen, accessory painters, engravers, copyists, framemakers, carvers, packers, and carriers who operated in well-defined parts of London such as Soho, upon whom the portraitist depended for the successful prosecution of his career.[49] Not everyone had the ability to organize their studios to fulfill the manifold expectations of their clients.

In some of his finest later work Reynolds was more direct and informal than he had been earlier; he displayed more vigorous action, greater expressiveness, richer chiaroscuro. Gainsborough's later portraiture also anticipated the

Fig. 7. Thomas Gainsborough, *Mrs. Richard Brinsley Sheridan, née Elizabeth Linley,* 1785–87, oil on canvas, 86½ × 60½ in. (219.7 × 153.7 cm). National Gallery of Art, Washington, D.C., Andrew W. Mellon Collection.

Fig. 8. Sir Thomas Lawrence, *Elizabeth Farren, later Countess of Derby;* exhibited at the Royal Academy in 1790; oil on canvas, 94 × 57½ in. (238.8 × 146.1 cm). Metropolitan Museum of Art. Bequest of Edward S. Harkness, 1940.

ethos of the romantic age. He enveloped his sitters in arcadian landscape settings, so that the two seemed to be synonymous (as in his portrait of *Mrs. Richard Brinsley Sheridan*, fig. 7), or showed them walking gently out of the canvas towards the spectator (*The Morning Walk*, 1785; National Gallery, London) rather than being posed or held within the confines of the frame, as in Reynolds's portraits of ladies bustling onto the picture stage (for example, *Miss Emily Pott as Thaïs*, Royal Academy, 1781; Waddesdon Manor, Buckinghamshire). These highly original works, recognized at the time to have been painted "in a nouvelle stile,"[50] had no progeny. But such portraits as his ravishing full-length of the Hon. Frances Duncombe (c. 1778; Frick Collection, New York), shown with lips parted and eyes sparkling, wearing a Van Dyck dress similar to that used for Mrs. Graham, and set against a vibrant background, were, quite as much as the late work of Reynolds, a starting point for Lawrence. In his magical portrait of Elizabeth Farren exhibited in 1790 (fig. 8) Lawrence depicted the lovely actress, who married Edward, twelfth Earl of Derby, from a dramatically low viewpoint, walking through a fresh, summer landscape, her head framed by scurrying clouds. It was while standing in front of Lawrence's exhibits at that year's Royal Academy that Reynolds is supposed to have declared to the young man, destined in 1820 to succeed West as the third president of the academy, "In you, sir, the world will expect to see accomplished what I have failed to achieve."[51] The torch had been handed on.

Notes

1. A full treatment of this subject would require its own book. The present essay is, slightly expanded and I hope improved, the script of a lecture. A lecture requires a connecting thread and I chose to discuss what aspects of the subject I could from the standpoint of one man, Sir Joshua Reynolds. I owe a particular debt to Edgar Wind's celebrated and seminal essay "Hume and the Heroic Portrait," in *Hume and the Heroic Portrait: Studies in Eighteenth-Century Imagery,* ed. Jaynie Anderson (Oxford: Clarendon Press, 1986) and to Marcia Pointon's lively and refreshing discussion, "Portrait-Painting as a Business Enterprise in London in the 1780s," *Art History* 7 (June 1984): 187–205.

2. *Public Advertiser,* 13 April 1785.

3. James Northcote, *The Life of Sir Joshua Reynolds,* 2 vols., 2d ed. revised and augmented (London: Printed for H. Colburn, 1819), 1:102. Sir Thomas Lawrence, too, overspent in "supporting a certain Manner in a Gentlemanly Profession and obliged to deal with Fashion and its thousand whims" (Lawrence to Edmund Antrobus, quoted in Kenneth Garlick, *Sir Thomas Lawrence: A Complete Catalogue*

of the Oil Paintings [Oxford: Phaidon Press, 1989], 14).

4. Mrs. Patrick Delany to Mrs. Dewes, Bath, 23 October 1760, in *The Autobiography and Correspondence of Mary Granville, Mrs Delany,* ed. Augusta Hall, Lady Llanover, 3 vols. (London: R. Bentley, 1861), 3:605.

5. So John Hoppner reported: noted in Farington's diary, 5 May 1795: *The Diary of Joseph Farington,* ed. Kenneth Garlick and Angus MacIntyre (vols. 1–6) and Kathryn Cave (vols. 7–16), 16 vols. (New Haven: Yale University Press, 1978–84), 2:339.

6. According to Sir Francis Bourgeois (*Diary of Joseph Farington,* 6 January 1799, ed. Garlick and MacIntyre, 4:1129–30).

7. Gainsborough to William Jackson, Bath, 2 September 1767, *The Letters of Thomas Gainsborough,* ed. Mary Woodall, 2d ed., rev. (London: Cupid Press, 1963), no. 150.

8. Gainsborough to James Unwin, [Bath], 30 December 1763, *Letters of Gainsborough,* no. 87.

9. Samuel Reynolds to Mr. Cutliffe, Plympton, 17 March 1740, *Life and Times of Sir Joshua Reynolds,* ed. Charles Robert Leslie and Tom Taylor, 2 vols. (London: J. Murray, 1865), 1:16.

10. "Discourse IV," 10 December 1771 (Sir Joshua Reynolds, *Discourses on Art,* ed. Robert R. Wark, 2d ed. [New Haven: Yale University Press, 1975; originally published San Marino: Huntington Library and Art Gallery, 1959], 57).

11. Lawrence provided this information himself (*Diary of Joseph Farington,* 17 February 1809, ed. Cave, 9:3401).

12. Reynolds, "Discourse IV," 61.

13. Unknown correspondent to the Countess of Leven, London, 28 September 1693; John Fleming, "Sir John Medina and His 'Postures,'" *Connoisseur* (American ed.) 148 (September 1961): 24.

14. Alexander Pope to Lady Mary Wortley Montagu, 1720, quoted in J. Douglas Stewart, *Sir Godfrey Kneller and the English Baroque Portrait* (Oxford: Oxford University Press, 1983), 82–83.

15. Gainsborough to William Jackson [Bath, n.d.], *Letters of Gainsborough,* no. 58.

16. Reynolds, "Discourse VI," 10 December 1774, *Discourses,* 98 and 99.

17. Ibid., 107.

18. Reynolds, "Discourse IV," 72.

19. The Hon. Luke Gardiner to Sir Joshua Reynolds, Dublin, 27 May 1773, *Life of Reynolds* 1:291.

20. Sir Joshua Reynolds to the Hon. Luke Gardiner, London [n.d.], *Life of Reynolds* 1:292.

21. Reynolds, "Discourse IV," 72.

22. Ibid.

23. Reynolds, "Discourse XI," 10 December 1782, and "Discourse IV," *Discourses,* 200 and 59.

24. Reynolds, "Discourse IV," 61.

25. Reynolds, "Discourse VII," 10 December 1776, *Discourses,* 140.

26. Gainsborough to William, 2d earl of Dartmouth, [Bath], 18 April [1771], *Letters of Gainsborough,* no. 18.

27. Wind, "Hume and the Heroic Portrait," 43.

28. Gainsborough to William Johnstone-Pulteney [Bath, n.d.], *Letters of Gainsborough,* no. 66.

29. Gainsborough to the Royal Academy Hanging Committee, London, 10 April 1784, *Letters of Gainsborough,* no. 3.

30. *Diary of Joseph Farington,* 12 April 1821, ed. Cave, 16:5646.

31. William T. Whitley, *Artists and Their Friends in England, 1700–1799,* 2 vols. (London and Boston: The Medici Society, 1928), 1:129.

32. *Diary of Joseph Farington,* 30 April 1794, ed. Garlick and MacIntyre, 1:185.

33. So Hoppner himself reported (*Diary of Joseph Farington*, 5 May 1795, ed. Garlick and MacIntyre, 2:339).

34. "Lawrence I breakfasted with. We had much talk about his lowering his prices in consequence of Hoppner particularly continuing to paint ¾ pictures [head and shoulders portraits] for 25 guineas . . . if Hoppner will not raise his price in proportion to the expences of the times." *Diary of Joseph Farington*, 29 May 1796, ed. Garlick and MacIntyre, 2:562–63.

35. Beechey was not specific when he told Farington that a "rule must be made that if portrait painters paint pictures larger than life,—they must not therefore command *center places*," but it is clear from Lawrence's exhibited works that it was he he had in mind: *Diary of Joseph Farington*, 26 April 1799, ed. Garlick and MacIntyre, 4:1212.

36. So Samuel Lane, then about to start his pupilage with Lawrence, had heard: *Diary of Joseph Farington*, 8 July 1800, ed. Garlick and MacIntyre, 4:1417.

37. Ibid., 24 February 1803, 5:1986.

38. Ibid., 7 April 1807, 8:3007.

39. Ibid., 5 May 1807, 8:3038.

40. Ibid., 2 July 1807, 8:3079.

41. Ibid., 13 December 1818, 15:5300.

42. Pointon, "Portrait-Painting as a Business," 195.

43. Gainsborough [to William Mayhew], Ipswich, 13 March 1758, *Letters of Gainsborough*, no. 25.

44. Ellis K. Waterhouse, *Reynolds* (London: K. Paul, Trench, Trubner & Co., 1941), 11 and 13.

45. Northcote, *Life of Reynolds* 1:83.

46. Ibid. 2:65.

47. Pointon, "Portrait-Painting as a Business," 190.

48. Michael Kitson, "Hogarth's 'Apology for Painters,'" *Volume of the Walpole Society* 41 (1968): 79.

49. Pointon, "Portrait-Painting as a Business," 190–92.

50. *Morning Herald*, 28 March 1786.

51. Whitley, *Artists and Their Friends in England* 1:129.

Part 2
The Artist in
American Colonial
Culture

The Meaning of "Likeness": Portrait-Painting in an Eighteenth-Century Consumer Society

T. H. BREEN

On the eve of the revolution Andrew Burnaby took what must have been for an Englishman the American equivalent of the Grand Tour. This Anglican minister traveled from Virginia to New Hampshire, recording conversations he had had with the "natives" in a large journal that was subsequently published in London. When Burnaby reached Rhode Island, he went out of his way to visit the house where George Berkeley, the famed immaterialist philosopher, had briefly resided some thirty years earlier. Local farmers entertained the visitor with stories about Berkeley, a thinker who they observed had held "wild and chimerical notions."

Although their tales apparently amused Burnaby, he concluded that such materials would be largely out of the place in a formal journal and therefore begged "the reader's indulgence" to repeat only a single story, presumably the best of the lot. Berkeley, it seems, envisioned "building

a town upon the rocks" overlooking the ocean and had drawn plans for a road that would lead down to a sheltered beach. A man called Smibert—the locals told Burnaby that he was a "designer" who had accompanied Berkeley to America—remained skeptical. He asked a "ludicrous question concerning the future importance of the place." To this inquiry the philosopher responded: "Truly, you have very little foresight, for in fifty years time every foot of land in this place will be as valuable as the land in Cheapside." But according to the locals Smibert had the last laugh, for on the very spot where Berkeley had predicted a real estate boom, Burnaby saw only "an indifferent wooden house" and a dairy that had once served as the philosopher's library.

The "designer" who asked such "ludicrous" questions, John Smibert, was one of the first professionally trained portrait painters to take up residence in colonial America. While Berkeley, his friend and patron, dreamed up quixotic real estate schemes, Smibert was presumably putting the final touches on a painting that has

The author thanks Richard Wendorf, James Oakes, Ellen G. Miles, Thad Tate, and Josef Barton for their suggestions and encouragement. This essay has been published in *Word & Image* 6, no. 4 (1990).

Fig. 9. John Smibert, *The Bermuda Group,* **c. 1729–31, oil on canvas, 69½ × 93 in. Yale University Art Gallery, New Haven, Conn. Gift of Isaac Lothrop.**

come to be known as the *Bermuda Group* (fig. 9). At the edge of this large canvas we encounter the painter himself. He peers at us, a sharp-featured man, looking a bit uncomfortable, even anxious, as if he had come to doubt the wisdom of exchanging the cosmopolitan comforts of London for the simplicity of colonial Rhode Island. One wonders why this intense person made so little impression upon the local farmers. Had the more curious among them not witnessed Smibert working on the *Bermuda Group?* Had they not heard that he later moved to Boston, becoming by the mid-1740s the most successful portrait painter in America? The vocabulary they used to describe him—he was the "designer"— seems strangely inappropriate for a man remembered as an artist. Why was he not a "painter," for example? Or Smibert, the person who made portraits?[1]

Even today we remain uncertain how best to situate an accomplished artist like Smibert in eighteenth-century American society. To be sure, we know a great deal more than did the Rhode Island farmers about the details of the painter's life. For Smibert, as well as for other, more obscure artists of the period, we possess impressive catalogues of surviving works, detailed investigations of the men and women who actually commissioned these paintings, and learned studies of each artist's style and technique.[2] But however valuable this scholarship— and this essay could not have been written without it—it does not satisfactorily link the artists and their works to a complex Anglo-American society which was in the process of generating many ideas and institutions that we now with the benefit of hindsight readily identify as modern.

Situating the provincial artists in a rapidly changing commercial society, therefore, involves a great deal more than collecting additional biographical detail or providing purely formalistic

commentary. The interpretive challenge requires us to consider how colonial Americans—in this case, painters, sitters, and viewers—went about the business of constructing a visual imagination out of the materials and experiences of everyday life. After all, the portrait was a project to which all participants brought a bundle of cultural assumptions. These notions, even when not fully articulated, informed conversation between artists and sitters. In other words, eighteenth-century painters were not engaged in the production of what we might call an objective "likeness." If they were to be successful in this provincial market, they had to craft images that resonated with broadly shared cultural meanings.

The reconstruction of social context might proceed in a number of different ways, some obviously more persuasive than others. One particular approach deserves special attention. Indeed, it is probably the most common way to get at the problem of linking the provincial artists and the society in which they worked. A respected art historian recently argued, for example, that the most successful portrait painters of Smibert's generation were men whose canvases reflected the core values of eighteenth-century America. The wealthy merchants and powerful lawyers—members of a colonial elite—apparently insisted on portraits that mirrored "their materialistic interests, their pragmatic outlook, their egalitarian spirit, and their quiet self-confidence, which came in part from the good life and the prosperity they had gained through their own labor. Such were the components defining the social being known as the colonial American . . . and it would be unthinkable that they should not appear as salient characteristics in the portraits of the upper-middle-class mercantile aristocracy." A struggling artist who did not understand what was expected of him or who foolishly introduced "artificial social conceits or ideals" soon found himself without commissions.[3]

However plausible this straightforward reading of mideighteenth-century portraits may sound, it does not resolve several major interpretive problems. First, the logic of the analysis is circular. The modern critic seems to have decided in advance what cultural values prevailed in provincial society and then proceeded to locate them in the paintings. In other words, a twentieth-century art historian has projected meanings onto the colonial portraits, and although one applauds the effort to situate the artist in a specific social setting, the interpretation really amounts to little more than asserting that bourgeois Americans commissioned what look to be bourgeois portraits.

A second difficulty with this approach relates to the claim that colonial portraits were "objective" portrayals of "physical reality."[4] This suggestion raises profound philosophic problems that need not detain us here.[5] It is probably sufficient to observe that one would be hard pressed to demonstrate that these portraits were mere transparencies, windows that provide modern viewers with direct access to the core values of a lost colonial reality. What we encounter in the portraits—a point made powerfully by Jean-Paul Sartre in *Nausea*—are interpretations of reality, or more precisely, interpretations devised by artists and sitters of their place within an imagined Anglo-American society.[6]

This essay handles the problem of contextuality in a different way. It focuses on a social process known as self-fashioning.[7] The very term implies human agency. Eighteenth-century men and women in conversation with artists like Smibert decided how they wanted to present themselves on canvas, and by attending closely to those elements of self-fashioning that were distinctive products of an eighteenth-century commercial society, we are able to recapture the culture meanings that the colonists, as opposed to the modern historian, brought to the creative exchange.

Such a hermeneutic strategy forces a radical reinterpretation of familiar mideighteenth-century portraits. I speculate here, for example, that for provincial Americans the central element in these paintings may have been the sitter's clothes, the character and the quality of the fabric, and not—as we have sometimes been led to believe—the posture of the body or the details of the face.[8] In fact, it is in the context of a vast Anglo-American consumer society that we not only gain fresh insight into the cultural meaning of "likeness," but also connect the world of Smibert to that of ordinary colonial farmers.

1

During the early eighteenth century it was a commonplace to discuss the British empire in terms of commerce. People who wrote about

such matters usually viewed the American colonies as a vital source of raw materials. Sugar, rice, and tobacco cultivated in the New World freed the English from dependence upon foreign products. This was classic mercantilism. What the political economists of the age were slow to appreciate was the importance of consumption in promoting happiness and prosperity throughout the empire. The facts, however, were clear enough for those who bothered to analyze them. Long before the onset of the Industrial Revolution, the English began demanding manufactured goods. The times were generally good; most workers had a little extra money in their pockets. And for those who were short of cash, storekeepers provided generous credit. Almost everyone in Great Britain could buy something—a small knife, a decorative plate, a piece of glassware, a yard of cloth—and with each passing year this domestic market grew. Roads and canals carried an ever-expanding number of items to eager purchasers; newspaper advertisements announcing the latest fashions fueled consumer desire.

Consumer demand, of course, was not an invention of the eighteenth century. It had a long history. Nevertheless, there was something strikingly unusual about this particular period. In previous societies, the wealthiest people had always purchased items that set them apart from the less well-off. In Roman times moralists had warned against the spread of Asiatic luxury; in the prosperous cities of Renaissance Italy an elite lived in personal splendor. In Georgian England, however, a much larger percentage of the population began to participate in the consumer marketplace. To be sure, this was an age of aristocratic resurgence, and the magnificent manors that dotted the English countryside displayed the wealth of the great landholders. But a growing middling group, perhaps containing as many as a million people, also acquired the new manufactured goods. These people could not compete with the landed elite in the quality and quantity of items purchased. They attended fewer concerts, owned fewer suits and gowns, made do with domestic china. They did not, however, buy different categories of goods. Everyone that could afford to do so, for example, acquired at least some china. That was the secret of Josiah Wedgwood's success. Entrepreneurs of his stripe created England's first mass market; they recognized the difference between elite consumption and a consumer society.[9]

The explosion of consumer demand transformed social relations in Great Britain. In fact, one historian has recently drawn attention to what he calls an eighteenth-century "revolution of manners."[10] In a society that allowed for a comparatively high level of social mobility—compared, that is, to contemporary European societies—people increasingly made claims to social status through the possession and display of goods. "Was there not," Gerald Newman asks rhetorically in his splendid study of eighteenth-century English nationalism, "a pattern of sharpening cultural differentiation during this period, expressing itself through significant alterations in dress, speech, etiquette, taste, intellectual tone, manners, and morality?"[11]

There is no doubt about the correct answer. Everywhere one looks, one encounters evidence of men and women attempting to distinguish themselves from members of other status groups, in other words, trying to establish clear markers separating themselves from all the others who were clambering up the social ladder. Consumer goods became the props in a new public theater of self-fashioning.[12] The "peacocks" who populated the Georgian court knew this. So, too, did the middling sorts who gave up spitting in their homes and who worried about speaking proper grammar. The entire system was extraordinarily unstable, or so observers claimed at the time. People differentiated themselves through their relations to goods, and since anyone with money or credit might purchase a handsome new suit of clothes or set of dishes, no one excepting perhaps the peers of the realm enjoyed security of status. There were too many claimants; the gradations within the hierarchy were too narrow. Fear of losing place—as much as the dream of upward mobility—spurred additional purchases. Indeed, popular consumption gave a frenetic, competitive edge to eighteenth-century English society.

These social tensions help explain the passionate intensity of the debate over luxury. Conservative moralists complained that "fashion" was contaminating society. They hated the new forms of self-fashioning. The rage for distinction had spawned envy, discontent, insolence, and insubordination among the lower and middling orders. Almost every major author of this period contributed to the public discourse about the decay of social etiquette. The topic obsessed Tobias Smollett; it energized John Brown's polemical writings. For these commentators, the prob-

lem was not original sin. The villain was mass consumption, a spreading evil that seemed inevitably to result in political leveling. Henry Fielding was only one of the many persons who sounded the alarm. In his *Enquiry into the Cause of the Late Increase of Robbers* (1751), Fielding announced that "the Introduction of Trade" had transformed the character of the lower orders. "This hath indeed given a new Face to the whole Nation, hath in great measure subverted the former State of Affairs, and hath almost totally changed the Manners, Customs, and Habits of the People, more especially the lower Sort. The Narrowness of their Fortune is changed into Wealth, the Simplicity of their Manners changed into Craft, their Frugality into Luxury, their Humility into Pride, and their Subjugation into Equality." The poorer people had become so addicted to material vices, Fielding argued, that they turned robber to fulfill their needs.[13] Such criticism was not directed solely at the "lower Sort." Other English Jeremiahs of the mideighteenth century attacked the aspiring bourgeoisie not only for its expensive dress but also for its increasingly vocal demands for political reform.[14]

Curiously, it was the Scots who most effectively undermined this dominant moral discourse. The major writers of this region openly questioned the negative effects of consumption. A few even dared to defend "luxury," noting that if nothing else, consumer demand stimulated the national economy and brought a higher level of comfort and prosperity to an ever-greater percentage of the population. In "Of Refinement in the Arts," David Hume shocked conservative sensibilities by stating that "Luxury is a word of an uncertain signification, and may be taken in a good as well as a bad sense." Whereas a Fielding or a Smollett berated consumer demand for unsettling the traditional social order, Hume saw it as personally liberating. The Scots, of course, condemned "vicious" luxury. In general, however, they argued that the possession of such goods freed people from dependence; it generated a spirit of "commerce and industry" among the populace. According to Hume, "In a nation, where there is no demand for such superfluities, men sink into indolence, lose all enjoyment of life, and are useless to the public, which cannot maintain or support its fleets and armies, from the industry of such slothful members."[15]

My interest in this debate is not that of the intellectual historian. I am less concerned with the arguments of various authors for or against luxury than I am in the fact that most of them were fully conscious of the power of mass consumption to transform the character of their society. These were people trying their best to make sense out of a new social landscape, one in which economic life became "in itself a realm of representations."[16] The colonial experience cannot be divorced from this English background. As eighteenth-century Americans became ever more dependent on Great Britain for a supply of manufactured goods, they also were compelled to confront the moral and political implications of self-fashioning in a consumer society.

The colonists were quickly incorporated into this expanding consumer market. Indeed, Ralph Davis, an economic historian, claims that the colonies became the dynamic element in the commerce of eighteenth-century Britain. English merchants responded to the protectionist policies that increasingly cut them off from traditional Continental markets by exporting ever larger quantities of finished manufactured goods to the New World. During the early decades of the century the American trade rose steadily. The major takeoff, however, occurred in the 1740s. Exports to the colonies accelerated dramatically. The effects of this sudden growth were soon apparent on both sides of the Atlantic. According to Davis, "The process of industrialization in England from the second quarter of the eighteenth century was to an important extent a response to colonial demand for nails, axes, firearms, buckets, coaches, clocks, saddles, handkerchiefs, buttons, cordage and a thousand other things."[17] This flood of exports finally overwhelmed the clerks of the British Customers service, and after midcentury they began lumping the scores of smaller consumer articles into a single general category—"Goods, several sorts."

This growth was a reflection in part of England's own protectionist policies. The colonies were covered by the Navigation Acts, seventeenth-century statutes that prohibited the Americans from importing manufactured goods from any place other than Great Britain. Articles of Continental origin had to be transshipped through an English port, thus adding considerably to the price that the American consumer eventually paid. Adam Smith, a harsh critic of mercantilism, grumbled in *Wealth of Nations* that "a great empire has been established for the sole purpose of raising up *a nation of customers* who

should be obliged to buy from the shops of our different producers, all the goods with which these could supply them." For the sake of maintaining this American monopoly, he insisted, "the home-consumers have been burdened with the whole expense of maintaining and defending the empire."[18]

But in this instance, Smith probably overrated the impact of the Navigation Acts on the flow of trade. The driving engine of this commerce was American demand. The colonists wanted the products of the English manufacturers as much as did the people of Great Britain. A few statistics indicate exactly what was happening. As Benjamin Franklin and others observed, the population of eighteenth-century America was doubling about every twenty-five years, a rate of growth so extraordinary that it became the foundation for Thomas Malthus's dark theories about the relation between population and food supply. But the colonists did not starve. They became consumers, purchasing finished manufactured goods at a rate that actually exceeded the expansion of population. Between 1720 and 1770, for example, per capita American imports went up by approximately 50 percent. Even these numbers underreport the trend. Since so many colonists at any given moment were young children and dependent workers, the bulk of the purchases must have been made by free adults. A fraction of the population, in other words, was buying ever-larger quantities of British goods. One estimate places the annual per capita expenditure on foreign imports between 1761 and 1770 at £3.35. Since the per capita income in this period was about £12, we must conclude that Americans spent about a quarter of their income on manufactured items.[19]

These statistics surprise us largely because we have come to see colonial America as a society composed of self-sufficient yeomen. There is no question that the overwhelming majority of people grew their own food. But in other matters they do not seem to have been able—nor particularly eager—to achieve full economic independence. Most households in the third quarter of the eighteenth century did not even have the capacity to produce cloth. They either lacked an adequate supply of raw fiber or did not possess the tools necessary to meet a family's basic clothing needs. An historian who has examined colonial probate records concludes that "in America only a fraction of what people wore or

put on their tables and beds had been spun at home."[20] The colonists' dependence on Great Britain for ceramics, metal goods, and glassware—just to name a few items—was even more pronounced. The weekly newspapers contained scores of advertisements announcing the arrival of the "latest goods from England." As in the homeland, the availability of easy credit opened the market to colonists of modest income. What was happening, of course, was that men and women throughout America were being integrated into an expanding, complex imperial economy, and though their primary loyalties were as always to family and community, they increasingly found that their sense of self was being transformed by external economic forces largely beyond their control.

This was not a development that most Americans seem to have resented. Being part of an Anglo-American empire in this period meant having access to manufactured goods, items that radically changed their material culture, making it warmer, cleaner, and more colorful. It was certainly more convenient to purchase a bolt of cloth from a shopkeeper than to produce it oneself. In this sense, Hume was correct. The spread of the consumer economy could be for many ordinary people immensely liberating. And for most of them, the very notion of being members of a British empire was bound up with these personal, highly symbolic transactions. For much of the eighteenth century, in fact, the burden of imperial authority weighed lightly upon the Americans. They could go months without even seeing a royal official; most of them had little personal involvement in the frontier wars against the French. We must conclude, therefore, that the "anglicization" of eighteenth-century American culture was largely a function of the marketplace. No doubt the process operated in different ways in different regions. But whatever the details may have been, there can be no disputing that the men and women who purchased these imports, wore English cloth, drank out of English glassware, ate off of English plates, shot English guns charged with English powder, smoked English pipes, and recorded their thoughts on English paper had by the eve of the revolution acquired an outlook on culture and society that was profoundly English.

Access to these imported manufactures was most certainly not restricted to members of the colonial elite. As in Great Britain, wealthier peo-

ple purchased goods of better quality, but even Americans of rather humble status—urban laborers, for example—could afford to buy something. A complex merchandising system developed to reach these scattered consumers. The large wholesalers like the Hancocks of Boston or the Beekmans of New York handled huge quantities of goods. They then sold—or more likely gave out on credit—various English manufactures to storekeepers located in the cities and the countryside. In the South the distribution was usually channeled through a resident Scottish factor.

And throughout eighteenth-century America one encountered peddlers, the men whom one leading wholesaler called simply "my country chaps."[21] What strikes us about these itinerant salespeople (the peddlers were female as well as male) is how eager the colonial consumers were to do business. Local buyers literally assailed the peddlers on the streets. In 1740 Alexander Hamilton, a Maryland physician, and his black servant ran into some of these aggressive purchasers in Newport. Hamilton reported that they arrived "betwixt seven and eight at night, a thick fog having risen, so that I could scarce find the town. When within a quarter of a mile of it my man, upon account of the portmanteau, was in the dark taken for a peddler by some people in the street, whom I heard coming about him and inquiring what he had got to sell." Hamilton later met a peddler in Stonington, Connecticut, who had traveled with his goods all the way from Annapolis.[22] Many colonial assemblies attempted to control the itinerants, who they suspected of dealing in stolen goods. Such efforts inevitably failed. There were too many Americans who wanted to see what the peddlers had for sale.

These imported manufactures changed patterns of self-fashioning in provincial America. The articles became markers, status indicators, that allowed people to think of themselves and others in relation to goods. Or, stated in slightly different terms, the colonists of the mideighteenth century increasingly communicated social status through possession of imported English goods. It is, of course, difficult to document such shifts with precision. The evidence by its very nature is bound to be impressionistic. Fortunately, Benjamin Franklin provides powerful insight into this psychological process. In his *Autobiography* Franklin describes how imported articles could acquire symbolic significance.

. . . my breakfast was a long time bread and milk (no tea), and I ate it out of a twopenny earthen porringer, with a pewter spoon. But mark how luxury will enter families, and make a progress, in spite of principle: being call'd one morning to breakfast, I found it in a China bowl, with a spoon of silver! They had been bought for me without my knowledge by my wife, and had cost her the enormous sum of three-and-twenty shillings, for which she had no other excuse or apology to make, but that she thought *her* husband deserv'd a silver spoon and China bowl as well as any of his neighbors. This was the first appearance of plate and China in our house, which afterward, in a course of years, as our wealth increas'd, augmented gradually to several hundred pounds in value.[23]

Franklin is telling us something about the psychology of taste in provincial America. His wife—and women seem to have played a major role in the consumption of imported goods—took her cues from "neighbors." In other words, she defined in part her standing in the community through the possession of visible English manufactures. The neighbors in turn probably learned about the fashion for china from newspapers that advertised the "latest goods from London" or from smart retail shops in Philadelphia. They were all students of the subtle process of social differentiation through goods. And as the quoted passage suggests, none was more perspicacious than Franklin himself. He recognized that his own social identity as an Anglo-American was somehow bound up in the silver spoon and china bowl. The purchases, of course, did not stop with a memorable breakfast. This form of presentation of self was expensive, and as Franklin looked back upon his long career, he recognized that his own success had been punctuated by additional acquisitions valued at "several hundred pounds."

The cost of maintaining one's place in this society amazed some colonists. John Wayles, a Virginian employed by a large Bristol merchant house, knew exactly how much the new material culture was costing the Chesapeake planters. During the early 1740s a local gentleman seldom ran up a debt to an English merchant of more than a thousand pounds. But consumption had changed the rules. The merchants offered easy credit, and the planters ran with the latest fash-

ions. By 1766 no one worried about a debt of over ten thousand pounds. "Luxury & expensive living," Wayles reported, "have gone hand in hand with the increase of wealth. In 1740 I don't remember to have seen such a thing as a turkey Carpet in the Country except a small thing in a bed chamber. Now nothing are so common as Turkey or Wilton Carpetts, the whole Furniture of the Roomes Elegant & every appearance of Opulence."[24] Wayles was less concerned about the morality of conspicuous consumption than about the possibility that his high-living customers might not pay their bills.[25]

For other Americans, however, the condemnation of luxury became almost an obsessive theme. Their shrill language paralleled that of the contemporary English discourse. Consumer goods had unsettled society. People no longer knew their proper place; they had forgotten God. The narcotic of fashion had undermined traditional values. If nothing else, the very passion of this rhetoric reveals how dramatically these goods must have changed colonial patterns of self-presentation. In 1740, for example, two gentlemen who were touring the northern colonies recorded the shocking excesses of a young farmer and his wife who lived just outside New York City. These patronizing visitors picked up quickly on the visible cues of material culture. One man "observed several superfluous things which showed an inclination to finery in these poor people; such as a looking-glass with a painted frame, half a dozen pewter spoons, and as many plates, old and wore out, but bright and clean, a set of stone tea dishes and a teapot." Such articles, the travelers decided, were too extravagant for this humble cottage, and one of them advised selling these goods "to buy wool to make yarn; that a little water in a wooden pail might serve for a looking-glass, and wooden plates and spoons would be as good for use, and when clean would be almost as ornamental. As for the tea equipage, it was quite unnecessary."[26] We do not know how the members of this family received this instruction. One suspects, however, that like Benjamin Franklin they added steadily to their inventory of English imports.

Colonial ministers, especially during the Great Awakening, railed against ostentatious consumption, equating luxury with sin. In 1727 the Reverend Thomas Prince used the occasion of an earthquake to warn his parishioners of the dangers of exalting themselves "against the Glorious God." The concern for externalities, for self-fash-

ioning through worldly possessions, promoted selfishness. "It expresses it self," the Boston minister explained, "in Boasting of and Praising our Persons or Actions [and] in extravagant Apparel, Building, Furniture, expensive and pompous ways of living."[27] A few years later a Boston newspaper reported that the evangelist James Davenport had actually destroyed the "corrupting goods" in a huge fire in New London. He instructed his followers that they "were guilty of idolizing their apparel, and should therefore divest themselves of those things especially [those that] were for ornament, and let them be burnt."[28] But perhaps to no one's surprise, Davenport did not roll back the consumer society. Nor did George Whitefield or Jonathan Edwards do much better. It was not that colonial buyers were unmindful of the perils of worldliness. No doubt, for many people, the acquisition of English imports created a certain amount of guilt. Such feeling may have discouraged extreme forms of conspicuous consumption. In the end, however, the goods poured into America, and those like Governor James Glen of South Carolina who tried to resist the tide were left sputtering: "I cannot help expressing my surprise and Concern to find that there are annually imported into this Province, considerable quantities of Fine *Flanders Laces*, the Finest Dutch Linens, and French Cambricks, Chints, Hyson Tea, and other East India Goods, Silks, Gold and Silver Lace, &c. . . . By these means we are kept in low circumstances. . . . I have always endeavored to correct and restrain the vices of Extravagance and luxury by my own example."[29]

As much of this commercial evidence suggests, the most important article among the British exports to eighteenth-century America—in terms of value as well as bulk—was cloth. The customs records reveal that approximately half of all colonial imports consisted of textiles. Some of these originated in foreign countries—silks, calicoes, and German linens, for example—and thus had to be reexported to the colonies through an English port. Most textiles purchased by the Americans, however, had been manufactured in Europe. Various types of woolens sold especially well. In fact, between 1754 and 1774 the amount of woolens shipped to the mainland colonies increased by over 300 percent.[30] It would not be a great exaggeration to claim that cloth held the empire together—it did, at least for the Americans. These fabrics acquired an emblematic character. They provided a palpa-

ble link with England, a physical tie that literally touched almost every colonist. If, as I have argued, the culture of eighteenth-century America was becoming increasingly anglicized, then surely a central element in that process was cloth.[31]

Self-fashioning through textiles became an exciting preoccupation in colonial society. These fabrics introduced Americans to an unprecedented range of consumer choice. The change occurred rather rapidly. In the early decades of the century, merchants offered a limited variety of textiles. After 1740, however, the market suddenly became alive with possibilities. One could purchase different textures and weights; shopkeepers offered an impressive selection of colors and designs. A survey of advertisements in the newspapers of New York City indicates the speed of this transformation. In 1733 there was only a single notice for satin. By the 1750s merchants found it necessary to distinguish various grades and colors: black satin, blue satin, corded satin, crimson satin, green satin, laced satin, pelong satin, pink satin, red satin, spotted satin, white satin, and yellow satin.[32] The colonists described cloth in a language richer and more complex than their parents would have known. This was not a vocabulary restricted to dry-goods merchants. The public understood—indeed, came to expect—a precise listing of offerings. In the *New-York Weekly Journal* of 4 June 1753 Thomas Forsey announced that readers would find in his store "in Hanover Square, just opposite the meat market":

Broad-cloths, german serges, sagathees, duroys, penstons, shalloons, tamies, stuff, durants, bearskins, cambletees, broad cambets, ever-lasting call-immancos, stamp'd camplets, ozenbrigs, 3-4, 7-8, yard-wide, yard and 3-8 and 6-4 linnen and cotton checks; cotton hollands, cotton gowns, 3-4 and 7-8 garlicks, scotch hankerchiefs, A choice assortment of cambricks, flower'd, strip'd and check'd lawns clear and pistol, do. tandems, silesias, brown, do. brittannias, diaper and damask clouting, table cloths . . . packit cambricks, sattin, damask, black, yellow, and light-colored china and persian taffeties, strip'd persians, tandem, dowlass, a choice assortment calicoes, buckram, allapeens, silk crapes, cotton romale, turky tobines, turkey and highland plad. . . .

In the same issue of this journal, Forsey's com-petitor on Dock Street, Dirck Brickenhoff, lured customers with "venetian poplins, check'd and corded, do. bombazeens, irish camblets, worsted brocades. . . . All of these, he declared, had been "Just imported from London."[33]

It is worth noting that during this period many colonial shopkeepers began carrying mirrors, especially the small, affordable looking-glasses employed in personal grooming. This may have been the first generation of Americans who could conveniently check how they actually appeared in public. The colonists admired themselves in these different fabrics. They decided whether they looked better in yellow or red, stripes or solids, light cottons or heavy woolens. They could monitor the process of self-fashioning anytime they pleased.[34]

Americans developed a good eye for textiles. It is surprising how often their descriptions of other people drew attention to the quality and color of garments. These word-pictures sometimes amounted to little more than commentaries on fashion. Philip Fithian was not a person whom one would expect to have noticed such things. This religious young man, a recent graduate of Princeton, served as a tutor for the children of Robert Carter. Fithian kept a private journal of his experiences at Nomini Hall, one of the largest plantations in Virginia. One summer evening in 1774 he met Miss Betsy Lee. "She wore a light Chintz Gown," Fithian recounted, "very fine, with a blue stamp; elegantly made, & which set well upon her—She wore a blue silk Quilt—In one word Her Dress was rich & fashionable. . . ." On another occasion he explained that when they attended church, "Almost every Lady wears a red Cloak; and when they ride out they tye a white handkerchief over their Head and face."[35] It was not only outsiders who made such observations. The Virginians commented extensively on the cut of Fithian's garments. When John Bartram, one of America's first botanists, set off in 1737 to visit two of Virginia's most influential planters, a friend advised him to purchase a new set of clothes, "for though I should not esteem thee less, to come to me in what dress thou will,—yet these Virginians are a very gentle, well-dressed people—and look, perhaps, more at a man's outside than his inside."[36]

When Bartram's friend used the word *outside*, in all probability he was not referring to the botanist's physical features. It was clothes that mattered. To be sure, Americans took note of an individual's height and weight. They spotted ob-

vious deformities. But when called upon to describe another colonist they inevitably concentrated on the color and quality of the person's garments. One sees this sensitivity to textiles expressed most dramatically in the frequent newspaper advertisements for runaway servants. These descriptions contained general information about hair color and body type. It was clothes, however, that received the most detailed attention. An advertisement that ran in the *Virginia Gazette* explained that when William Smith disappeared, "He had on . . . a light coloured broad cloth coat, which is broke at the elbows, and with very few buttons on it, a pail duroy waistcoat, a pair of deep blue sagathy breeches, coarse shoes, several pair of stockings, steel buckels, coarse felt hat, a *Newmarket* coat of light bath coating, not bound, but stitched on the edges with death head buttons on it, a pair of wrappers, rather of a darker colour than the *Newmarket* coat . . . he likewise carried off with him a black sattin capuchin, a piece of new *Virginia* cloth, containing eight yards, striped with blue and copperass."[37] Such advertisements for servants appeared in newspapers throughout the colonies, indicating if nothing else that the consumer revolution touched the lives of even the most humble eighteenth-century Americans. During the French and Indian War, military authorities attempting to track down deserters employed virtually the same descriptive language. When John Thomas left Captain Thomas Shaw's Company of New Jersey Provincials, for example, he "had on . . . a white Drugget Jacket, and Breeches of the same, a Calico under Jacket, check Shirt, grey Worsted Stockings and new Shoes, with large Brass Buckles in them."[38]

Social distinctions expressed through the quality of cloth extended even to the decoration of the various Virginia churches. As historian Dell Upton explains, "Expenditures on textiles could easily outstrip even elaborate architectural work in parish churches." In 1751 one parish spent over £103 in Virginia currency, a large sum of money, to obtain imported crimson velvet hangings with gold fringe and lace. The decision doubled the local church rate, but no one seems to have complained. After all, most Virginia parishes "preferred imported crimson or red velvet hangings. Less wealthy parishes chose ingrain broadcloth in crimson or purple."[39]

The most graphic account of a colonist attempting to negotiate social status through cloth comes from Maryland. Dr. Alexander Hamilton—the man whom we encountered in Newport with his serving man—entered a rural tavern called Curtis's, located on the Maryland-Pennsylvania border. There he met William Morison, an individual to whom Hamilton took an immediate dislike. Morison, it seems, was "a very roughspun, forward, clownish blade, much addicted to swearing, [and] at the same time desirous to pass for a gentleman." The proprietor certainly did not think he merited special treatment. She took one look at his clothes—"a greasy jacket and breeches, and a dirty worsted cap"—and concluded that Morison must be a "ploughman or carman." And at Curtis's such persons received weak tea and scraps of cold veal.

When he saw his meal, Morison exploded, yelling that it was only the presence of another gentleman that kept him from throwing "her cold scraps out of the window and [breaking] her table all to pieces, should it cost him 100 pounds for damages." Lest no one question his claims, Morison exchanged "his worsted nightcap" for a "linen one out of his pocket" and announced to the assembled onlookers, "Now . . . I'm upon the borders of Pennsylvania and must look like a gentleman." But even after they had departed the tavern, Morison remained defensive, as if he suspected that the doctor really did think him a common laborer. As Hamilton recounted, Morison "told us that tho' he seemed to be but a plain, homely fellow, yet he would have us know that he was able to afford better than many that went finer; he had good linen in his bags, a pair of silver buckles, silver clasps, and gold sleeve buttons, two Holland shirts and some neat nightcaps." And to clinch the case, he bragged that "his little woman at home drank tea twice a day."[40] Morison assumed that Hamilton—and the owner of Curtis's for that matter—understood the language of goods. They were all products of a consumer society, people skilled in interpreting the cues of a richly textured material culture.

2

Like almost everyone else in this Anglo-American empire of goods, colonial portrait painters were caught up in a swirling consumer economy. They crafted objects that eighteenth-century Americans wanted to buy. Though this state-

ment is obviously a commonplace, it helps to frame a hermeneutic interpretation. It directs our attention away from purely aesthetic judgments and encourages us to situate their work within a world of commerce. It helps us to understand how they wove the materials and experiences of everyday life into a distinctly new set of visual symbols. This claim is not intended to degrade their artistic accomplishment. Copley and West produced magnificent paintings. By considering these portraits within a specific historical context, however, we begin to reconstruct lost meanings that might otherwise escape our attention.

One way to force a rethinking of interpretive categories—to link artists and sitters in a common cultural project—is to see the painters themselves as articles of commerce. The portrait painters of midcentury—the great majority in any case—were themselves colonial imports. Their very presence in America is testimony to the close connection between art and commerce in this society. Many migrated after 1740, the year that marks the dramatic rise in colonial consumption. Like other migrants, British artists traveled to the New World looking for economic opportunities. And judging from their activities once they had arrived, we must conclude that these men knew a good deal about how to run a small business. It was not uncommon for them to advertise in local newspapers. In May 1752, for example, Lawrence Kilburn announced in the *New-York Weekly Post-Boy* that he had "just arrived from London," and he guaranteed that any person "inclined to favor him in having their Pictures drawn, that he don't doubt of pleasing them . . . and giving agreeable Satisfaction, as he has heretofore done to Gentlemen and Ladies in London."[41] This was the same argument that merchants used to sell cloth and other goods. Kilburn took for granted the anglicization of the American consumer. Other artists ran advertisements in Boston and Charleston.[42]

Some American painters became shopkeepers in the New World. However disappointed they may have been, they discovered that only the most talented artists could support themselves by portraits alone. During the late 1740s Gerardus Duyckinck II sold paints and looking glasses in New York City. He also gave drawing lessons.[43] Thomas Johnson of Boston offered an even wider assortment of imported goods. His trade card of 1732 stated that Johnson sold fur-

niture, "japaned" woods, "Looking-Glasses," and "Coach, Chaise, or Sign Painting at Resonable Rates."[44] Even a person like Smibert, who received important commissions, was forced to maintain what today might be called an art supply store. He carried a selection of prints and glass. In fact, the only Smibert letters that have been preserved concern his business dealings with a London agent.[45]

Like the peddlers who hawked English goods from town to town, the American painters were highly mobile, a sort of commercial itinerant. Almost every biography of an eighteenth-century artist mentions travel. John Wollaston may have held the record, for like his famous contemporary George Whitefield—a revivalist who was known as the Great Itinerant—Wollaston took extended trips in America. He is known to have worked in New York, Maryland, Virginia, Philadelphia, and Charleston.[46] John Hesselius came close to matching Wollaston's performance. He left a trail of paintings scattered through Virginia, Maryland, Delaware, and Pennsylvania.[47] Copley and West left their homes to try their luck in New York City. Joseph Blackburn shifted his activities from Boston to Portsmouth, New Hampshire. Robert Feke accepted commissions in Philadelphia as well as Boston. And not a few colonial painters simply disappeared from the records after working in a town for only a few months. Like commercial travelers, they probably had taken to the road in search of new business.[48]

Portrait painters operated in a peculiar market. After all, they were not selling a finished product. Both parties—sitter and artist—had to negotiate the details of a process by working out schedules and prices. During these discussions colonial consumers do not seem to have been intimidated by the painter's "expertise." They expressed opinions and made demands. It is perhaps not surprising that many commissions during this period came from newly successful merchants, or in other words, from businessmen who were used to bargaining over goods. Artists tried to anticipate these expectations.[49] In 1744 Smibert demonstrated good judgment by ordering from London a set of prints depicting ships of "modern construction." He explained to his agent that he intended to employ these models "in a distant view in Portraits of Merchts etc *who chuse such.*"[50]

It was by making such choices that merchants

participated in the production of an artifact, which is exactly how many of them perceived the process. The portrait was an object, an article of commerce, an ornament to be displayed with other possessions. Americans who were not merchants shared this materialist perspective. It was a turn of mind that drove the ablest artists, especially those who rose to prominence in the late colonial period, to distraction. Benjamin West recounted for his biographer, John Galt, the constraints the market placed on the artistic imagination.

> In New York Mr. West found the society wholly devoted to mercantile pursuits. A disposition to estimate the value of things, not by their utility, or by their beauty, but by the price which they would bring in the market, almost universally prevailed. Mercantile men are habituated by the nature of their transactions to overlook the intrinsic qualities of the very commodities in which they deal. . . . The population of New York was formed of adventures from all parts of Europe, who had come thither for the express purpose of making money. . . . Although West, therefore, found in that city much employment in taking likenesses destined to be transmitted to relations and friends, he met with few in whom he found any disposition congenial to his own.[51]

Though Galt surely exaggerated, there was no question that it irritated people like West to be treated as a mere artisan, a maker of commodities. In 1767 Copley informed an English correspondent—again, somewhat hyperbolically—that "A taste of painting is too much Wanting [in America] to affoard any kind of helps; and was it not for preserving the resembla[n]ce of perticular persons, painting would not be known in the plac[e]. The people generally regard it [as] no more than any other useful trade, as they sometimes term it, like that of a Carpenter[,] tailor or shew maker, not as one of the most noble Arts in the World."[52]

Copley had a point. People in the eighteenth century did consider paintings as wall furniture. Wealthy colonists regarded the huge, elegantly framed canvas as an essential element in fashionable interior design.[53] The portrait did not seem to enjoy independent standing as fine art. It found meaning for contemporary Americans largely within a context of other objects. Fithian helps us to comprehend this way of viewing material culture. When he visited Mount Airy,

the magnificent Tayloe plantation located on the Rappahannock River, the young tutor noted, "The House is about the Size of Mr. *Carters* [sic], built with Stone, & finished curiously, & ornamented with various paintings, & rich pictures."[54] Northerners recorded similar reactions. During a tour of western Massachusetts in 1760, Paul Coffin, a Harvard student, commented on the disparity between the external and internal appearance of the homes. "The Painting and Utensils and Furniture in the House," Coffin observed "did not equal outward Appearance of their Houses in this part of the Country."[55]

Like Fithian, Coffin lumped paintings in with a number of other goods. Size and context seemed to have determined as much as quality how one responded to this "wall furniture." That is certainly what Charles Carroll, perhaps the richest planter in Maryland, believed. He was dismayed when he heard that Charles Willson Peale had decided to specialize in miniature painting. There was no market for such works in America. "I would have you Consider," he wrote to the young artist, who was then studying in London, "whether that may be so advantageous to you here or whether it may suit so much the Taste of the People with us as Larger Portrait Painting which I think would be a Branch of the Profession that would turn out to Greater Profit here."[56]

3

As Carroll and other colonial patrons knew full well, however, size alone did not assure excellence. Americans expected portrait painters to produce a "likeness." As we have already noted, this is an extremely elusive term. On one level it involves no more than an insistence on absolute realism: did the sitter really look like the person in the painting? According to Jules Prown, Copley owed his financial success to his ability to produce portraits precisely of this type. "Copley's clients wanted realism," Prown writes, "and Copley gave it to them. Like any successful Boston dealer in a commodity for which there was a market, he reaped all the rewards that society had to offer."[57]

Such claims—correct though they may be—are based almost completely on the fact that people purchased these paintings. We have almost no evidence how provincial Americans actually viewed the works. William Byrd provides one notable exception. John Perceval, Earl of Eg-

mont, sent the Virginia planter a portrait of himself. At an earlier time in Byrd's life the two men had been close friends, and the American was fully aware that the powerful Egmont was in a position to distribute political favors. "I have the pleasure," Byrd declared in a letter in 1736, "of conversing a great deal with your picture. It is incomparably well done & the painter has not only hit your ayr, but some of the vertues too which use to soften and enliven your features. So that every connoisseur that sees it, can see t'was drawn for a generous, benevolent, & worthy person."[58] After the passage of so many years, Byrd still recognizes Egmont, and the portrait brings back pleasant memories. There is nothing in the Virginian's fawning letter, however, to suggest that he had the slightest interest in the artist who painted the picture. Nor, for that matter, in the color or composition of the portrait. He looked at the painting the way that someone today might view a snapshot in a family album.

We should not make too much of Byrd's letter. Most Americans who commissioned portraits in the mideighteenth century apparently did not want the artist to produce an exact mirrorlike depiction. They were certainly not interested in a realism that included—as Oliver Cromwell might have said—warts and all.[59] The painter and sitter participated in a process of self-fashioning. Both parties fully understood what was at stake. The goal was not simply to represent the sitter, but rather to depict that person as he or she wanted to be represented. In this sense, the painting of a portrait involved a cultural conversation. The artist and client understood realism within the context of an anglicizing society, one in which, as we have seen, people increasingly defined themselves and their relations to others through English imports. It is not surprising, therefore, that colonial artists freely borrowed ideas for composition and costume from English prints. They were being paid to fashion Anglo-Americans.[60]

Even in this expanded context, however, "likeness" remains a problem. In portraits painted by Copley one can appreciate the personality of the sitter. He presents these people as distinct individuals. We can read the signs of human strength and weakness on their faces. But Copley was unusual. The majority of the paintings that survive from the mideighteenth century shows us men and women who seem to

have been cloned for a common source. When one looks at the faces of the colonists painted by John Wollaston, Robert Feke, John Hesselius, Joseph Blackburn, and Jeremiah Theus—productive and successful painters—one is overcome by a sort of visual *déjà vu* (see figs. 10–11). We repeatedly encounter the same square-jawed, almond-eyed, awkward men and women. The female faces are particularly disappointing.[61] One wonders how Americans could possibly have accepted these portraits as genuine "likenesses"? Were they looking at some aspect of the painting that eludes us today?

The answer has already been suggested by William Morison, the "roughspun, forward, clownish blade" whom Dr. Hamilton encountered in a Maryland tavern. The eye is drawn in these midcentury portraits not to the faces, but to the garments the people wore. However poorly a painter handled a sitter's physical features, he almost always managed to capture the brilliance and luster of the clothes. Indeed, these portraits celebrate the colorful silks and rich satins, the bright velvets and gold lace that colonial merchants were then importing in such volume from Great Britain. The provincial Americans were concerned in these portraits to fashion a visual identity through cloth. It was in this manner that they expressed their individuality; the textiles distinguished them from other sitters. This was a material language that the "drapery painters" whom they hired fully understood.[62]

In colonial America these men did very well for themselves. And none seems to have succeeded better than John Wollaston. This itinerant artist painted at least three hundred portraits in the colonies (e.g., see fig. 12). Modern critics who have viewed this scattered work have expressed considerable ambivalence about Wollaston's artistic achievement. Though the faces of his sitters possess a dull sameness, their garments are painted brilliantly. George Groce, for example, praised "the sheen of [Wollaston's] satins, the soft warmth of his velvets, and the delicate pattern of his laces. . . ."[63] And Edgar P. Richardson claims that what Wollaston's works "lacked in characterization was made up by his skill in painting laces, silks, and satins." He notes that these portraits must be seen in the context of Georgian drawing rooms, where one can fully appreciate the large canvasses in relation to other decorative objects. "That a painter," Richardson explains, "whose skill lay in painting

Fig. 10. Robert Feke, *Mrs. Charles Willing,* 1746, oil on canvas, 50 × 40 in. Courtesy, Henry Francis du Pont Winterthur Museum, Winterthur, Del.

Fig. 11. Jeremiah Theus, *Elizabeth Wragg Manigault (Mrs. Peter Manigault)*, 1757, oil on canvas, 49½ × 39⅝ in. Courtesy of the Charleston Museum, Charleston, S.C.

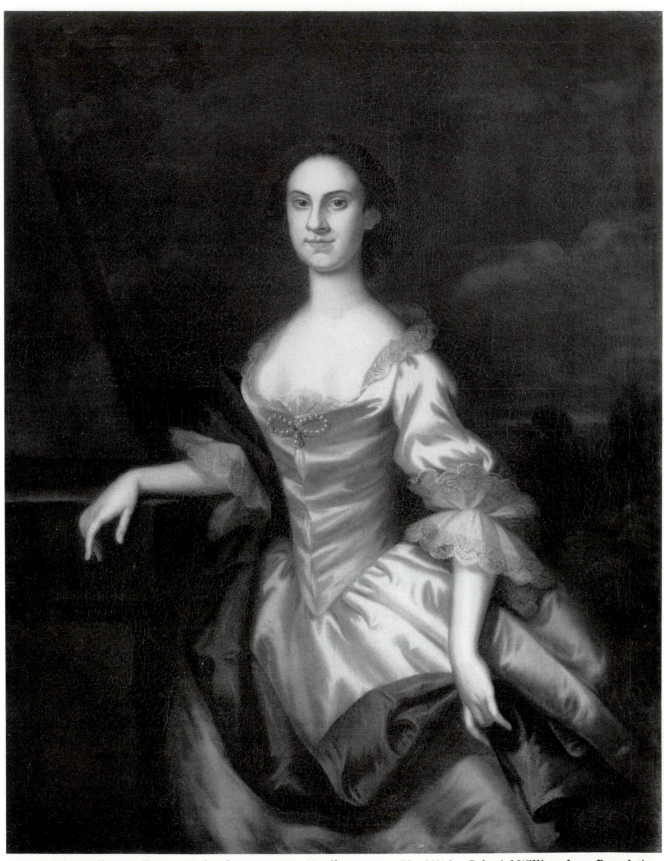

Fig. 12. John Wollaston, *Frances Tasker Carter,* **c. 1750–60, oil on canvas, 50 × 39½ in. Colonial Williamsburg Foundation, Williamsburg, Va.**

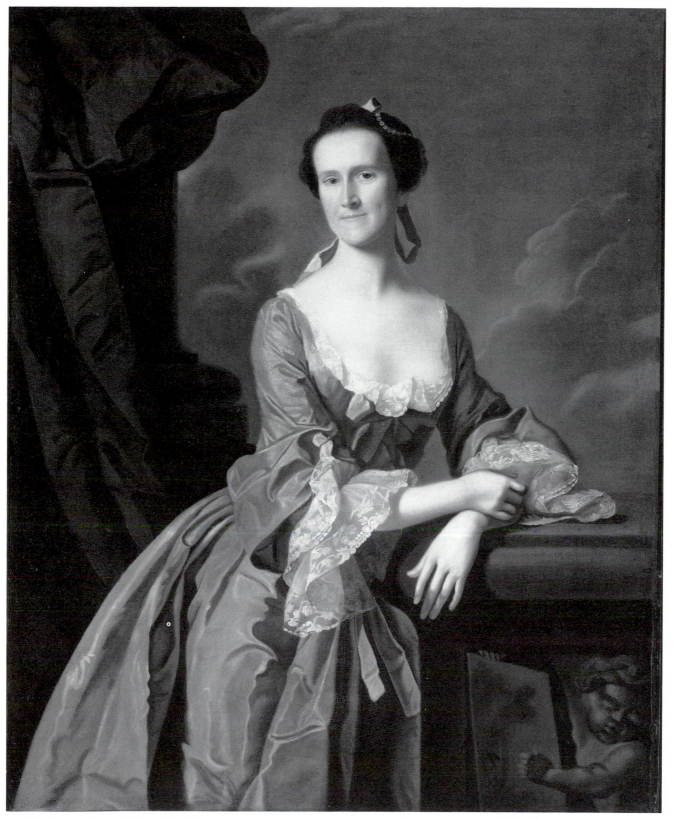

Fig. 13. John Singleton Copley, *Mrs. John Amory (Katherine Greene)*, c. 1764, oil on canvas, 49½ × 40 in. (125.7 × 101.6 cm). M. and M. Karolik Collection of Eighteenth-Century American Arts. Courtesy, Museum of Fine Arts, Boston.

textiles rather than faces should enjoy such success implies an intense desire for portraits among the colonial gentry and the acceptance of the portrait more as a symbol of status than as a person characterization."[64] Richardson's analysis can be pushed another step. It is true that the portrait itself was a symbol of status. But—and this is the point Richardson missed—status was also negotiated through the quality and character of the fabric that the sitter chose to wear at the moment of self-fashioning.

Sometimes these relationships became quite complex. Copley, for example, painted three women—Mrs. John Amory, Mrs. Daniel Hubbard, and Mrs. John Murray—in exactly the same dress (figs. 13–14). The design for this gown in turn was taken from an English mezzotint by John Faber of *Mary Finch, Viscountess Andover* (fig. 15). What seems to have occurred was that each American woman—no doubt influenced by Copley himself—made a conscious decision to look exactly like the English lady depicted in the print. Again we see colonists participating in a process of self-fashioning. Each sitter appears in a dress of a strikingly different color. This discovery suggested to Frederick Sweet "that Copley was working from actual materials. All three ladies are painted in a very solid, three-dimensional manner and their voluminous gowns seem to stand out in a clearly defined space. . . . This implies the actual presence of his sitters dressed in a model gown and could not have been achieved if he had merely copied the entire mezzotint except for the head."[65] In other words, for these three colonists the central element of the portrait was not how they looked, but how they looked in a specific garment. With Copley's help they manipulated "reality." They were playing at being English. And in the consumer society in which they lived, all three were apparently content to express their individuality through the color of a dress.

To see this kind of self-fashioning as a distinguishing characteristic of eighteenth-century society or as the special preserve of an elite within that society would be a mistake. There was nothing uniquely American about the relation between art and commerce. Though it is beyond the scope of this essay, one might speculate that similar cultural and economic forces were at work in seventeenth-century Holland, a nation that probably experienced mass consumption

earlier than any other in Europe and that, according to Svetlana Alpers, encouraged the "privileging of portraiture."[66] This art form was also extremely popular in Georgian England, another society that was being transformed by broad popular consumption. The same may have been true among the very wealthy in contemporary Ireland.[67] The interpretation advanced here is structural, rather than chronologic. It tells us something significant about a specific historical context and in no way anticipates the subsequent development of American art.

Nor would I argue that this framework of analysis applies only to a colonial elite. From the perspective advanced here it makes no sense to separate "high" or "patrician" art from other forms of self-fashioning in early America. To be sure, only the wealthiest members of this society could afford to commission a major painter to do their portrait. Even in "folk" or "primitive" works, however, one finds the same concern for presenting the sitter in relation to objects, especially to British manufactures. A painting from the Garbisch collection, *Susanna Truax* (fig. 16), provides an example of this phenomenon. This portrait by an unknown artist shows a young girl outfitted in a bright, striped dress, obviously a garment made of imported cloth. On a table one sees a tea pot, sugar cubes, and a cup and saucer. Though the picture does not possess the finely detailed lines of a work by Copley, it clearly situates the girl within an Anglo-American consumer economy. Like William Morison, the man who bragged of owning a linen cap and several holland shirts, she demands the viewer's attention. A tea set and a fashionable dress support her claim to social standing. What gives this painting special charm is the fact that Susanna Truax is so demonstrably at ease among her possessions.

I returned finally to the original challenge of situating those portraits in a specific historical context. It is important to avoid a reductionist interpretation. There were obviously many different ways to read these eighteenth-century paintings, and each possesses strengths and weaknesses. I have argued here that the portraits of this period were doubly encoded. On one level the portraits themselves were artifacts, not unlike the fancy tea sets and fine textiles. They allowed the colonists who possessed them to differentiate themselves from those who did not.

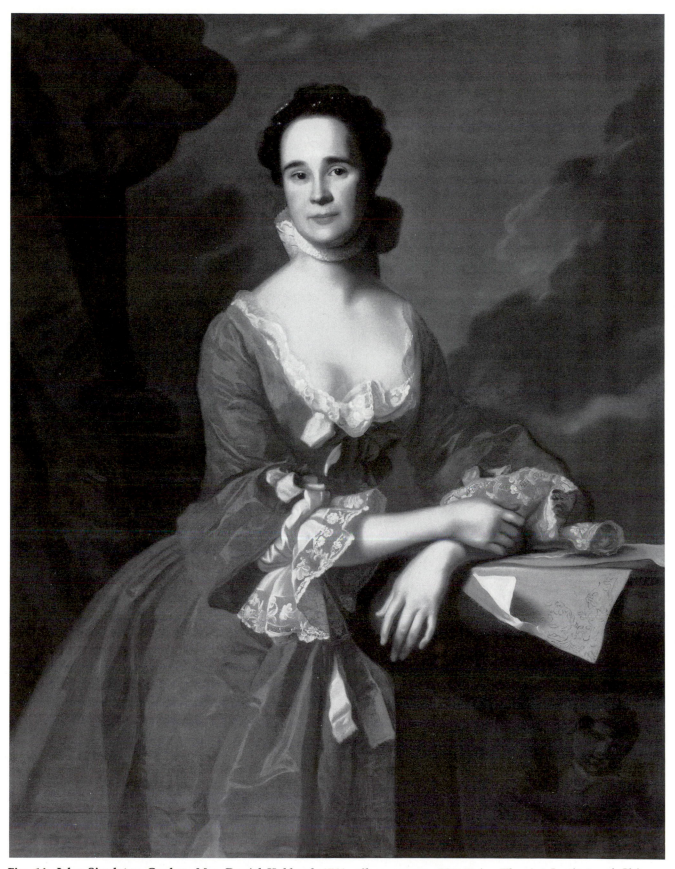

Fig. 14. John Singleton Copley, *Mrs. Daniel Hubbard,* 1764, oil on canvas, 58×48 in. The Art Institute of Chicago Purchase Fund, 1947.28. Copyright 1990 The Art Institute of Chicago, all rights reserved.

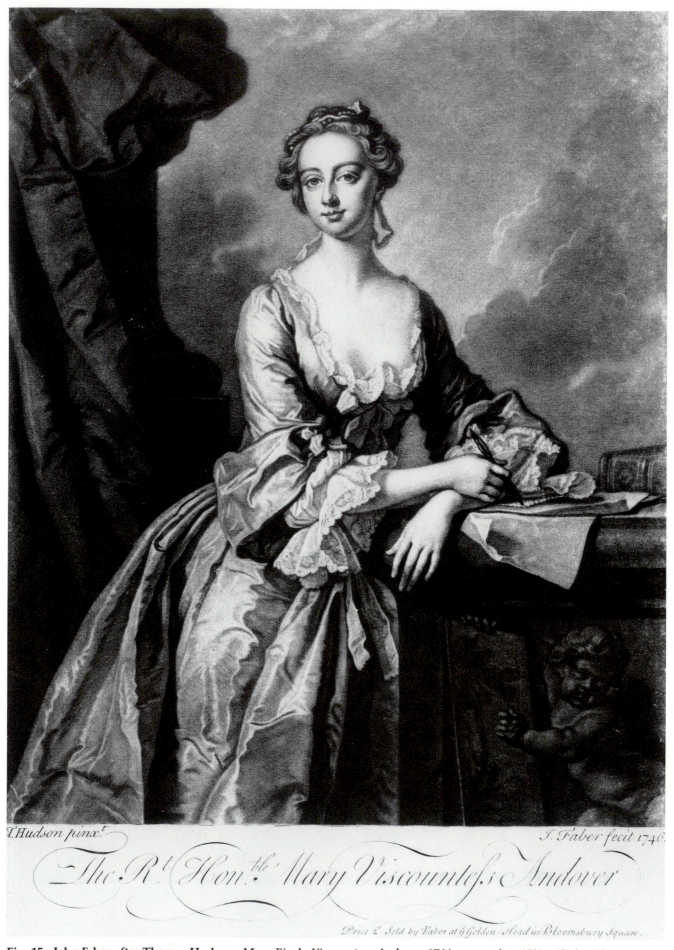

T. Hudson pinx.t J. Faber fecit 1746.

The Rt. Honble. Mary Viscountess Andover

Price 2s. Sold by Faber at ij Golden-Head in Bloomsbury Square.

Fig. 15. John Faber after Thomas Hudson, *Mary Finch, Viscountess Andover,* **1746, mezzotint, 12¼ × 9⅞ in. The Trustees of the British Museum.**

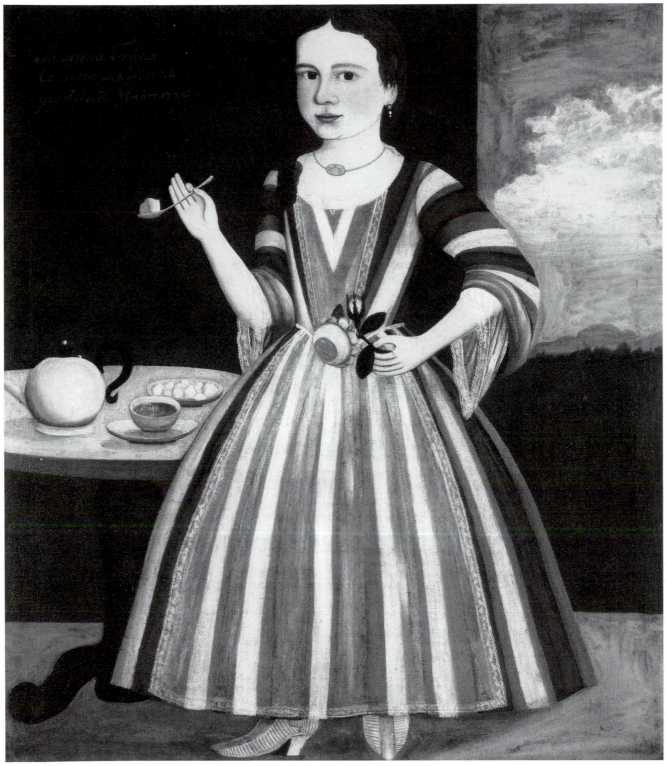

Fig. 16. Gansevoort Limner, possibly Pieter Vanderlyn, *Susanna Truax,* 1730, oil on canvas, 37¾ × 32⅞ in. (95.8 × 83.6 cm). National Gallery of Art, Washington, D.C.; gift of Edgar William and Bernice Chrysler Garbisch.

In this sense the portraits were what Copley and West most feared: wall furniture, mere ornaments in a consumer society. On another level, however, these paintings show people living with goods and making status claims through their relation to goods. These works explore the meaning of "likeness" for men and women who were busy fashioning new social identities within an Anglo-American empire. Put somewhat differently, the portraits were at once objects in a consumer society and a cultural commentary upon that society.

Notes

1. Rev. Andrew Burnaby, *Travels through the Middle Settlements in North America, in the Years 1759 and 1760*, in *A Generall Collection of the Best and Most Interesting Voyages and Travels in All Parts of the World . . .*, ed. John Pinkerton (London, 1812), 13:740.

2. The most useful review of the current state of eighteenth-century American art history can be found in Richard H. Saunders and Ellen G. Wiles, *American Colonial Portraits: 1700–1776* (exh. cat., Washington, D.C.: National Portrait Gallery, 1987). See also Margaretta M. Lovell's thoughtful attempt to situate early American portraits in a specific social context: "Reading Eighteenth-Century American Family Portraits: Social Images and Self-Images," *Winterthur Portfolio* 22 (1987): 243–64.

3. Wayne Craven, *Colonial American Portraiture: The Economic, Religious, Social, Cultural, Philosophical, Scientific, and Aesthetic Foundations* (Cambridge: Cambridge University Press, 1986), 268.

4. Craven, *Colonial American Portraiture*, 268.

5. See, for example, Richard Rorty, *Philosophy and the Mirror of Nature* (Princeton: Princeton University Press, 1979).

6. These issues are explored at greater length in T. H. Breen, *Imagining the Past: East Hampton Histories* (Reading, Mass.: Addison-Wesley, 1989). See also Benedict Anderson, *Imagined Communities: Reflections on the Origin and Spread of Nationalism* (London: Verso, 1983).

7. Stephen Greenblatt, *Renaissance Self-Fashioning: From More to Shakespeare* (Chicago: University of Chicago Press, 1980). A number of books and articles written by art historians helped shape my thinking about these interpretive issues. Among the most valuable were a series of essays in *Representations* (vol. 12, 1985): Svetlana Alpers, "Art or Society: Must We Choose?: Foreword 1;" Thomas Crow, "Codes of Silence: Historical Interpretation and the Art of Watteau," 2–14; Stephen Greenblatt, "Exocism into Art," 15–23; Michael Baxandall, "Art, Society, and the Bourguer Principle," 32–43; and Svetlana Alpers, "Is Art History?," *Daedalus* 106 (Summer, 1977): 1–13; and T. J. Clark, *Painting of Modern Life: Paris in the Art of Manet and His Followers* (New York: Alfred A. Knopf, 1985), intro.

8. This essay is part of a larger study that will analyze the relation between the development of an eighteenth-century commercial society and the transformation of political ideology. The general argument of the forthcoming book is outlined in T. H. Breen, " 'Baubles of Britain': The American and Consumer Revolutions of the Eighteenth Century," *Past and Present*, no. 199 (1988): 73–104. See also, Jürgen Habermas, *The Structural Transformation of the Public Sphere: An Inquiry into a Category of Bourgeois Society*, trans. Thomas Burger (Cambridge, Mass.: MIT Press, 1989).

9. Much of the material discussed here is in greater detail in T. H. Breen, "An Empire of Goods: The Anglicization of Colonial America, 1690–1776," *Journal of British Studies* 25 (1986): 467–99. See Neil McKendrick, John Brewer, and J. H. Plumb, *The Birth of a Consumer Society: The Commercialization of Eighteenth-Century England* (Bloomington: Indiana University Press, 1982); Ralph Davis, *A Commercial Revolution in English Overseas Trade in the Seventeenth and Eighteenth Centuries* (London: London Historical Assn., 1967); Eric Jones, "The Fashion Manipulators: Consumer Tastes and British Industries, 1660–1800," in *Business Enterprise and Economic Change; Essays in Honor of Harold F. Williamson*, ed. Louis P. Cain and Paul J. Uselding, 198–226 (Kent, Ohio: Kent State University Press, 1973); and Lorna Weatherill, "A Possession of One's Own: Women and Consumer Behavior in England, 1660–1740," *Journal of British Studies* 25 (1986): 131–56.

In a subsequent book I intend to explore what distinguishes the consumer society of the mideighteenth century from those of other periods. Several historians have argued that a major—if not *the* major—transformation in the relation of the self to manufactured goods occurred in the late nineteenth century. T. J. Clark, for example, dates what he terms the "colonization of everyday life" from this period. This massive shift, he explains, involved an "*internal* extension of the capitalist market—the invasion and restructuring of whole areas of free time, private life, leisure, and personal expression which had been left, in the first push to constitute an urban proletariat, relatively uncontrolled. It indicates a new phase of commodity production—the marketing, the making-into-commodities, of whole areas of social practice which had once been referred to casually as everyday life" (*Painting of Modern Life*, 9). Several American historians have accepted this general interpretive framework: see Richard W. Fox and T. J. Jackson Lears, eds., *Culture of Consumption: Critical Essays in American History, 1880–1980* (New York: Pantheon Books, 1983); and William Leach, "Transformations in a Culture of Consumption: Women and Department Stores, 1890–1925," *Journal of American History* 71 (1984): 319–42. This literature sees consumer goods as capable of transforming the self. It becomes transparent, merging its identity with the very object of its desire. If one purchases a certain brand of cigarette or automobile, for example, one takes on the attributes that are popularly associated with that article, becoming in the process more desirable, beautiful, and intelligent. In my estimation these historians fail to distinguish an earlier, equally significant psychological stage in the development of a consumer society. During the eighteenth century the self was still coherent; it could be represented through goods, could acquire social status through consumption, could literally fashion itself before others, without thereby losing its integrity.

10. T. C. Smout, *A History of the Scottish People, 1560–1830*, 2d ed. (New York: Scribner, 1970), 285.

11. Gerald Newman, *Rise of English Nationalism: A Cultural History, 1740–1830* (New York: St. Martin's Press, 1987), 33.

12. Clark, *Painting of Modern Life*, 6.

13. Cited in John Sekora, *Luxury: The Concept in Western Thought, Eden to Smollett* (Baltimore: Johns Hopkins University Press, 1977), 91.

14. Ibid., chap. 4.

15. David Hume, "Of Refinement in the Arts," *Essays and Treatises on Several Subjects*, 2 vols. (London, 1758), 1:307.

16. Clark, *Painting of Modern Life*, 6.

17. Ralph Davis, "English Foreign Trade, 1700–1774,"

Economic History Review, ser. 2, 15 (1962): 290.

18. Adam Smith, *An Inquiry into the Nature and Causes of the Wealth of Nations,* ed. Edwin Cannan (New York: Modern Library, 1937), 626.

19. John J. McCusker and Russell R. Menard, *The Economy of British America, 1607–1789* (Chapel Hill: University of North Carolina Press, 1985), 279; Carole Shammas, "How Self-sufficient Was Early America?", *Journal of Interdisciplinary History* 13 (1982): 247–72.

20. Ibid., 258.

21. See Breen, "Empire of Goods," 473–96.

22. Alexander Hamilton, *Hamilton's Itinerarium,* ed. Albert Bushnell Hart (St. Louis, Mo.: W. K. Bixby, 1907), 184, 196.

23. Benjamin Franklin, *Autobiography,* intro. Lewis Leary (New York: Collier Books, 1962), 80. The interpretation of mideighteenth-century colonial culture and society offered here differs substantially from that advanced by Richard Bushman in "American High-Style and Vernacular Cultures," in *Colonial British America: Essays in the New History of the Early Modern Era,* ed. Jack P. Greene and J. R. Pole, 345–83 (Baltimore: Johns Hopkins University Press, 1984). As this essay should make clear, I do not subscribe to the notion that early American society was divided into two separate classes or groups. On this point see Peter Burke, "From Pioneers to Settlers: Recent Studies of the History of Popular Culture," *Comparative Studies in Society and History* 25 (1983): 187; Roger Chartier, *Cultural History; Between Practices and Representations,* trans. Lydia G. Cochrane (Ithaca: Cornell University Press, 1988); and David D. Hall, *Worlds of Wonder, Days of Judgment: Popular Religious Beliefs in Early New England* (New York: Alfred A. Knopf, 1989). Two provocative interpretations of Franklin are Michael Warner, "Franklin and the Letters of the Republic," *Representations* 16 (1986): 110–30; and Mitchell Robert Breitwieser, *Cotton Mather and Benjamin Franklin: The Price of Representative Personality* (New York: Cambridge University Press, 1984). See also T. H. Breen, "'The Meaning of Things,' Interpreting the Consumer Economy of the Eighteenth Century," paper delivered at the William Andrews Clark Memorial Library Lecture Series, Los Angeles, 3 April 1988.

24. John M. Hemphill, ed., "John Wayles Rates His Neighbours," *Virginia Magazine of History and Biography* 66 (1958): 305. See Breen, "'Baubles of Britain,'" 73–104.

25. T. H. Breen, *Tobacco Culture: The Mentality of the Great Tidewater Planters on the Eve of Revolution* (Princeton: Princeton University Press, 1985), chaps. 3–4.

26. Hamilton, *Itinerarium,* 64–65.

27. Cited in J. E. Crowley, *This Sheba, Self: The Conceptualization of Economic Life in Eighteenth-Century America* (Baltimore: Johns Hopkins University Press, 1974), 79.

28. *Boston Weekly Post Boy,* 28 March 1743.

29. James Glen, "A Description of South Carolina," *Historical Collections of South Carolina,* ed. B. R. Carroll (New York: Harper and Bros., 1836), 2:227–28.

30. These figures are based on statistics found in *Customs 3: Ledgers of Imports and Exports, 1696–1780* [microform] (East Ardsley, Wakefield, Yorkshire, 1974). Also see Davis, "English Foreign Trade," and Elizabeth B. Schumpeter, *English Overseas Trade Statistics 1697–1808* (Oxford: Clarendon Press, 1960).

31. See Breen, "'Baubles of Britain.'"

32. Observations about the character and content of eighteenth-century colonial American advertising found in this article are based on extensive research in the newspapers of Boston, New York, Philadelphia, Williamsburg, and Charleston carried out by the author and Rebecca Becker of Northwestern University.

33. These various terms are defined in Isabel B. Wingate, ed., *Fairchild's Dictionary of Textiles,* 6th ed. (New York: Fairchild Publications, 1979).

34. The statistics for the importation of mirrors are derived from Customs 3. Also see Benjamin Goldberg, *The Mirror and Man* (Charlottesville: University Press of Virginia, 1985).

35. *Journal and Letters of Philip Vickers Fithian,* ed. Hunter Dickinson Farish, 2d ed. (Williamsburg, Va.: Colonial Williamsburg, 1957), 29, 130–31.

36. Peter Collinson to John Bartram, 17 February 1737, quoted in T. H. Breen, *Puritans and Adventurers: Change and Persistence in Early America* (Oxford: Oxford University Press, 1980), 153–54.

37. Cited in Bernard Bailyn, "Voyagers in Flight: A Sketchbook of Runaway Servants 1774–1775," in his *Voyagers to the West: A Passage in the Peopling of America on the Eve of the Revolution* (New York: Alfred A. Knopf, 1986), chap. 10.

38. Gary Zaboly, "Descriptions of Military Uniforms and Equipage in North America, 1755–1764, Part I," *Military Collector and Historian* 39 (1987): 8.

39. Dell Upton, *Holy Things and Profane: Anglican Parish Churches in Colonial Virginia* (Cambridge, Mass.: MIT Press, 1986), 152–53.

40. Hamilton, *Itinerarium,* 14–15.

41. Cited in Wayne Craven, "Painting in New York City, 1750–1775," in *American Painting to 1776: A Reappraisal, Winterthur Conference for 1971,* ed. Ian Quimby (Charlottesville: University Press of Virginia, 1971), 266.

42. See Margaret Simons Middleton, *Jeremiah Theus, Colonial Artist of Charles Town* (Columbia: University of South Carolina Press, 1953), 7–8; Henry Wilder Foote, *John Smibert: Painter* (Cambridge: Harvard University Press, 1950), 76.

43. Craven, "Painting in New York City," 255; Michael Kammen, *Colonial New York: A History* (New York: Scribner, 1975), 269.

44. Sinclair Hitchings, "Thomas Johnson," in *Boston Prints and Printmakers, 1670–1775,* ed. Walter Muir Whitehill (Boston: The Colonial Society of Massachusetts, 1973), 102.

45. Foote, *John Smibert,* 84–92, 100–101.

46. George C. Groce, "John Wollaston: A Cosmopolitan Painter in the British Colonies," *Art Quarterly* 15 (1952): 133–48; Wayne Craven, "John Wollaston's Career in England and New York City," *American Art Journal* 7 (1975): 19–31.

47. Richard K. Doud, "John Hesselius, Maryland Limner," *Winterthur Portfolio* 5 (1969): 129–53.

48. Craven, *Colonial American Portraiture,* passim.

49. Jules David Prown, *John Singleton Copley: In America, 1738–1774* (Cambridge: Harvard University Press, 1966), 1:26.

50. Foote, *John Smibert,* 88 (italics added).

51. John Galt, *The Life, Studies, and Works of Benjamin West, Esq. . . .* (London, 1820), pt. 1, 81–82.

52. *Letters & Papers of John Singleton Copley and Henry Pelham, 1736–1776* (Massachusetts Historical Society) *Collections* 71 (1914): 65–66.

53. Kenneth Silverman, *A Cultural History of the American Revolution: Painting, Music, Literature and the Theatre in the Colonies and the United States* (New York: T. Y. Crowell, 1976), 14.

54. Fithian, *Journal,* 94.

55. Cited in Kevin M. Sweeney, "Mansion People: Kinship, Class, and Architecture in Western Massachusetts in the Mid-Eighteenth Century," *Winterthur Portfolio* 19 (1984): 249.

56. Cited in Charles Coleman Sellers, *Charles Willson Peale* (New York: Scribner, 1969), 62.

57. Prown, *John Singleton Copley* 1:46.

58. Byrd to John Perceval, earl of Egmont, 12 July 1736, in *The Correspondence of the Three William Byrds of Westover, Virginia, 1684–1776,* ed. Marion Tinling (Charlottesville: University Press of Virginia, 1977), 2:487.

59. Karin Calvert, "Children in American Family Portraiture, 1670 to 1810," *William and Mary Quarterly,* 3d ser., 39 (1982): 87–113.

60. Waldron Phoenix Belknap, Jr., *American Colonial Painting: Materials for a History* (Cambridge: Belknap Press, 1959).

61. Calvert, "Children in Portraiture," 90; Silverman, *A Cultural History,* 17; Edgar P. Richardson, *Painting in America from 1502 to the Present* (New York: Thomas Y. Crowell, 1965), 50, 69.

62. Michael Kitson, "Hogarth's 'Apology for Painters,'" *Walpole Society* 41 (1966–68): 100.

63. Groce, "John Wollaston," 134.

64. Edgar P. Richardson, *American Paintings and Related Pictures in the Henry Francis Du Pont Winterthur Museum* (Charlottesville: University Press of Virginia, 1986), 30; Richardson, *Painting in America,* 50, 69.

65. Frederick A. Sweet, "Mezzotint Sources of American Colonial Portraits," *Art Quarterly* 14 (1951): 148–57. See also Roy Porter, "Seeing the Past," *Past and Present,* no. 118 (1988): 186–205.

66. Svetlana Alpers, *The Art of Describing: Dutch Art in the Seventeenth Century* (Chicago: University of Chicago Press, 1983), 78; John Michael Montias, *Artists and Artisans in Delft: A Socio-Economic Study of the Seventeenth Century* (Princeton: Princeton University Press, 1982); Simon Schama, *Embarrassment of Riches: An Interpretation of Dutch Culture in the Golden Age* (New York: Alfred A. Knopf, 1987).

67. T. W. Moody, F. X. Martin and F. J. Byrne, eds., *A New History of Ireland* (Oxford: Clarendon Press, 1987), vol. 4, chaps. 15–16.

"In just Lines to trace"—The Colonial Artist, 1700–1776

JESSIE POESCH

On the eve of his return to France from America, in January 1783, the Marquis de Chastellux, who had served with the French Expeditionary Forces during the Revolution, addressed a philosophical essay to the president of William and Mary College on the progress of the arts and sciences in America.[1] It was first published in English in 1787. He expressed doubts as to how well the arts could flourish in a democratic society: "It is sad to confess that it is to a very great inequality in the distribution of wealth that the fine arts are indebted for their most brilliant periods," such as in Greece under Pericles, or Rome in the Renaissance. He raised a second problem, "the arts, there can be no doubt about it, can never flourish, except where a great number of men are assembled. They must have large cities, they must have capitals. America possesses five such which seem ready to receive them."[2] As a true French *philosophe* concerned with the educational role of the arts, he nonetheless expressed some optimism, saying, "Let us now see what use may be made of them by the Public, the State, and the Government."[3] He looked forward to an essentially public art, when art would serve to memorialize and teach the lessons and accomplishments of the new country. The roles that art plays or should play in the public life of a nation—and in this nation—is still open to debate.

Though Chastellux gave scant notice to what had been accomplished, his first translator, in a note, applauded the work of American artists such as Copley, West, and Peale, artists whose careers developed in what the translator called the "infant state" of America.[4]

The exhibition American Colonial Portraits: 1700–1776 honored the accomplishments of colonial artists and their patrons during this "infant" state of American art, when portraiture dominated. As Chastellux implied, it had not been easy (and would not be) for the fine arts to flourish in the sparsely settled new country. The artists had to secure training and to equip themselves, to establish their reputations as artists and to define their roles in their communities. To achieve some measure of success, they had to satisfy their patrons, who wanted believable likenesses. For this paper I wish to look at colonial artists as a group and to examine some of the circumstances of the lives of these creative individuals, as well as their studio practices. Portraiture is essentially a private art, a relationship between the artist and the patron. However, through showings in the painting rooms of the artists and through attention received from

poems written about portraits, some of which were printed in newspapers and journals, I would like to suggest that this seemingly private art played a modest role in public thought and discourse. The poems have not heretofore been discussed as a group, hence I will focus on them in some detail in the latter part of this study.

First, who were the artists who made these portraits? Thanks to the efforts of several generations of antiquarians and scholars we now have a substantial body of information about individual artists working between 1700 and 1776. For this study I have used information about fifty-two who are known by name and by some surviving works.[5] There is even a certain elegance and dramatic inevitability in the happenstance that the three most gifted and most prolific —Benjamin West, John Singleton Copley and Charles Willson Peale—are the best documented. Yet despite meticulous research, our information is imprecise. There is much that we do not know and probably never will know about their way of life and creative output. A measure of how much we do not know is the fact that the researchers at the Museum of Early Southern Decorative Arts, who combed all sorts of legal and other records, have come up with the names of eighty-three individuals who may have been artists of one sort or another in the South in the period 1700–1776, while only forty-three have been associated with existing works, in many cases only one or two pictures per artist. Yet most of us know by name only twenty or twenty-five of these.[6] One hesitates to make general statements because each artist is unique, but we can nonetheless make some general observations.

When did they work, and where were they from? Most of the artists whom we know by name were working *after* 1735. Those working earlier than this were of diverse origin and include: Peter Pelham, who came from London; John Smibert, originally from Scotland by way of London; Nathaniel Emmons, born in Boston; Nehemiah Partridge, probably from Massachusetts; Pieter Vanderlyn, a native of Holland; Gerardus Duyckinck, born in New York; John Watson from Scotland; Gustavus Hesselius from Sweden; Justus Engelhardt Kuhn, a German; and Henrietta Dering Johnston, probably from Ireland, possibly by way of England. In addition there were still other artists whom we can only identify by their subjects, such as the Pollard painter, active c. 1721 in Boston, or the Gan-

sevoort limner, active c. 1720–30 in New York State.

If one takes the group who were working after 1735 (including Pelham, Smibert, Emmons, Vanderlyn, Watson, and Gustavus Hesselius, since their careers extended beyond 1735) we find twenty-four born in America.[7] Nine were from Britain; four from London, four from Scotland, but two of these had resided in London or had their work exhibited there, and two others were from elsewhere in England. Two others were also presumably from England. Five are known to be from Europe, and there is a remaining group of nine whose origins are unknown. Something like one-third to one-half appear to have been relatively recent arrivals. The historian Bernard Bailyn has suggested that the peopling of North America in the period before the Revolution was a part of the broader pattern of domestic mobility found in the lands of the immigrants' origins, and that London was often a stage in the migration pattern. People went from the provinces to London, and from London to America.[8] Our small sample seems to confirm this. Most of the newcomers could be classified as "metropolitan" migrants.[9] They were among those who helped to serve as role models and provide some instruction to the native-born who became artists.

We also can make an approximation of the number of artists working in each of the small cities and adjacent areas at different times. The numbers vary from year to year, but in the period 1740 through 1755 the cities of Boston, New York, Philadelphia, Annapolis, the Williamsburg area, and Charleston each usually had from one to three portrait painters active at one time. Between 1756 and 1776 the numbers increased somewhat, with as many as five to seven at one time in several of the cities. Eight of these artists also worked for a time in one of the islands of the West Indies or Bermuda; those known to have spent some time there are: Joseph Blackburn (came from Bermuda to America in 1753 or 1754), James Claypoole, Jr. (in Jamaica by 1771), Abraham Delanoy (to West Indies in 1768), John Green (to Bermuda about 1765), John Greenwood (in Surinam in 1752–58), William Johnston (to Barbados by 1770), William Williams (in Jamaica 1760–62/63), and John Wollaston (possibly in the West Indies 1759–65). The small numbers of artists in each city suggest that the life of a painter in the American colonies was a relatively

lonely one. This is especially so when compared with the fifty-seven "eminent" artists listed as practicing in London in 1748 by an anonymous author writing in the November issue of *The Universal Magazine*.[10] If it were possible, it would be more appropriate to make comparisons with what went on in provincial cities in Britain. For example, Saunders, in discussing the early career of Smibert, says that in 1716 or 1717 there was only one significant portrait painter in Edinburgh—a situation comparable to Gustavus Hesselius in Philadelphia at that time, or Kuhn in Annapolis.[11] There is little firm evidence on similar situations in cities such as Liverpool, Norwich, or Bristol, so comparison is difficult.[12] We do know that in 1769 an Art Society was formed in Liverpool, but of twenty-two people, only three were "undoubted" professionals. No similar attempt at an exhibiting society was founded in America at this time, but the number of working artists in the city—three to seven—suggests comparison with Philadelphia or New York.[13]

Almost all colonial artists showed a degree of mobility in their lives. After migrating from Europe, several selected a town to settle in: Pelham and Smibert in Boston, Gustavus Hesselius in Philadelphia, Kuhn in Annapolis, Charles Bridges in Williamsburg, and Henrietta Johnston and Jeremiah Theus in Charleston. Of American-born artists, Joseph Badger stayed in his native Boston; so did John Singleton Copley, though he later migrated to England, where he made his reputation as a painter of prestigious history paintings rather than of portraits. John Hesselius ultimately settled near Annapolis, and Charles Willson Peale, in 1776, settled in Philadelphia. Others, however—Blackburn, Wollaston, Durand, and Feke, for example—had more peripatetic careers in that each resided, usually for at least a year or more, in several towns. Some have called them itinerant. It depends on how itinerancy is defined. A certain amount of mobility is characteristic of many of our artists, but itinerancy—following a circuit—does not seem to be the appropriate term for the travel patterns of these artists. The length of time any given artist lived in a single colonial town is more likely measured in months and years than in days and weeks. Blackburn was in Providence, then Boston, then Portsmouth during the decade of 1754–1763. Wollaston was in New York, Philadelphia, Annapolis and elsewhere in Maryland, in Virginia, then later in Charleston, in the almost-twenty-year period from 1749 to 1767. Durand first showed up in New York, then Connecticut, and then Virginia, between 1766 and 1782. Feke is associated with Boston and Newport and is known to have made professional trips to Philadelphia during the period 1741 to 1750. When in Virginia and Maryland these artists may have been itinerant in that they moved for a time from one plantation to another, but there do not seem to have been regular travel routes, or circuits, such as those of itinerant artists who made seasonal trips down the Mississippi River in the early nineteenth century. John Hesselius and C. W. Peale were fairly itinerant in the early phases of their careers, and John Mare and several other artists may have made regular journeys up the Hudson River.

We also know something of the training of some colonial artists. Of the foreign-born artists working in America in the period 1700–1776 we know the most about John Smibert.[14] He was important as a role model for his American-born associates because he came out of a crafts background, as did many of them. Nonetheless his subsequent development represented what was considered appropriate training as defined by English and European connoisseurs and theoreticians. This was a pattern that native-born artists could hope to emulate. Having served an apprenticeship to a house painter and plasterer, Smibert went on to London where he studied at the Queen Street Academy governed by Kneller. By 1716 or 1717, his initial training completed, he returned to Edinburgh where he began his career as a portrait painter. Then, no doubt spurred on by the prevailing idea among connoisseurs and patrons that an artist's training was not complete unless the work of the great masters of Italy had been seen, he made the requisite visit in 1719–21. He returned to England and set up a studio in London, where he remained until his departure for America in 1728. As is well known, he brought with him to America some of his collection of copies after European masterpieces.

Thanks in part to Mather Byles's poem "To Mr. Smibert on the sight of his Pictures," people in Boston and elsewhere soon knew about the artist. This poem was first published in the *Boston Gazette* in January 1729/30, was reprinted in the Philadelphia *American Weekly Mercury* in February of the same year, and then reprinted in the

London Daily Courant, which also had some circulation in America, on 13 April 1730.[15] This publicity helped to suggest to his fellow American artists the role and reputation that an artist might achieve. From him, too, other artists gained some familiarity with famous European paintings about which they had only read because his studio room and his painting collection were kept intact and could be seen long after his death.[16] John Trumbull rented Smibert's old rooms as late as 1777–78, and he later recorded that his study of Smibert's copies of "celebrated pictures" from Europe, including *The Continence of Scipio* after Poussin (fig. 17), helped him to "make progress." By then Copley had left Boston, Trumbull recalled, and there was no one from whom he "could gain oral instruction," clearly suggesting that such contact with living artists was an all-important aspect of training.[17]

Our knowledge of the training of most of the other foreign-born artists is sketchy. Nonetheless, the work of "newly arrived" artists made it possible for the native-born to become acquainted with new tastes.

The training of American-born artists was often a haphazard affair, as it may well have been for other callings as well. Painters ranged from seemingly self-taught to those with some record of training and contact with already practicing artists. Knowledge of the materials of oil painting demands at least minimum contact with someone who has access to the specialized pigments and can give instruction in their use. Several of the artists used what we know was a popular learning device—mezzotints copied as the basis for a composition.[18] These artists had to translate the black-and-white prints into a larger scale, create a reasonable facial likeness of the sitter, and, most important, introduce their own color schemes.

In addition to Smibert's collection there were other English and European paintings in America that an artist could study; portraits of the English monarchs and the royal governors were on display in some public places, and at least a few individuals, such as William Byrd II, had private collections of portraits or of other European paintings. A number of Americans are also known to have had their portraits done abroad, which they brought home.[19] America in the first three-quarters of the eighteenth century was not quite the "barb'rous Desert" that Mather Byles, in his poem to Smibert, said it had once been.

The "softer arts" were known in some quarters, yet for a young person with a yearning to be an artist the opportunities to see many works of art were still few and far between.

Both Benjamin West and Charles Willson Peale told of a series of fortunate circumstances and coincidences that led to their painting careers. Both stories are well known in the annals of American art, but salient parts of these stories bear brief repetition and comment because their experiences also shed light on how other artists may have developed.[20] Their achievements were also celebrated in poetic form.

West was a precocious draftsman and his talent was early encouraged. Very important to him was a meeting with William Williams, a practicing artist who gave him two books. The first was John Dryden's translation of Du Fresnoy's *De Arte Graphica*. This lengthy Latin poem had originally been published in France in 1668, while Dryden's translation into English prose, *The Art of Painting*, was first published in 1695, with Roger de Piles's observations on paintings appended. The second English edition, published in 1716, was prefaced with a poem by Alexander Pope honoring Charles Jervas, principal painter to George I. It was a popular publication; at least six editions were printed before 1811.[21] Portraiture is given short shrift. Rather, this is probably the most important source in English of the influential humanistic theory *ut pictura poesis*—as in painting so is poetry—which stressed the parallels between epic poetry and history painting, both of which told a story and pointed a moral.[22] These ideas were rooted in antiquity and revived in academic Italian Renaissance circles. Therefore concepts and advice for creating history paintings, usually based on classical or biblical themes and involving groups of figures in action and with various expressions, were given: "make a choice of a subject beautiful and noble."[23] Dryden's preface implies a sense of the disadvantages of English artistic traditions. He writes that to be a learned painter, "there is further required a long Conversation with the best Pieces, which are not frequent either in France or England."[24] There is, on one occasion, a hint of exasperation with the exalted status of academic Italian ideas, "In these pompous Expressions . . . the Italian has given you his *Idea* of a *Painter*; and though I cannot much commend the Style, I must say there is somewhat in the Matter."[25] Dryden nonetheless follows Du Fresnoy in giving less

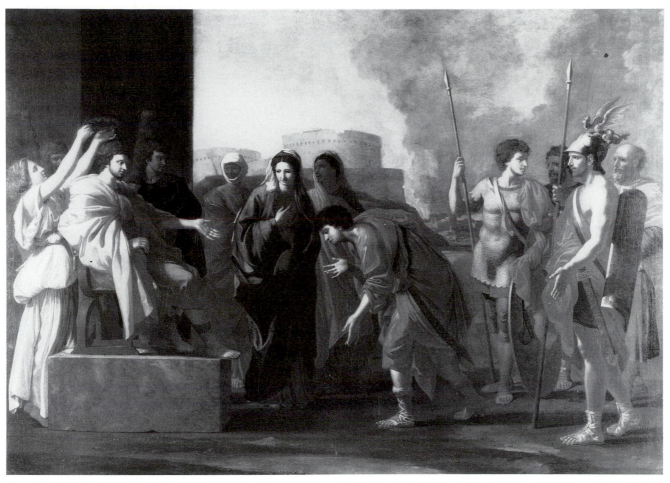

Fig. 17. John Smibert after Nicholas Poussin, *The Continence of Scipio*, c. 1715–25, oil on canvas, 46 × 62 in. (116.8 × 157.5 cm). Bowdoin College Museum of Art, Brunswick, Me. Bequest of James Bowdoin II.

status to portraiture, for "this *idea* of *Perfection* is of little use in Portraits"[26] and, moreover, expresses the idea that modern times are inferior to the Renaissance: "And the great *Genius* of *Raphael,* and others, have succeeded to the times of Barbarism and Ignorance . . . the Performance of it [painting] is much declin'd in the present Age."[27] (He also anticipates West's later defense of the use of modern dress in a history painting: "But if the Story which we treat be modern, we are to vary the Customs, according to the Time, and the Country."[28]) Thus though there is some discerning advice on composition, proportions of the human figure, and the use of light and shade, this not a practical how-to book, but one in which the emphasis is on high-minded philosophical artistic ideas. In West's case it was to fill his mind with dreams of fame and glory and to shape his ideas of what an artist should choose for subject matter. This volume was available to other artists and their patrons in America, for, in addition to the copy given to West, thirty-one

records of its presence in America before 1815 have been located.[29] John Singleton Copley and Charles Willson Peale are known to have been acquainted with it; Col. William Byrd II and Robert Carter, both patrons of artists in Virginia, owned it; the Library Society of Charleston, South Carolina, the Harvard College Library, and the Redwood Library Company in Newport, Rhode Island, each owned the 1716 edition.[30]

The other book given to the youthful West was by Jonathan Richardson, possibly *An Essay on the Theory of Painting,* published in 1715, or else his *Two Discourses* on art criticism and connoisseurship, published in 1719. Richardson also spoke of the great "Prodigies of Art" of the past, and though proud of English accomplishments in portraiture, also reflected a sense of English backwardness in the arts: "I am in hopes that our own Country Does, or Will produce those that will come as near 'em as any other Nation, I mean as to History Painting, for that we already excel all others in Portraits is indisputable."[31]

Reading these books, one can see how West was inspired to take up history painting after he left America, for he deemed it a more exalted calling than portraiture. To judge by extant records, Richardson's works were less well known in the American colonies.[32]

West received some practical training from John Valentine Haidt, a little-known German artist working in Pennsylvania. He also studied engravings. West soon attracted the attention of Dr. William Smith, provost of the College of Philadelphia, and then met several of Philadelphia's intelligentsia, including Francis Hopkinson. By 1757 one of West's friends composed a poem "Upon Seeing the Portrait of Miss xx——xx by Mr. West," which was published in the newly launched Philadelphia journal *The American Magazine* in February of that year; it was a public recognition of his talent at a time when the colonials were developing a greater sense of their Americanness. After a stint of portrait-painting in New York in 1758, some Philadelphians helped him to make a trip abroad. The rest is familiar—his study abroad and successful establishment as an artist in England. News of his success spread quickly. Matthew Pratt became West's first American pupil in 1764, Copley was corresponding with West by 1766, and occasional newspaper accounts such as one in the *Virginia Gazette* of 24 August 1769 reported how West's work was "vastly admired." Hailed as the "American Raphael" in England, West was an absent but palpable presence among artists and patrons in America from 1764 or so until his death in 1820. West's collection of pictures, sculpture, and Italian engravings were displayed in a spacious gallery in his London home and were seen and studied by his many American visitors and students.[33]

Charles Willson Peale was no childhood prodigy, and it was not until after he had completed an apprenticeship as a saddler that he decided to try painting. On a journey to Philadelphia he met a painter, probably Christopher Steele, where he saw a painting room with the artist's easel and palette—equipment he said he had never seen before—as well as prints, drawings, and paintings.[34] In a bookstore he found Robert Dossie's two-volume *The Handmaid to the Arts*. This book, first published in London in 1758, is essentially a cookbook, with much useful and detailed information on pigments and their colors, but with no how-to information on human

proportions, modeling, or perspective drawing. Peale subsequently visited the artist John Hesselius and watched him paint. Still later, in 1765, he visited Boston and was allowed to see Smibert's former painting room with pictures "in a style vastly superior" to any he had seen before. Further enlightenment came with a brief contact with Copley, only three years his senior but already an accomplished painter, who gave him a painting to copy. Not long thereafter, a group of Maryland gentlemen put together money for Peale to go to England for a year's study. He returned in 1769 and set up his painting room in Annapolis. (He was not lured by ideas of history painting and happily concentrated on portraiture.) As his work became known, he too was favored with poetic encomiums. One was published in the *Maryland Gazette* of 18 April 1771, another on 7 November 1771. These confirmed his entree into the world of art and literature.

Thus it was through chance encounters, encouragement from friends, copying, observing, some catch-as-catch-can training, plus some help from books, that these two men developed first as more-or-less self-taught portrait painters, and later as successful practitioners.

We can surmise something about the training of others. Family connections were often relevant. Gerardus Duyckinck II followed his father in the business of limning. Copley surely absorbed fundamentals and ideas from his stepfather, Peter Pelham, as well as from Joseph Blackburn, who was painting in Boston when Copley was young. He quickly surpassed them both. Several books, theoretical and practical, such as a book on anatomy, were important to his development.[35] In Philadelphia, James Claypoole, Jr., could have learned the rudiments of the uses of pigments from his father, James Claypoole, a house painter and glazer.[36] Matthew Pratt was the nephew of James Claypoole, Sr., and was apprenticed to him from 1749 to 1755, before he went to England.[37] Peale also met Claypoole. Moreover, James Peale, who was first instructed by his older brother Charles, married Claypoole's daughter. There was apparently a loose network among painters in each community and they learned, as well as occasionally competed, with each other.

Among articles that were probably available to some painters is one by an anonymous "Pictor" titled "The Art of Painting" in the November

1748 issue of *The Universal Magazine*, published in London. It contains more practical information than many treatises and is useful for the detailed information it gives on how an eighteenth-century artist went about painting portraits.[38] The author describes the materials an artist needs: an easel, a palette, a smudgepan (to hold the refuse from paint and varnish pots), the straining frame (on which the canvas is stretched), the primed cloth (this had been prefaced with a detailed description on how to prime a canvas), the pencils (various sizes of brushes and materials are later mentioned), and the "stay" or Molstick. Pigments and colors are described, and then the reader was instructed to "Dispose the several colours upon the pallet . . . the vermillion, then the lake, burnt oker, Indian-red, pink, umber, black and smalt in their order. And lay the white next to your thumb, for that is used the oftenest; for all the shadows are to be lightened with it; and next to the white lay a stiff sort of lake, and then the palette will be furnished with simple colours for a face." Advice is given on how to blend or temper colors for a fair complexion, for the deep shadows of a face, for brown or swarthy complexions. Three sittings are recommended. The person should be placed "on a seat rather higher than your own." At the first sitting the artist will only "dead colour" the face. That is, the artist is to make a bold or rudely traced drawing, then fill in with a mixture of lake and white, then heighten some features with red lead, "with faint and gentle strokes." The second sitting "commonly requires four or five hours, in which you are to go over the face. . . ." The third sitting "commonly takes up to two or three hours, and is spent in closing what was before left imperfect and rough, but principally in giving to every deep shadow the strong touches and deepenings, as well in the dark shadows of the face, as in the eyes, eye-brows, hair and ears . . . these touches, if well done, add exceedingly to the life." In each case Pictor gives quite detailed advice: "over, under and about the eyes you will perceive a delicate and faint redness," or "the tip of the ear, and the roots of the hair, are commonly of the same colour."

Copley apparently proceeded in a manner similar to this. (See his unfinished portrait of Nathaniel Hurd, fig. 18.) After he was in Italy he mentioned in a letter that he had "half Dead Colour'd" his copy after Correggio.[39] But if some artists could complete a painting of a face in three sittings, Copley could not. One disgruntled patron wrote about how his wife had "set many days" and a painting was still not finished.[40] On another occasion, Myles Cooper, the president of King's College (now Columbia University) in New York, wrote first on 24 October 1768 asking if his picture was finished, then again on 9 January 1769, asking if not for the picture, his gown: "As for the portrait itself, the want of it cannot be attended with any great inconvenience, but the gown I think you are impardonable in keeping in your hands so long."[41] For completing the drapery, Copley on this occasion and on others probably used a life-sized figure, or "layman" (see fig. 19). When Copley was on his painting trip to Philadelphia in 1771, he had his stepbrother pack up and send his layman as well as other materials.[42] Later, when in Italy, Copley wrote back to Pelham, that his layman was "as good or better as any that I have seen since I left America."[43]

Once having achieved a level of skill, some of our artists were able to work full-time as portrait painters, though some carried on other business or craft. We know that Smibert, Copley, Peale, and Cosmo Alexander each had a room where their work could be seen. Alexander Hamilton twice mentioned visiting Mr. Smibert and seeing his collection of pictures during his 1744 trip. Of the second visit he wrote, "I visited Mr. Smibert in the afternoon and entertained my self an hour or two with his paintings."[44] Peale set up a painting room in his home in Annapolis shortly after he returned from England. Here he showed some of his own work as well as a Venus copied by West from Titian.[45] Visitors and friends came to admire his work, whether or not he was there. In fact, the poem that appeared in the 18 April 1771 *Maryland Gazette* was said to have been pinned beneath a portrait of Peale's wife, Rachel, in the artist's absence. While Copley was in New York in the summer and fall of 1771 some of his correspondence with his stepbrother concerned the remodeling of his house, and particularly the arrangement of his painting room, the type of wainscotting, and the placement of windows in it.[46] Cosmo Alexander's painting room, in Newport, was said to be "well provided with cameras [camera obscuras] and optical glasses for taking prospective views."[47] Though not public galleries, these rooms seem to have been working studios or adjacent places where the artists' works could be seen by visitors and potential

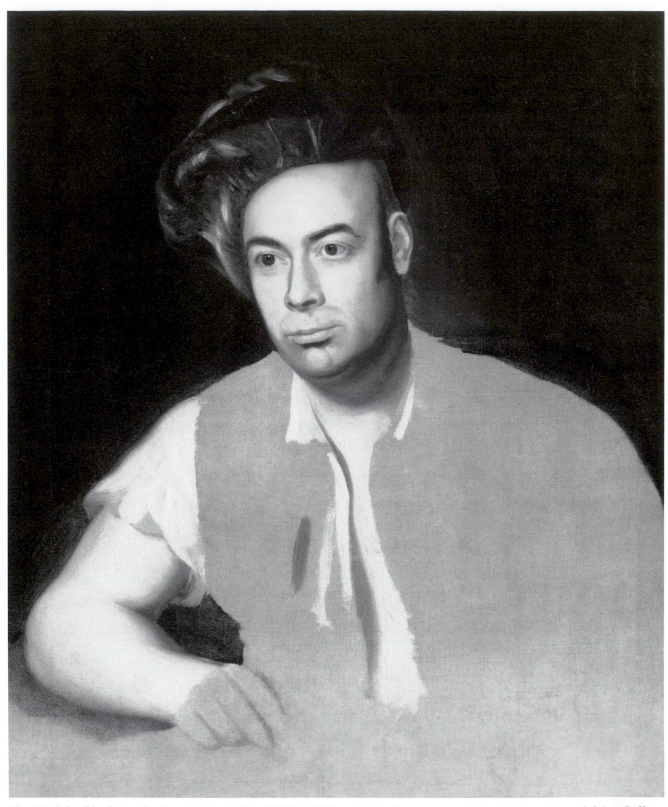

Fig. 18. John Singleton Copley, *Nathaniel Hurd (1729–1777),* c. 1765, oil on canvas, 29⅜ × 24⅝ in. Memorial Art Gallery of the University of Rochester, Rochester, N.Y. Marion Stratton Gould Fund.

Fig. 19. Artist's layman, undated, owned by Thomas Sully (1783–1872); wire armature, fabric stuffing, papier maché (head), cotton fabric covering (1986 replacement for original silk covering); 60 in. tall. National Portrait Gallery, Smithsonian Institution.

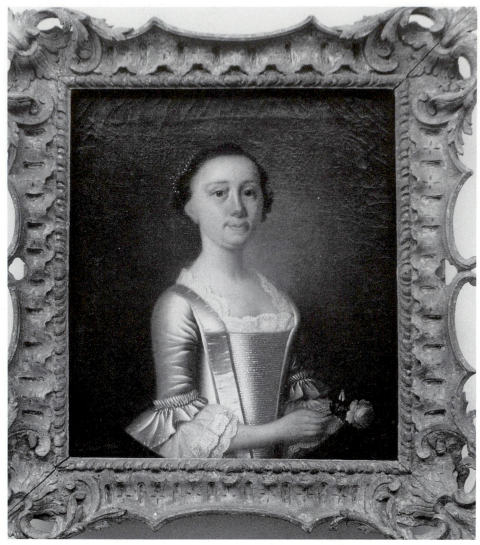

Fig. 20. Jeremiah Theus, *Mrs. Algernon Wilson,* **1756, oil on canvas, 16⅝ × 14¼ in. Collection of the Museum of Early Southern Decorative Arts, Winston-Salem, N.C.**

patrons. On a more modest scale, they apparently served a function similar to that of the large painting rooms or galleries of artists such as Kneller, Reynolds, or West in England.

Also on the practical side, artists had to equip themselves with pigments, canvases, brushes, and so forth, as well as providing frames. Framemakers were to be found in most of the colonial cities; there is also documentary evidence that some frames were imported.[48] Many of Theus's portraits (including one of Mrs. Algernon Wilson, fig. 20) are believed to be in their original frames. The account book of the cabinetmaker Thomas Elfe in Charleston shows that he made frames, provided stretchers, packing cases, and even packed pictures for Theus.[49]

Though frames could be acquired from craftsmen in America, as well as from abroad, pig-

ments and some other supplies were generally imported, either by the artist or by a middleman. A few dealers, such as John Gore in Boston, in the 1760s handled paints and sold "half-length cloths, Kitt-Katt and three-quarters ditto," along with brushes and pallette knives.[50] In some cases the tradesmen prepared the pigments for the painters by grinding them, mixing them with a medium, and putting them in pig bladders for storage. Sometimes the artists had to do this themselves. When they wanted to use the color, painters would puncture the bladder with a tack, and after use plug the hole with a tack, or bone.[51] (See fig. 21.)

Beyond the professional skills and practical considerations of these colonial artists, what were their other interests, what kind of roles did they play in their communities, and how were

Fig. 21. Oil paints stored in animal bladders. National Museum of American History, Smithsonian Institution.

they esteemed? Fragmentary evidence suggests something about their interests and associations.

Religion was a motivating factor in the lives of two of the artists who lived in the South. Henrietta Dering Johnston accompanied her husband, who was commissary of the Bishop of London in South Carolina and rector of Saint Phillips' Church in Charleston.[52] Charles Bridges, who came to Virginia around 1735 as a mature man, had long been active in England with the Society for Promoting Christian Knowledge. His hope, and that of the Bishop of London, was that he would instruct black Americans in the Christian faith, a project that came to naught. His status, however, meant that he readily established contacts with the leaders of Virginia society.[53]

Gustavus Hesselius, though not a cleric himself, was a member of a family long known "for piety and learning." His father was a Lutheran pastor of a church in Sweden, and his sister married a bishop. His older brother Andreas was sent out to become pastor of the Swedish colony on the Delaware (now Wilmington), and Gustavus accompanied him to the new world. He served his faith by installing an organ for the Moravian Congregation at Bethlehem, Pennsylvania, in 1743, believed to be one of the earliest pipe organs built in America.[54] When the Swedish naturalist Peter Kalm visited America in

1748, Hesselius helped him to become familiar with American plants and took him to meet the American naturalist John Bartram.[55] Hesselius's son John inherited his father's painting equipment and chamber organ.[56] The son, in addition to becoming a painter, apparently followed his father's interests in music and science, for the estate inventory taken after his death recorded several musical instruments—a harpsichord, a flute, and three violins—and some music books, as well as several scientific instruments, including a microscope.[57]

John Greenwood, after he left Boston for Surinam in 1752, is said to have collected or sketched its fauna, plants, and natural curiosities.[58] Charles Willson Peale, an acquaintance of William Bartram and other natural scientists in Philadelphia, was another artist with an interest in things scientific.

Peter Pelham, in Boston in 1731, is credited with holding one of the earliest concerts open to the public. (Concerts open to the public were not common in England until the late seventeenth century.[59]) Pieter Vanderlyn is credited with writing a song, probably around 1730.[60] In 1754 the young Ezra Stiles, an acquaintance of Smibert's son Nathaniel, noted that he was "At Mr. [Nathaniel] Smibert's, saw his paintings and heard him play on the Spinet."[61] The multi-talented William Williams, who designed theater sets when in Philadelphia around 1759, and who wrote what may be the earliest American novel, advertised in the *Pennsylvania Journal* of 13 January 1763 that he had "an Evening School, for the Instruction of Polite Youth, in different branches of Drawing, and to sound the Hautboy, German and Common Flutes."[62] William Johnson of Boston received an appointment as organist after he had settled in Barbados sometime before 1770.[63] For those artists with the ability, music was important. It was part of what the eighteenth century called "the polished life." The artists were, in this and other fields, the carriers or transmitters of aspects of the cultural life.

Other occupations attracted some artists, including teaching. The role of drawing masters or mistresses in the artistic life of the colonies is still fairly elusive. There are a number of such references in advertisements or other sources, but unless these individuals are known for their paintings or other accomplishments their influence is hard to discern. When Peter Pelham established himself in Boston in 1727 he appar-

ently hoped to support himself as a printmaker. But by the late 1730s he had established a school in Boston for the "Education of Children in Reading, Writing, Needlework, Dancing, and the Art of Painting on Glass."[64] In 1744 Jeremiah Theus in Charleston announced "to all young Gentlemen and Ladies inclinable to be taught the Art of Drawing, that an Evening School for that Purpose will be opened."[65] He was but one of several people who advertised from time to time that they taught drawing.[66] When William Dering settled in Williamsburg in 1737 he advertised as a teacher of dancing "in the newest French Manner."[67]

Some artists had an interest in architecture, perhaps because of their patrons. Peter Faneuil commissioned Smibert to design the civic market hall that he gave to the city of Boston.[68] Colonel John Montresor was a surveyor-engineer who drew beautiful maps for the British forces. As mentioned earlier, when Copley made his extended painting trip to New York City in 1771, his newly acquired house in Boston was being remodeled. The artist sent a letter to his step-brother with instructions on how to build a piazza and advised that Montresor could "sett you right" in case he was at a loss as to how it should be built.[69]

While practitioners of painting and architecture shared an interest in form, poets and painters shared a feeling for imagery. Dryden, paraphrasing Du Fresnoy, had written, "the chief End of Painting is to please the Eyes: and 'tis one great End of Poetry to please the Mind." Each art, in its own way, was to instruct.[70] We have seen that a number of colonial painters had poems written in their honor. Some have been quoted in the literature, but usually only in connection with an individual artist. This poetic phenomenon, which had English counterparts, deserves closer examination, for the poems have not been discussed as a group and thus have not been seen as an aspect of the artistic-literary life of the time. Such poems reflect some of the prevalent ideas about paintings or painters. In both England and America poetry was an important part of public discourse. Colonial newspapers, for example, show this. Though most were only a few pages long, many had a "Poet's Corner" as a regular feature. Poems were written on a wide range of issues and subjects.[71] There were eulogies, pastorals, and satires. The poetry was not always of high quality and ranged in subject matter and style from those cleverly written or laden with classical erudition to simple doggerel. The poets, both English and American, freely borrowed from each other. Versifying challenged the skill and wit of some, and for others it was a parlor pastime. Poems probably were read aloud on special occasions or circulated among friends, and the prevalence of such poetry suggests that it was part of popular culture.

The published poems on art brought the artists and their patrons to the attention of the public. Both gained public recognition or esteem. Though portraiture is essentially a private art created for the patron and his family, the poetry brought this "softer art" into the public arena.

By the 1700s the relationship between poetry and painting had a long and honorable tradition, as some of the colonial poets assuredly knew. In the American and English poems I wish to discuss there is often an allusion to the parallel roles of poet and artist. For example, in Mather Byles's poem on Smibert the verbal and visual are paired:

> Alike our Labour, and alike our Flame,
> 'Tis thine to raise the Shape:
> 'Tis mine to fix the Name.[72]

These poems are usually in honor of a painter or about a portrait or several paintings by an artist.

A brief identification of the poems about artists in America shows their number and content. Even before he came to America, Smibert was praised in a 1721 poem by his friend, the elder Allan Ramsay, and mentioned in a poem by J. Roberts about Kneller's death.[73] Mather Byles's poem "To Mr. Smibert on the Sight of his Pictures," already cited, was probably first published in the *Boston Gazette* in January 1729/1730, and then reprinted several times (see n. 72 above). A mischievous reply, probably by Joseph Green, "To Mr. B——, occasioned by his verses to Mr. Smibert on seeing his Pictures," appeared on 13 April 1730.[74] Joseph Green was also the author of a friendly lampoon about a Smibert portrait of the Reverend John Checkley, probably written in the 1730s.[75] In 1744 Byles republished his poem on Smibert's pictures in a collection of his poems. It was now addressed simply "To Pictorio," with classical names substituted for

specific references to portraits such as those of Sewall and Mascarene.[76]

Other artists and paintings received similar poetic attention. James Bowdoin II was inspired to write a poem about Robert Feke's portrait of his wife, probably around 1748, the year they were married.[77] A poem by a Dr. T. T., "On seeing Mr. Wollaston's Pictures in Annapolis," appeared in the *Maryland Gazette* of 15 March, 1753, and five years later, in September 1758, Francis Hopkinson published "Verses inscribed to Mr. Wollaston" in *The American Magazine*.[78] These suggest that Wollaston also had a room where his works could be viewed by friends and acquaintances.

West was praised on 15 February 1758 when an anonymous "Lovelace" published a poem in *The American Magazine*, "Upon seeing the portrait of Miss xx——xx by Mr. West."[79] Hopkinson's poem on Wollaston, in *The American Magazine*, concluded with a eulogy to the promise of young Benjamin West, then not quite twenty years old. When John Thomas, the neighbor of Jane Galloway, the subject of a portrait by West, saw that painting around 1762, he wrote a poem "To a Lady of Maryland."[80] Hopkinson again honored West, along with the Bishop of Worcester, in a long poem entitled "Genius."[81]

Three poems about art and artists appeared in the Boston newspapers in the mid-1750s. On 8 September 1755 a poem was published in the *Boston Gazette* titled "On seeing a Young Lady painted in the character of the Goddess Diana." On the fifteenth, a second poem was prefaced with "The following Lines were written some time ago, on the Sight of a celebrated Picture in this Town." Presumably they were written about the same picture, which must have been on view in Boston.[82] Unfortunately we do not know where the painting (or paintings) mentioned in the poems was to be seen and how it became "celebrated." In a different vein, on 2 May 1757, six months after Nathaniel Smibert, the talented son of John Smibert, had died at the age of twenty-two, the *Boston Gazette* published a Latin elegy by the scholar-teacher John Beveridge.[83] Among the few paintings young Smibert painted is that of Ezra Stiles, who later became president of Yale; he seems to have had learned friends.

On the lighter side, a long poem discoursing upon the nature and character of a man's beard was composed by the subject, Mr. William Scott,

a shoemaker, and placed under a painting of himself by Joseph Badger. Though the shoemaker was from Boston, his poem was published on 3 February 1764 in *The New Hampshire Gazette and Historical Chronicle of Portsmouth*. It included these lines:

> These Lines I hope you will excuse,
> As I get Bread by making Shoes.[84]

The poem, or the painting, elicited four short verses by several young women identified only as Clarissa Perp, Arabelle Tickle, Ann Sober, and Betty Simper, all published in the same issue. Ann Sober's read:

> The women now are out of Shoes,
> and sorely they complain
> They view Scott's Face, and gratify
> a curious Taste though vain.[85]

For at least a small circle of friends this painting must have represented an event, an occasion for talk and merrymaking with and about the poetically inclined subject, and admiration for the painter. Publication in a newspaper provided further notoriety.

In these poems, praise is generally more common than criticism. However, an anonymous poet, in his "On a Young Lady's Picture," published in the 9 March 1769 *Virginia Gazette*, did not hesitate to castigate an unlucky artist, an equally anonymous R——s, and instructed the artist as to his duty:

> R——s, thy pencil draws each line too faint,
> And wrongs the beauty it means to paint.
> Where is that easy look, that pleasing air
> Which speak her fairest 'midst a thousand fair?
> .
> To flatter age with soothing strokes of art,
> To add more bloom, is held the painter's part;
> But you (a grosser fault sure ne'er was seen)
> Have made her thirty, though she's scarce
> fifteen!

Like Smibert, Charles Willson Peale received considerable poetic attention. Peale's local fame, as recorded in published poems, began when his name was invoked in the *Maryland Gazette* of 6 September 1770, when an anonymous bard suggested that their "self-tutor'd Peale" might paint the actress Miss Nancy Hallam in her role of Imogen in Shakespeare's *Cymbeline*.[86] It was not

until a year later, when the company returned, that Peale painted Miss Hallam, a painting that again drew forth poetic journalistic praise, "To Mr. Peale, on his Painting Miss Hallam in the Character of Fidele in Cymbeline," this probably from the pen of Jonathan Boucher.[87] This appeared in the *Maryland Gazette* of 7 November 1771. Peale's portrait of his wife, Rachel, brought forth a glowing panegyric that was published in the 18 April 1771 "Poet's Corner" in the *Maryland Gazette*. This poem, like the one related to the Badger painting, had at first been pinned underneath the picture.[88] This painting, now unlocated, showed Rachel in a madonnalike pose with their child and must have been on display in his painting room. On 8 July 1773 another even more fulsome poem about it or a similar painting was printed in the *Maryland Gazette*.[89] Yet another of Peale's works done before 1776 that drew forth a poem was the sad and somber 1772 painting of Rachel and their dead child. This painting was in the painting room, but always covered with a curtain. The poem about it was not published until 4 December 1782, in the *Freeman's Journal,* but may have been written earlier.[90]

These poetic effusions about American paintings had an abundance of English prototypes, many of which would have been known to the colonists.[91] Such verses were a popular genre— one could do an entire anthology. They were engendered in part because a number of English artists and poets in the seventeenth and eighteenth centuries were close friends. For example, Sir Godfrey Kneller's circle included Dryden, Addison, Tickell, and Pope, several of whom wrote poems about the artist.[92] Among other English prototypes of the American works are two poems by Richard Lovelace honoring the artist Sir Peter Lely, written in 1640 and 1647.[93] Poet John Dryden, in the preface to his translation of Du Fresnoy's *De Arte Graphica,* noted that in translating he took "the advise of those more knowledgeable," presumably his painter friends.[94] Dryden's work also includes his poem "To Sir Godfrey Kneller," written around the time that Kneller painted a portrait of Dryden.[95] The poem of Alexander Pope, "To Mr. Jervas," was, as noted, prefaced to the 1716 and most later editions of Dryden's translation of Du Fresnoy.[96] Jervas, principal painter to George I and then to George II, included literary men such as Jonathan Swift, Pope, and Sir Richard

Steele among his friends. Pope himself had studied with Jervas for a year and a half or so, to learn the techniques of painting. Another of the many poems concerned with paintings or painters is that by Joseph Addison, "To Sir Godfrey Kneller on His Picture of the King," first published in 1716.[97]

Certain ideas are found again and again in both the English and American verses, and some comparisons are relevant. One theme was the awareness of the artistic traditions of the past. The implication often was that the artist being praised follows or rivals previous masters. Lovelace, in his "Panegyrick" to Lely, for example, invokes Titian, Holbein, and "great Vasari." Dryden, in his poem to Kneller, refers to the very "Rudiments of Art," to Greece, Rome, the Goths, and Vandals, then the "heavy Sabbath" when the Sister Arts did "in iron sleep" (the Middle Ages), and then to Raphael and Titian. In Pope's poem, "To Mr. Jervas," the poet's admiration of the Renaissance was summed up in the lines:

> Together o'er the Alps methinks we fly,
> Fired with ideas of fair Italy
>
>
>
> A faded fresco here demands a sigh:
> Each heav'nly piece unwearied we compare,
> Match Raphael's grace with thy lov'd Guido's
> air,
> Caracci's strength, Correggio's softer line,
> Paulo's free stroke, and Titian's warmth divine.

These quotable lines of Pope are echoed in a number of later poems; in J. Roberts's eulogy to Kneller, for example, he simply incorporates four lines from Pope into his work. Addison, writing on Kneller's picture of the king, worked in a comparison between Phidias's sculpture of Jove and Kneller's portrait of George.

The lure of Italy was again called up in Ramsay's 1721 poem to Smibert, "To a Friend at Florence, on his way to Rome":

> Your steady impulse foreign climes to view,
> To study nature, and what art can shew,
> I now approve, while my warm fancy walks
> O'er Italy, and with your genius talks;
> We trace, with glowing breast and piercing
> look,
> The curious gall'ry of th' illustrious duke,
> Where all those masters of the arts divine,
> With pencils, pens, and chisels greatly shine,
> Immortalizing the Augustine age.
>
>

We'd enter Rome with an uncommon taste,
And feed our minds on every famous waste;
On Medals, canvass, stone, or written page,
Ampitheatres, columns, royal tombs,
Triumphal arches, ruins of vast domes . . .

American poems refer to this European artistic tradition as well. Mather Byles, an admirer of Pope, prefaced his poem on Smibert's picture collection with a quote from Ovid's *Metamorpheses* concerning the statue that Pygmalion brought to life. In the poem, he refers to the paintings in Smibert's collection:

> The Italian master sits in easy state,
> Vandike and Rubens show their Rival Forms.

The pseudonymous "Lovelace," who wrote the poem "Upon seeing the portrait of Miss xx——xx by Mr. West," which appeared in the February 1758 issue of *The American Magazine*, invoked Guido as a paradigm for West:

> The easy attitude, the graceful dress,
> The soft expression of the perfect whole,
> Both Guido's judgment and his skill confess,
> Informing canvas with a living soul.

In April 1771 Peale was compared with Rubens,

> When P——e his lovely Arria drew,
> Like Rubens erst, by Love impel'd.

In the poem of November 1771 to Peale's painting of Miss Hallam we read:

> The grand Design in Grecian Schools was
> taught,
> Venetian Colours gave the Pictures Thought.
> In thee, O Peale, both Excellences join
> Venetian Colours, and the Greek design.

In contrast to the glorious history of art on the Continent, several of the English poems reflect a sense of their inferior circumstances. Lovelace, in his "Panegyrick," asks:

> Where then when all the world pays its respect,
> Lies our transalpine barbarous Neglect?

and some lines later speaks of "this un-derstanding land," and again

> And I unto our modern Picts shall show,
> What due renown to thy fair Art they owe.

Dryden saw Kneller as without rival in their time, but qualified the observation by saying theirs was an inferior age:

> None of this Age; for that's enough for thee,
> The first of these Inferiour Times to be:

and, after writing of the "wondrous Art" of Rome and Venice, he says to the artist,

> That yet thou hast not reach'd their high
> Degree,
> Seems only wanting to this Age, not thee;
> Thy Genius bounded by Times like mine,
> Drudges on petty Draughts, nor dare design
> A more Exalted Work, and more Divine.
>
> And They who pay the Taxes, bear the Rule:
> Thus thou sometimes are forc'd to draw a Fool:

Given lines and circumstances in England such as these, one can see how the mature Copley, while still in America, could say, in an oft-quoted passage, that portrait painting was "no more than a useful trade."[98] He may have been reflecting English ideas on the difficulties and the inferiority of portrait painting as well as his own experience in Boston. As I already mentioned, similar ideas were articulated in the theoretical ideas of Dryden and Richardson.

An awareness of history, and feelings of both humility and pride, are also among common elements in many of the American poems. Though essentially celebratory of Smibert's work, and of progress, Mather Byles started his poem by evoking a picture of the raw new world:

> Ages our Land a barb'rous Desert stood,
> And Savage Nations howl'd in every Wood;
> No laurel'd Art o'er the rude Region smil'd
> Nor blest Religion dawn'd amidst the Wild;
> Dullness and Tyranny, confederate, reign'd
> And Ignorance her gloomy State maintain'd

Joseph Green, in his spoofing response to Byles, teased the poet:

> Unhappy bard! Sprung in such Gothic Times
> As yield no friendly muse, t' extol your Rhymes
> Hard is the task you singly undergo
> To praise The Painter and the Poet too.

None of the other American poems cited have equivalent statements on the "rude region" of the "Gothic Times" of this colonial period. In-

stead, theirs is a more optimistic tone, proud of what is happening. Even Byles takes this up:

Each Year succeeding the rude Rust devours,
And softer Arts lead on the following Hours:
.
Till the great Year the finish'd Period brought,
A Smibert painted and a ——— wrote,

Dr. T. T., on Wollaston, expressed somewhat similar pride in the artist's accomplishments because he could

. . . such heav'nly Charms portray
And save The Beauties of this Land
From envious Obscurity.

Both English and American poets devote many lines to eulogy and description. In these the artist is called upon to make, or cited for making, character and emotion tangible. Thus Addison on Kneller's portrait of King George:

The magick of thy art calls forth
His secret soul and hidden worth,
His probity and mildness shows,

or Byles describing two paintings of Smibert (fig. 22):

In hoary majesty, see Sewall here;
Fixt strong in thought there Byfield's Lines
 appear:

In paintings of women there is often emphasis on physical beauty. James Bowdoin II, writing of Robert Feke's portrait of his wife, a portrait probably done about the time of their marriage in 1748 (fig. 23), described her features in sensuous terms, starting with her "charming locks" and including "her comely neck," "her piercing eyes," her cheeks and "coral lips," and ending with "her tempting breasts":

See down her neck the charming locks descend;
And, black as jet, in waving ringlets end:
The jetty locks, as down her neck they flow,
The lovely white to great advantage show:
.
Her tempting breasts in whiteness far outgo
The op'ning lilly, and the new faln snow;
Her tempting breasts the eyes of all command,
And gently rising court the am'rous hand.

In a similar vein Dr. T. T. wrote of a colonial beauty seen in a painting by Wollaston, this in his poem published 5 March 1753 in the *Mary-land Gazette:*

The Lilly blended with the Rose,
Blooms gaily on each fertile Cheek,
Their Eyes the sparkling Gems disclose,
And balmy Lips, too, seem to speak.

One senses from these lines that portraits of men were meant to convey character and that artists were given some license in order to enhance the beauty of women. In both cases, however, a fairly accurate likeness was desired.

Over and over there are lines that praise the artist's ability to "make the lifeless Canvas Breathe," an elegant way of saying it is a good likeness. Again, as in Dr. T. T.'s poem:

Behold the won'drous Power of Art!
That mocks devouring Time and Death,
Can Nature's ev'ry Charm impart;
And make the lifeless Canvas Breathe.

The poem that had been pinned under a portrait of the artist's wife, Rachel, when it was hung in Charles Willson Peale's painting room, included this verse:

Yes Plastic Nature cou'd alone,
To this fair form this meaning give;
 or else she taught her genuine Son,
To bid the breathing Canvis live.
.
Give me, depictur'd Warm from Life,
 Each soft Emotion of the mind;
Give me the Mother and the Wife
 As here, in sweetest Union join'd."

Byles, in praising Smibert, implied the artist's ability to create a believable landscape (there may have been landscape backgrounds in some of the paintings in Smibert's collection) as well as beautiful face:

'Tis yours, great Master, in just Lines to trace
The rising Prospect, of the lovely Face.

Tied to this idea that artists are gifted in their ability to create the illusion of reality, the likeness, is the belief that painting preserved an image for the future, giving a kind of immortality. Thus Pope on Jervas:

Beauty, frail flower, that every season fears
Blooms in thy colours for a thousand years.

The witty Joseph Green could chidingly assure his friend John Checkley, who had apparently

Fig. 22. John Smibert, *Judge Samuel Sewall*, 1729, oil on canvas, 30¼ × 25½ in. (76.8 × 64.8 cm). Bequest of William L. Barnard by exchange and the Emily L. Ainsley Fund. Courtesy, Museum of Fine Arts, Boston.

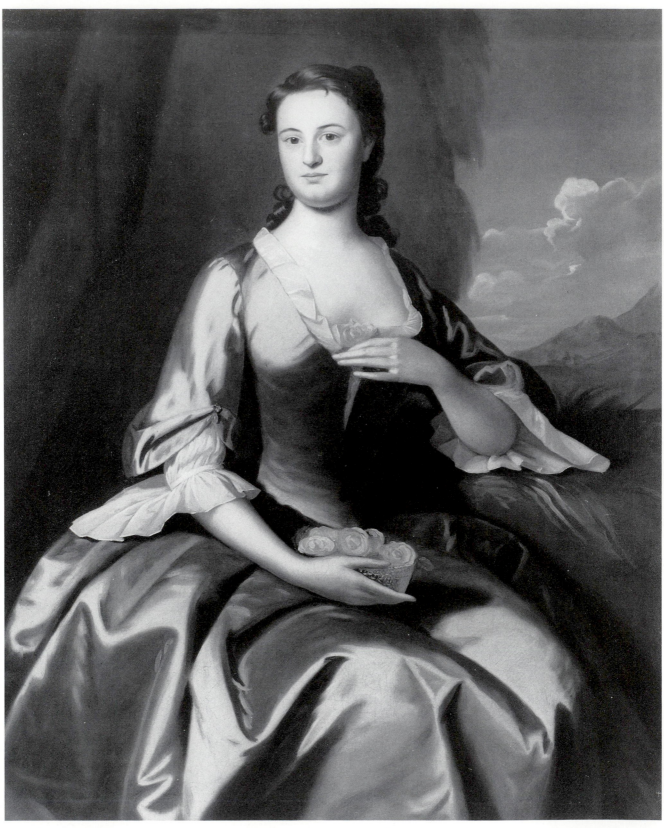

Fig. 23. Robert Feke, *Mrs. James Bowdoin II*, 1748, oil on canvas, 50⅛ × 40⅛ in. Bowdoin College Museum of Art, Brunswick, Me. Bequest of Mrs. Sarah Bowdoin Dearborn.

recovered from a serious illness, that a painting by Smibert would give him immortality:

> John, had thy sickness snatch'd thee from our
> sight,
> And sent thee to the realms of endless night,
> Posterity would then have never known
> Thine eye—thy beard,—thy cowl and shaven
> crown.
> But now redeemed by Smibert's skilful hand,
> Of immortality secure you stand.
> When Nature into ruin shall be hurl'd,
> And the last conflagration burn the world,
> This piece shall then survive the general evil,
> For flames we know cannot consume the
> Devil.[99]

As indicated by Green's poem, in some cases the decision to have a portrait done was because a threatened life had been saved; on other occasions a portrait may have been commissioned because there was a threat to life. One of the frankest records of such an occasion was noted by Charles Willson Peale in his diary of June 1795. He wrote of how he had to get the stretching frames ready for a painting he wished to make of his daughter, Angelica, then expecting her first child: "This I was induced to do for dispatch, as the situation of Angelica required that no time be lost, as it was daily expected that she would be *in the straw.*"[100] Such dire occasions were but one reason for commissioning a portrait, others were more felicitous, such as at a time of marriage, the acquisition of wealth, or some other change in social status.[101] In each case the desire was to preserve a likeness, a moment, for the future.

Also intertwined with the idea that the painter is especially able to preserve a "breathing" image for the future are verses comparing the sister arts of poetry with painting, with the literary person often making a modest disclaimer. Thus Dryden on Kneller:

> But Poets are confin'd in Narr'wer space;
> To speak the Language of their Native Place;
> The Painter widely stretches his command;
> Thy Pencil speaks the tongue of ev'ry Land.

And Pope on Jervas:

> Read these instructive leaves, in which conspire
> Fresnoy's close art, and Dryden's native Fire:
> And reading wish, like theirs, our fate and
> fame,
> So mix'd our studies, and so join'd our name.

Byles, in lines already quoted, expressed ideas similar to those of his English mentors. In Green's witty rejoinder to Byles he writes:

> If you to future Ages would be known,
> Make this Advice I freely give your own.
> Go to the Painter—for your Picture sit
> His art will long survive the Poet's wit.

In "Verses inscribed to Mr. Wollaston," the poem believed to be by Francis Hopkinson and published in *The American Magazine* of 18 September 1758, the author was more complex in intertwining his work with praise of the artist:

> And thou, my muse! seek not to raise thy
> name,
> On the heap'd ruins of another's fame;
> But still employ thy numbers to set forth
> Distinguish'd genius and uncommon worth.
> To you fam'd *Wollaston!* these strains belong,
> And be your praise the subject of my song:
> When your soft pencil bids the canvas shine
> With mimic life, with elegance divine,
> Th' enraptur'd muse, fond to partake thy fire,
> With equal sweetness strives to sweep the lyre;
> With equal justice fain would paint your praise,
> And by your name immortalize her lays.

In his final praise of the youthful West in the same poem, he suggests that some future muse will be needed to do the artist justice:

> Nor let the muse forget thy name O West,
> Lov'd youth, with virtue as by nature blest!
> If such the radiance of thy *early Morn,*
> What bright effulgence must thy *Noon* adorn?
> Hail sacred *Genius!* may'st thou ever tread,
> The pleasing paths your *Wollaston* has lead.
> Let his just precepts all your works refine,
> Copy each grace, and learn like him to shine.
> So shall some future muse her sweeter lays,
> Swell with your name, and give *you* all *his*
> praise.

When Dr. T. T. wrote on Wollaston, his comparison was not between poetry and painting, but between nature and art:

> And know not justly which to praise,
> Or Nature, or the Painter most.

Hopkinson, on the portrait by West, raised the question:

> Can nature still superior charm impart,
> Or warmest fancy add a single grace?

Though quite a few poets make reference to application of color and suggest process, such as Byles's "Raise the ripe Blush, bid the quick Eyeballs roll," the experience of seeing a painting in process is best suggested in the verses to Wollaston just mentioned:

Oftimes with wonder and delight I stand,
To view th' amazing conduct of your hand.
At first unlabour'd sketches lightly trace
The glimm'ring outlines of a human face;
Then by degrees the liquid life o'erflows
Each rising feature—the rich canvas glows
With heightned charms—The forehead rises
 fair;
And, glossy ringlets twine the nut-brown hair;
The sparkling eyes give meaning to the whole,
And seem to speak the dictates of a soul.
The lucid lips in rosy sweetness drest,
The well-turn'd neck and the luxuriant breast,
The silk that richly flows with graceful air—
 All tell the hand of *Wollaston* was there.

Hopkinson, like Pope, actually tried his hand at painting, so had some idea of the process.[102]

These poems thus provide some insight into how eighteenth-century patrons and artists, and their friends, esteemed and valued paintings, and convey something of how they thought and talked about them. Some poems suggest that the completion of a work created a kind of occasion when friends gathered. Still other poems may have been written but never recorded. The poems also reveal some of the ideas portraits called up. The belief that paintings give a kind of immortality and have a universality is articulated and implied: pictures can surpass or outlast words in conveying the nature of a person. Important, also, are the related ideas that poetry and painting go hand in hand, that the poet and artist are both a part of what the eighteenth century thought of as "the polished life," and that they, along with their patrons, were all "people of condition," of status, of a worthiness that lent gravity, elegance, and sparkle to life. The emphasis in the poems is usually on emotional response to the sitter and to the painter's canvas. Patrons and poets wanted a likeness, a "breathing" canvas, and a sense of character. The artist must "in just Lines to trace." Appearances were determined by the eighteenth-century sense of decorum. It is clear from these poems, too, that portraits were something to be talked about, to be seen and written about, in private but also in public. The artist's role was to create likenesses, and in so doing they brought a kind of immortality to their sitters and to themselves. Pope, in his *Essay on Man*, wrote:

Know then thyself, presume not God to scan;
The proper study of Mankind is Man.

It is not too presumptuous to suggest that artists and poets felt that they too were contributing to this study, to help to enlighten man about himself.

Notes

1. Howard C. Rice, Jr., trans. and intro., *Travels in North America in the Years 1780, 1781, and 1782 by the Marquis de Chastellux*, 2 vols. (Chapel Hill: University of North Carolina Press, 1963), 1:25–29; 2:529–48.

2. Ibid., 2:537.

3. Ibid., 2:544–45.

4. Ibid., 2:655, n. 10. George Grieve was the eighteenth-century translator.

5. In order to make some general statements, I prepared a series of lists and Sally Main prepared a chart detailing where and when each known artist worked. These are too detailed to reproduce here, but the statements that follow sum up this information. Since some of our information is imprecise, other scholars might have come up with slightly different names and numbers.

6. Whaley Batson to the author, 22 August 1987, Museum of Early Southern Decorative Arts, Winston-Salem, N.C.

7. The artists used in this compilation who worked after 1735, and their place of origin are as follows. *Native-born:* Joseph Badger; Henry Benbridge; Winthrop Chandler; James Claypoole, Jr.; John Singleton Copley; Abraham Delanoy; Gerardus Duyckinck III; Nathaniel Emmons; Robert Feke; John Greenwood; John Hesselius; William Johnston; Samuel King; John Mare; John Meng; Nehemiah Partridge; Charles Willson Peale; James Peale; Henry Pelham; Matthew Pratt; Nathaniel Smibert; Gilbert Stuart; John Trumbull; and Benjamin West. *From Britain:* Cosmo Alexander, Scotland and London; Charles Bridges, Northamptonshire via London; Alexander Gordon, Scotland; Lawrence Kilburn, London; Thomas Leech, London; Peter Pelham, London; John Smibert, Scotland and London; John Watson, Scotland; William Williams, England; and John Wollaston, London. *Presumably English:* Joseph Blackburn and John Grafton. *From Europe:* Pierre Eugene du Simitière, Geneva, Switzerland; John Valentine Haidt, Danzig, to America via Germany and London; Gustavus Hesselius, Sweden; Jeremiah Theus, Switzerland; and Pieter Vanderlyn, Holland. *Place of origin unknown:* William Dering; John Durand; William Faris; Joseph Fournier; John Green; Thomas McIlworth, possibly Scotland; Bishop Roberts; Mary Roberts; and William Williams #2. (There were probably two different artists named William Williams. See E. P. Richardson, "William Williams—A Dissenting Opinion," *American Art Journal* 4 (Spring 1972): 5–23.)

8. Bernard Bailyn, *The Peopling of British North America* (New York: Alfred A. Knopf, 1986), 20–43, esp. 20 and 40–41.

9. Ibid., 12.

10. Pictor [pseud.], "The Art of Painting," *Universal Magazine* 3 (November 1748): 225–33.

11. Richard Henry Saunders III, "John Smibert (1688–1751): Anglo-American Portrait Painter," Ph.D. diss., Yale University, 1979, 1:7.

12. Ellis Waterhouse, *The Dictionary of British 18th-Century Painters in Oil and Crayons* (Woodbridge, Suffolk: Baron Publishing, 1981), 15.

13. E. Rimbault Dibdin, "Liverpool Art and Artists in the Eighteenth Century," *The Walpole Society, 1917–1918* 6 (1918): 12–93. Another article dealing with art in a provincial British city is Trevor Fawcett, "Eighteenth-Century Art in Norwich," *The Walpole Society, 1976–1978* 46 (1978): 71–90.

14. The three basic studies on Smibert's career are Henry Wilder Foote, *John Smibert, Painter* (Cambridge: Harvard University Press, 1950); Sir David Evans, John Kerslake, and Andrew Oliver, *The Notebook of John Smibert* (Boston: Massachusetts Historical Society, 1969), and Saunders, "Smibert." Many of the same primary documents are cited by Foote and Saunders.

15. J. A. Leo Lemay, *A Calendar of American Poetry in the Colonial Newspapers and Magazines and in the Major English Magazines Through 1765* (Worcester, Mass.: American Antiquarian Society, 1972), nos. 131 and 133, p. 24.

16. Walter K. Watkins, "The New England Museum and Home of Art in Boston," *Bostonian Society Publications*, ser. 2 (1917): 103–30, traces the ownership of the rooms.

17. Theodore Sizer, ed., *The Autobiography of Colonel John Trumbull, Patriot-Artist, 1756–1843* (New Haven: Yale University Press, 1953), 44–45.

18. Waldron Phoenix Belknap, *American Colonial Painting: Materials for a History* (Cambridge: Harvard University Press, 1959).

19. Richard [H.] Saunders and Ellen G. Miles, *American Colonial Portraits, 1700–1776* (exh. cat., Washington, D.C.: National Portrait Gallery, 1987), 20–22 and 53–58.

20. For West, see Robert C. Alberts, *Benjamin West, A Biography* (Boston: Houghton Mifflin, 1978), 7–23, for Peale, Charles Coleman Sellers, *The Artist of the Revolution: The Early Life of Charles Willson Peale* (Philadelphia: American Philosophical Society, 1947), 49–66.

21. For an idea of the publishing history, see the listings in *The British Library General Catalogue of Printed Books to 1975* (London: K. G. Saur, 1985), 88:336. The edition I have used for this discussion is [John] Dryden, trans., *The Art of Painting by C. A. DuFresnoy, Translated into English, with an Original Preface, Containing a Parallel Between Painting and Poetry* (London: Bernard Lintott, 1716).

22. There is a great deal of literature on this subject. The classical art historical survey of the subject is Rensselaer W. Lee, "Ut Pictura Poesis: The Humanistic Theory of Painting," *Art Bulletin* 22 (1940): 197–269. Another useful study is Jean H. Hagstrum, *The Sister Arts: The Tradition of Literary Pictorialism and English Poetry from Dryden to Gray* (Chicago: University of Chicago Press, 1958). As the title suggests, this book stresses the impact of the visual arts upon the English imagination as expressed in literature.

23. Dryden, *Art of Painting*, 13.

24. Ibid., ii.

25. Ibid., xii–xiv.

26. Ibid., xvii.

27. Ibid., xxxii.

28. Ibid., xxxviii.

29. Janice G. Schimmelman, "A Checklist of European Treatises on Art and Essays on Aesthetics Available in America Through 1815," *Proceedings of the American Anti-quarian Society* 93 (1983): 95–195, esp. 124.

30. Ibid.

31. Jonathan Richardson, *An Essay on the Theory of Painting* (London, 1715), 130 and 142–43.

32. Schimmelman, "Checklist," lists only twelve copies, and of these only two—those mentioned by West and Williams—were published before 1776; see 152–54.

33. Alberts, *West*, esp. 165–71.

34. As indicated in n. 20 above, data on Peale is based on Sellers, *Artist of the Revolution*, 49–66. For Peale and Christopher Steele, see Ellen G. Miles, "The Portrait in America, 1750–1776," in *American Colonial Portraits: 1700–1776*, 33–34.

35. Jules D. Prown, *John Singleton Copley In America, 1738–1774* (Cambridge: Harvard University Press, 1966), 15–18.

36. E. P. Richardson, "James Claypoole, Jr., Re-Discovered," *Art Quarterly* 33 (1979): 159–75.

37. Charles Henry Hart, "Autobiographical Notes on Matthew Pratt," *Pennsylvania Magazine of History and Biography* 19 (1896): 460–67. See also Dorinda Evans, *Benjamin West and His American Students* (Washington, D.C.: National Portrait Gallery, 1980), 24–33.

38. "Pictor," "The Art of Painting," 225–33. Since this is an article rather than a book, it does not appear in Schimmelman, "A Checklist."

39. *Letters and Papers of John Singleton Copley and Henry Pelham, 1739–1776* (1914; reprint, New York: 1970): 328. Letter of 25 June 1775.

40. Ibid., 313.

41. Ibid., 73–74.

42. Ibid., 126

43. Ibid., 339.

44. Carl Bridenbaugh, ed., *Gentleman's Progress: The Itinerarium of Dr. Alexander Hamilton, 1744* (Chapel Hill: University of North Carolina Press, 1948), 114 and 134.

45. Sellers, *Artist of the Revolution*, 93.

46. *Copley-Pelham Letters and Papers*, 141–42, and 146.

47. As cited from Dunlap, in G. L. M. Goodfellow, "Cosmo Alexander in America," *Art Quarterly* 26 (1963): 309–22, esp. 316.

48. For a discussion of types of American-made frames see Jessica Foy, "American-made Picture Frames from the Colonial Era," M.A. thesis, University of New York at Cooperstown, 1987. See also the various entries listed in George Francis Dow, *The Arts and Crafts in New England 1704–1775* (Topsfield, Mass.: Wayside Press, 1927), 17–20,32, 37, etc.: Rita S. Gottesman, *The Arts and Crafts in New York 1726–1776* (New York: The New-York Historical Society, 1938), 3, 5, etc.; and Alfred Coxe Prime, *The Arts and Crafts in Philadelphia, Maryland and South Carolina*, Part 1, 1721–1785 (New York: Walpole Society, 1929), 10, 33, etc.

49. Mabel L. Webber, "The Thomas Elfe Account Book, 1768–1775," *South Carolina Historical and Genealogical Magazine* 35–40 (1934–1941): 35, p. 163; 36, p. 56; 37, pp. 25, 28, 29, 79, 152, 155; 38, p. 132; 39, p. 135.

50. See "The trade of the artists' colourman," in Lynda Fairbairn, *Paint and Painting* (London: Tate Gallery, 1982), 35–43, and the section on "Paint," in Dow, *Arts and Crafts*, 237–43.

51. *Paint and Painting*, 67.

52. Frank J. Klingburg, ed., *Carolina Chronicles: The Papers of Gideon Johnston, 1707–1716* (Berkeley and Los Angeles: University of California Press, 1946), 31 and 35.

53. Graham Hood, *Charles Bridges and William Dering* (Charlottesville: University Press of Virginia, 1978), 1–9.

54. E. P. Richardson, "Gustavus Hesselius," *Art Quarterly* 12 (Summer 1949): 220; Charles Henry Hart, "The

Earliest Painter in America," *Harper's New Monthly Magazine* 96 (March 1898): 566–70; Roland E. Fleischer, *Gustavus Hesselius, Face Painter to the Middle Colonies* (exh. cat., Trenton: New Jersey State Museum, 1988); " 'With God's Blessings on Both Land and Sea': Gustavus Hesselius Describes the New World to the Old in a Letter from Philadelphia in 1714," translated by Carin K. Arnborg, with commentary by Roland E. Fleischer, *American Art Journal* 21 (1989): 4–17.

55. Adolph B. Benson, *Peter Kalm's Travels in North America*, 2 vols. (New York: Wilson-Erickson, 1937), 1: 17, 36–37, and 60.

56. *Pennsylvania Genealogical Magazine* 22 (1961): 35, as cited in Richard K. Doud, "John Hesselius, Maryland Limner," *Winterthur Portfolio* 5 (1969): 128–53 (note is on p. 132).

57. Doud, "John Hesselius," 140–41.

58. Cited in the *Dictionary of American Biography*, material communicated by Dr. Isaac J. Greenwood from papers in his possession.

59. Henry Wilder Foote, "Musical Life in Boston in the Eighteenth Century," *Proceedings of the American Antiquarian Society* 49 (October 1939): 305.

60. Manuscript in Kingston Senate House Association, Kingston, New York. Reproduced by Mary C. Black, "Pieter Vanderlyn and Other Limners of the Hudson," in *American Painting to 1776: A Reappraisal*, ed. Ian M. Quimby (Charlottesville, Va., Winterthur Conference Report 1971), 238.

61. As cited by Josephine Setze, "Ezra Stiles of Yale," *Antiques* 72 (October 1957): 348–51.

62. As cited in Richardson, "William Williams," 5–23, esp. 12–13.

63. Lila Parrish Lyman, "William Johnston (1732–1772), A Forgotten Portrait Painter of New England," *New York Historical Quarterly* 39 (January 1955): 63–78.

64. Anne Allison, "Peter Pelham—Engraver in Mezzotinto," *Antiques* 52 (December 1947): 441–43.

65. *South Carolina Gazette*, 22 October 1744, as cited in Margaret Simons Middleton, *Jeremiah Theus, Colonial Artist of Charles Town* (Columbia: University of South Carolina Press, 1953), 40.

66. See Anna Wells Rutledge, *Artists in the Life of Charleston*. Transactions of the American Philosophical Society, n.s., vol. 39 (Philadelphia: American Philosophical Society, 1949), 113–14.

67. *Virginia Gazette*, 25 November 1737, as cited by Graham Hood, *Charles Bridges and William Dering*, 99–100.

68. Hugh Morrison, *Early American Architecture* (New York: Oxford University Press, 1952), 439–42 and nn. 16 and 17, and p. 588.

69. *Copley-Pelham Letters*, 114, 165–66, and 175. See also Jessie Poesch, "A British Officer and His 'New York' Cottage: An American Vernacular Brought to England," *American Art Journal* 20 (1988): 74–97.

70. Dryden, *Art of Painting*, xxii.

71. See Lemay, *Calendar of American Poetry*. He lists 2,091 examples of poetry on a wide variety of subjects.

72. Ibid., nos. 131 and 133, p. 24, with bibliography. This poem has been printed in a number of places, for example, Henry Wilder Foote, "Mr. Smibert Shows His Pictures, May 1730," *New England Quarterly* 8 (March 1935): 19–21.

73. Ramsay's poem is printed in Foote, *Smibert*, 12. Foote is wrong in saying that the 1721 date is incorrect. The poem by Roberts, "A Session of Painters Occasioned by the Death of the Late Sir Godfrey Kneller," is in Michael Morris Killanin's *Sir Godfrey Kneller and His Times, 1646–1723* (London: B. T. Batsford, 1948), 91–94.

74. Lemay, *American Poetry*, no. 144, p. 26, with bibliography. Reprinted in Foote, *Smibert*, 56.

75. In Samuel L. Knapp, *Biographical Sketches of Eminent Lawyers, Statesmen, and Men of Letters* (Boston: Richardson and Lord, 1821), 135; also in Edmund F. Slafter, *John Checkley; or The Evolution or Religious Tolerance in Massachusetts Bay* (Boston: Prince Society, 1897), 5.

76. Reprinted in Benjamin Franklin V, comp., *Mather Byles' Works* (Delmar, N.Y.: Scholars' Facsimiles and Reprints, 1978), 89–93.

77. Marvin S. Sadik, *Colonial and Federal Portraits at Bowdoin College* (Brunswick, Me.: Bowdoin College Museum Art, 1966), 49–51.

78. Lemay, *American Poetry*, no. 1125, 158–59, and no. 1486, p. 206. The first is reprinted in George C. Croce, "John Wollaston (fl. 1736–1767); A Cosmopolitan Painter in the British Colonies," *Art Quarterly* 15 (1952): 140; Lemay, no. 1125, suggests that Dr. T. T. may be "the Dr. Thomas Thornton who was invited as a stranger to the Annapolis Tuesday Club on Jan 22d, 1754." The second is in Theodore Bolton and Harry Lorin Binsse, "Wollaston, an Early American Portrait Manufacturer," *Antiquarian* 16 (June 1931): 33.

79. Lemay, *American Poetry*, no. 1414, 195–96. Reprinted in Theodore Hornberger, "Mr. Hicks of Philadelphia," *Pennsylvania Magazine of History and Biography* 53 (1929): 344. Though this article attributes the poem to a Mr. Hicks, a number of recent scholars believe the author to have been Joseph Shippen, as suggested by Lemay.

80. Miles, *American Colonial Portraits*, 196. This is as quoted in J. Reaney Kelly, " 'Tulip Hill': Its History and Its People," *Maryland Historical Magazine* 60 (December 1965): 362–63, previously published in *Extracts in Prose and Verse* (Annapolis, 1808), 2: 166–67.

81. Quoted in part in George E. Hastings, *The Life and Works of Francis Hopkinson* (Chicago: University of Chicago Press, 1926), 150–51. No date for the poem is given.

82. Lemay, *American Poetry*, cites the 15 September poem, no. 1276, p. 178, but not the one of 8 September, which, so far as I know, has not been reprinted.

83. The poem is reprinted in Foote, *Smibert*, 258–59.

84. Lemay, *American Poetry*, no. 1957, p. 270.

85. Ibid., no. 1956, p. 270.

86. Reprinted in Charles Coleman Sellers, *Charles Willson Peale* (New York: Charles Scribner's Sons, 1969), 93–94. This is a revised version of Sellers, *The Artist of the Revolution*. Sellers suggests that William Eddis was the author. See also Lillian B. Miller, *The Selected Papers of Charles Willson Peale and His Family*, Vol. 1; *Charles Willson Peale: Artist in Revolutionary America, 1735–1791* (New Haven and London: Yale University Press, 1983), 108, n. 1. She suggests Jonathan Boucher as another possible author of this poem.

87. Reprinted in Sellers, *Charles Willson Peale*, 94–95. Re Boucher as author, see Charles Coleman Sellers, *Portraits and Miniatures by Charles Willson Peale*, in Transactions of the American Philosophical Society, n.s.42 (Philadelphia, 1952), 96. See also Miller, *Selected Papers of Charles Willson Peale*, 107–9; she also suggests Boucher as a probable author. See also Ellen G. Miles in *American Colonial Portraits*, 287–88.

88. Reprinted in Sellers, *The Artist of the Revolution*, 96–97. Also in Sellers, *Charles Willson Peale*, 92. Here Sellers suggests that Peale himself may have written it. See also Sellers, *Portraits and Miniatures*, 163, no. 643, where he describes this painting. See also Miller, *Selected Papers of Charles Willson Peale*, 92–94. She too seems to feel that Peale was the author and that the poem may have been given to the *Gazette* by John Beale Bordley.

89. Reprinted in Sellers, *Charles Willson Peale*, 105, where he suggests that this poem was written about a second painting of Rachel. However, in Sellers, *Portraits and*

Miniatures, 163, no. 643, written in 1952, he says that the two poems are probably about the same painting.

90. Sellers, *Charles Willson Peale*, 106–7. See also Miller, *Selected Papers of Charles Willson Peale*, 380–82. Peale was probably the author of the poem.

91. One needs only to go through Horace Walpole's *Anecdotes of Painting in England*, rev. ed. (London: Henry G. Bohn, 1849) to get an idea of the number of poems that appeared in the popular press. Additional examples are in a later volume, edited and published in 1937: Frederick W. Hilles and Philip B. Daghlian, eds. (New Haven: Yale University Press).

92. See Killanin, *Kneller*, chap. 9, "Kneller and the Poets," 62–75.

93. "A Panegyrick to the Best Picture of Friendship Mr. Pet. Lilly," and "To My Worthy Friend Mr. Peter Lilly: on that excellent Picture of his Majesty, and the Duke of York, drawn by him at Hampton Court," both in C. H. Wilkinson, ed., *The Poems of Richard Lovelace* (Oxford: Clarendon Press, 1930), 180–83 and 57–58.

94. Dryden, *The Art of Painting*, ii.

95. James Kinslay, *The Poems and Fables of John Dryden* (London: Oxford University Press, 1962), 495–500.

96. For a discussion of the poem and a copy of the first draft, probably begun in 1714, see Whitewell Elwin and William John Courthope, intro. and notes, *The Works of Alexander Pope*, new ed. (New York: Gordian Press, 1967), 3:209–14 and 531–32.

97. A. C. Guthkelch, ed., *The Miscellaneous Works of Joseph Addison* (London: G. Bell and Sons, 1914), 190–91.

98. *Copley-Pelham Letters*, 65.

99. There is no firm evidence that Checkley's portrait was actually painted by Smibert. Knapp, *Biographical Sketches*, 134–35, tells the story that when Checkley recovered from his illness, "It was proposed that he should sit for his portrait," and that then Joseph Green would "sketch a few lines to be placed under it." Foote, *Smibert*, 73–74, indicated that he had seen a photograph of a painting that might have been of Checkley. According to Richard H. Saunders, the existence or location of this painting is unknown (telephone conversation with Saunders, 1 June 1990).

100. Sellers, *Portraits and Miniatures*, 6–9 and 183 (italics in the original).

101. For an excellent discussion of both private and public reasons for commissioning portraits, see Miles, "The Portrait in America, 1750–1776," in *American Colonial Portraits*, 46–48.

102. John Adams, in a letter to Abigail Adams, 21 August 1776, told of meeting Hopkinson and described him as a poet and a painter; see C. F. Adams, ed., *Familiar Letters of John Adams and His Wife, Abigail Adams* (New York: Hurd and Houghton, 1876), 216–17.

Soul or Style?
Questions about
Early American
Portraits

GRAHAM HOOD

Just before reviewing the papers by Tim Breen and Jessie Poesch, I read a new book by Kenneth Lockridge on William Byrd II of Virginia.[1] It is a recent publication of the Institute of Early American History and Culture and is wonderfully subtle and illuminating. Byrd was a remarkable pan-Atlantic man and I could not have resisted including his portrait in an exhibition such as the one that was the occasion for this symposium. Lockridge brilliantly opens up the extreme, almost barren terseness of Byrd's secret communications so that one sees the man revealed as never before. He takes Byrd's formal façade, the equivalent in language of many of the images discussed in the symposium and shown in the exhibition, and analyzes it with such sensitivity that it is almost like meeting a new person. What makes Byrd an especially intriguing subject for this kind of analysis is not just his sophistication and attainments, but rather that the formal persona he delineated in his diary was so cocooned in secret code that only he, of all those around him, could understand what he had written.

It is with some dismay, having praised the book so highly, that I must go on to say that while Lockridge uses as illustrations the two por-

traits generally thought to represent this quintessential Virginia planter, he does not mention them at all in his text. He denies us a sensitive exegesis of the encoded secrets locked into those three square yards of thinly painted canvas. So at the end of the book we are left asking the kind of question about the two antique artifacts similar to that asked about related items many years ago by John Demos in his marvelous book *A Little Commonwealth*—"What ultimately *are* we to make of these things?"[2]

It is encouraging to note that the essays of the symposium and the catalogue of the exhibition, *American Colonial Portraits: 1700–1776*, offer some important clues, signposts, and directions for getting at what these things—these images, these icons—did mean to the people who made them and acquired them; what they do say about the interaction between patron and tradesman and those around them; and conversely, how the interactions between patron and tradesman inform the objects themselves.

Conventional, contemporary documentation is generally unhelpful. Two examples for an otherwise well-documented context prove the point. In November 1768, full-length state por-

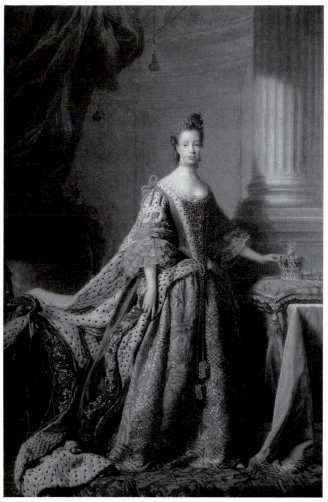

Fig. 24. Allan Ramsay, *Queen Charlotte,* c. 1761, oil on canvas, 94¾ × 59¾ in. Colonial Williamsburg Foundation.

traits of King George III and Queen Charlotte by Allan Ramsay (fig. 24) arrived in Williamsburg and were hung in the ballroom of the Governor's Palace. Within two years virtually every Virginia burgess had dined or been entertained in that room, where the portraits were beautifully lighted by almost forty candles. Every faculty member and student of the College of William and Mary and virtually every gentleman and lady within a considerable radius of the city had also been entertained in the room. Two neighboring governors and their wives had stayed in the building. That includes almost everyone in the vicinity who might have had an intelligent comment on the portraits. Beautifully painted and brilliantly colored, the portraits were sumptuous icons indeed for the edge of the wilderness. Hardly any of those visitors to the palace could have ever seen such sensuous use of paint to create human images. But from all those hun-

dreds of viewers there has not, as far as I know, survived a single word of comment on them.

Virginians generally, for reasons that are inscrutable to me, did not seem to have been too much interested in the sensuous joys of oil paint, anyway. Another portrait that arrived in Virginia from England at almost exactly the same time is anything but juicy and joyous. It is, however, full of symbolism, pregnant with program and grave, cerebral content. Painted in London by the young Charles Willson Peale, the portrait of William Pitt was sent to a group of gentlemen in Westmoreland County in the northern neck of Virginia, foremost among them Richard Henry Lee, who was not an inarticulate or mindless man. It is a most unusual picture in the Virginia context. Once again, not a word of comment, except for a brief announcement in the local newspapers, in which the only critical words were "His countenance is animated with a glow of fire and expression, and he seems to wait for a reply to what he had just said. The likeness is said to be very striking, but quite unlike the prints we have hitherto had of his Lordship."[3]

It is not that Virginians were completely uninterested in portraits or painters. Washington used his influence to extend Peale's circle of patronage by promoting him among his friends and acquaintances in northern Virginia, as well as commissioning portraits himself. At the same time the young Jefferson was drawing up a most sophisticated and ambitious list of paintings and sculpture for his new saloon at Monticello. The *Virginia Gazettes* of the period contain a series of comments on the progress and prowess of Benjamin West in London, while Matthew Pratt thought the Virginia market auspicious enough to have an exhibition of his works in Williamsburg in 1773. It was not that Virginians were uninterested in the subject. But what did they actually think of these matters and how did they communicate these thoughts, if they did at all, to the painters they met?[4]

Consumerism as deftly and clearly detailed by Timothy Breen gives us some insightful answers, and I believe his conclusions are important to future studies of American colonial portraiture. What he says is certainly true for Virginians. Consumers they undoubtedly were, with a vengeance. The story Breen tells in his book *Tobacco Culture* of their spending in the decade before the Revolution shows a pattern that is almost reckless. And a number of competent painters

came along to provide (more or less) fashionable consumer products for them. Take John Wollaston, for example, a pedestrian practitioner of the art if ever there was one. But he obviously filled a consumer need and was certainly kept busy, to judge by the number of his surviving portraits. As an aspect of consumerism, his prettily colored, smooth pictures must have given the majority of his patrons "an agreeable satisfaction," to paraphrase Lawrence Kilburn's advertisement. Despite the fact that in Virginia, at any rate, Wollaston's portraits have an almost mesmeric repetitiveness to them (but perhaps it was that very sameness that was reassuring to most of his patrons), they certainly seem to have fulfilled a need for those who wanted a likeness of a loved one or of a prominent or absent family member, a souvenir or memorial "to keep up those sentiments that frequently languish by absence," as Jonathan Richardson charmingly put it.

Though Wollaston's imagination seems to have suffered from severe undernourishment, he does appear to have responded to his Virginia patrons in a somewhat different way from those of other regions. It is possible to distinguish between his Virginia portraits and those painted further north or further south. One or two of these latter portraits have some individuality, showing that he was sensitive to the nature of local consumer demand. And, as Ellen Miles points out in *American Colonial Portraits*, by William Dunlap's time the tradition in Virginia was that Wollaston had been "very good."

Was the way Wollaston saw Virginians, and the way we see his portraits today, really how colonial Virginians wanted to be seen? Perhaps it was, and perhaps, in applying modern standards of connoisseurship to Wollaston, we are applying the wrong standards. Perhaps he did capture the essence of a people who "look[ed] more at a man's outside than his inside," in the words of Peter Collinson, the great English facilitator of the dynamic trade and correspondence between American and European naturalists. Perhaps, in at least their opinion, his formulaic serious of facilely adjusted, bland likenesses suited them precisely.

There is further dimension to all this, however, as Jessie Poesch points out. Wollaston was also deemed worthy of a poem—and a serious one. In writing about him Francis Hopkinson used phrases like "liquid life" to describe the paint flowing onto the canvas. The climax of the poem is this couplet:

> The sparkling eyes give meaning to the whole,
> And seem to speak the dictates of a soul.

Now the very last quality that most students of this subject today would associate with Wollaston's portraits is a spiritual experience. Was Hopkinson just indulging in poetic conceit or convention? Was he really looking at the portraits? Did he and others really consider Wollaston's art so intense, so refined, so sensitive, that it could reach into that enigmatic realm called the spiritual? What did Hopkinson have to compare it with? After all, colonial society was not so sophisticated visually, not that well endowed or familiar with a wide range and variety of human images. Yet if Dunlap was reporting accurately and if Hopkinson was not just fantasizing, it is obvious that the colonists saw, even in what we now consider mundane talents like Wollaston's, not only a satisfying opportunity to practice their consumerism but also an appropriate vehicle or stimulant for their higher emotions.

I was intrigued by the numerous poems about pictures that Jessie Poesch cited. It suggested to me that perhaps the writings of Hopkinson and others should not be discounted as just wistful musing. After all, what more sensitive vehicle than poetry is there to convey the meanings and emotions of so sensitive a medium as painting? In the past, however, I must admit that my problem has been to get beyond the stultifying quality of so many of the poems and not dismiss them as mere poetastery. Yet once again, like Wollaston's art, I suspect that I have misread or misjudged and have applied wrong standards.

Take the remarkable portrait of Nancy Hallam by Charles Willson Peale, for example—the first portrait of the American stage, extraordinary for American colonial painting in its content as well as its format (Colonial Williamsburg Foundation, see *American Colonial Portraits*, 287–88). With the delayed Shakespeare bicentennial being featured in American newspapers at the time it was painted, it positively reverberates with cultural allusions. A poem was written about the actress's interpretation of her role as Imogen in *Cymbeline*, and another about Peale's representation of her interpretation. I never thought it a particularly good poem. It was addressed to Peale:

Shakespeare's immortal scenes our wonder
raise
And next to him thou claim'st our highest
praise

.

Thy pencil has so well the scene conveyed
Thought seems but an unnecessary aid.

Yet it its frank invocation of emotion—"Tears fill each eye and passion heaves each breast"—and in its forthright claim that "Nature and art are here at once combined," it is probably saying more than I understand, the same way that William Byrd's ostensibly superficial daily confessional was, until someone like Lockridge came along to interpret it.

Jessie Poesch cited two lines from a poem that just took my breath away. The poem was addressed to Peale's portrait of his wife:

Give me, depictur'd Warm from Life
Each soft Emotion of the mind . . .

Is this really what patrons were asking for in a portrait? Is this really what these painters were trying to achieve?

For me these lines open up realms of perception and feeling that surely most recent art history has just slid by. How different these poetic words are from our own prosaic parlance! For the person who wrote the poem, the lines represented a very important element of the portrait. I strongly suspect that was true for Peale too, and John Singleton Copley, in other contexts. After all, Copley had reacted to Peale's mezzotint of Pitt thus—"the most exalted character human nature can be dignified with." Surely sentiments like "each soft emotion of the mind" hovered in Copley's mind as he sought repeatedly to capture the essence of a person in pigments on cloth. We know how intense and tremendously ambitious for their art were Charles Peale and John Copley. But then, what about John Hesselius or John Watson or John Mare or John Durand, who, in the opinion of most of us today, did not achieve the same level of quality as Copley and Peale? Did they consciously try to picture each soft emotion of the mind? And if they did, how do we judge how well they succeeded?

I do not know. But I am sure that the realms of perception and feeling that those lines of poetry invoke are not an isolated occurrence, are not of serious concern only to ambitious, determined

painters like Copley and Peale and West. I think we have much to learn.

Finally, I want to return to William Byrd and the passage from his correspondence that Richard Saunders quotes in his essay. About thirty years after they had known each other as young men, Byrd received a portrait he had requested from John Percival, now Earl of Egmont.

I had the honour of your Lordships commands of the 9th of September, and since that have the pleasure of conversing a great deal with your picture. It is incomparably well done & the painter has not only hit your ayr, but some of the vertues too which usd to soften and enliven your features. So that every connoisseur that sees it, can see t'was drawn for a generous, benevolent, & worthy person. It is no wonder perhaps that I coud discern so many good things in the portrait, when I knew them so well in the original. . . . But I own I was pleasd to find some strangers able to read your Lordships character on the canvas, as plain as if they had been physiognomists by profession.[5]

Though I have not seen this portrait, which I understand has survived in somewhat damaged

Fig. 25. Hans Hysing, *John Percival, First Earl of Egmont,* **1733, oil on canvas, 49 × 39 in. Courtesy of Oglethorpe University, Atlanta, Ga.**

condition, if it is like the other portraits I have
seen from Byrd's gallery of approximately three
dozen likenesses, it represents the kind of por-
trait that we would categorize today as "con-
sumer products" of a mild baroque kind, and not
much more. A larger contemporary version of
the portrait of Percival, in good condition, is
owned by Oglethorpe University (fig. 25).[6] But
what extraordinary qualities Byrd found in it!
Are we to take him and his somewhat Richardso-
nian sentiments literally? Are we to take literally
the lines addressed to Peale's wife's portrait?
These are questions that I think are worth ex-
ploring, that these two papers have helped me to
formulate in my mind. I believe we should add
them to the interesting and sometimes novel
questions that recent scholars have been asking
of the same images, the images that are here, as
John Durand said, "to give us their silent
lessons."

Notes

1. *The Diary and Life of William Byrd II of Virginia, 1674–*
1744 (Chapel Hill: University of North Carolina Press:
1987). The book reproduces two portraits of William Byrd,
at Colonial Williamsburg and the Virginia Historical Society,
Richmond.

2. John Demos, *A Little Commonwealth: Family Life in*
Plymouth Colony (New York: Oxford University Press, 1970).

3. Two versions of this account exist, in the *Virginia Ga-*
zette (published by Alexander Purdie and John Dixon), 20
April 1769, and the *Virginia Gazette* (published by William
Rind), 21 April 1769. See also Richard Saunders and Ellen
G. Miles, *American Colonial Portraits, 1700–1776* (Wash-
ington, D.C.: National Portrait Gallery, 1987), 289–96.

4. Seymour Howard, "Thomas Jefferson's Art Gallery for
Monticello," *Art Bulletin* 59 (1977): 583–600.

5. William Byrd II to the Earl of Egmont, 12 July 1736,
quoted by Richard Saunders in "The Portrait in America,
1700–1750," in *American Colonial Portraits,* 17; and by Mark
R. Wenger in his introduction to *The English Travels of Sir*
John Percival and William Byrd II: The Percival Diary of 1701, ed.
Mark R. Wenger (Columbia: University of Missouri Press,
1989), 39. The version of the portrait that was in Byrd's
collection is reproduced in ibid., 40. On page 43 Wenger
explains his preference for the spelling of Percival's name
with an *i* instead of the traditional spelling, "Perceval."

6. On Byrd's collection of portraits, see David Meschutt,
"William Byrd and His Portrait Collection," *Journal of Early*
Southern Decorative Arts 14 (May 1988): 18–46. I thank David
Meschutt for his assistance in locating the version of Per-
cival's portrait reproduced with this essay.

Part 3
The Colonial
Sitters and Their
Self-Image

Rarer than Riches:
Gentility in
Eighteenth-Century
America

STEPHANIE GRAUMAN WOLF

To an English wag in the seventeenth century, the gentility were those who had "long since confuted Job's aphorism [that] Man is born to labour." Some two hundred years later, echoing across centuries of change, came the ironic retort that "there is nothing so vulgar as gentility."[1] Between these two remarks, both sarcastic to be sure, lay a surging sea of political, economic, and social transformations that floated independence in America, an industrial revolution in England, and the emergence of a prominent middle class in both. None was made more seasick by the waves of change than the gentry, that "class of people above the vulgar," as eighteenth-century Englishmen on both sides of the Atlantic defined it.[2] Never a legal position in England, as it was in some parts of the Continent, membership in the gentry was something like the sociological definition of a Jew: "a person who considers himself one, and/or is considered one by the community."

Actually, while either half of the definition by itself is sufficient to establish Jewishness, it required both halves to be an eighteenth-century gentleman.[3] The final judgment was, therefore, not absolute: no single criterion engendered recognition in all places, nor was rejection in one place or at one time necessarily a final sentence. The Winthrops and the Pynchons of Massachusetts Bay had arrived in the colonies during the seventeenth century from backgrounds that assured them of comfortable, if minor, status as landed gentry at home. While they strived to enlarge their economic opportunities in the New World by engaging in the fur trade or other mercantile pursuits and were required to have their political dominance ratified through annual election, "they saw themselves as natural rulers—as persons prepared by God, training, and status to act in the colonists' best interests. [They] received advice from the people with ill-grace viewing any attempt to limit their discretionary powers as a personal insult," as T. H. Breen has written.[4] Yet when Edward Randolph, a well-connected but impecunious English gentleman, arrived in Boston to do the king's business in 1676, he found the leaders of the colony to be nothing but "inconsiderable Mechanicks."[5] By the start of the eighteenth century Virginia had a self-defined, native-born gentry whose powerful

families—Carters, Byrds, Beverleys and Worm-eleys—owned vast lands; controlled the politi-cal, military, and religious institutions of their colonies; and dominated the lives of thousands of souls, blacks whom they owned and less afflu-ent white settlers who depended on them. Their claims to gentility were still based almost com-pletely on their wealth, which could melt away with a single turn of the wheel of fortune. With-out great riches, their social position would evaporate as well since they were really no better than the "ordinary sort of planters [who under-stood perfectly] from whence these mighty dons derive their originals," explained English gentle-man and Governor Francis Nicholson, with a literary curl of his lip.[6]

If we consider wealth as the *sine qua non* of gentility, the number of colonials eligible for such distinction by the time of the Revolution was not large, but the gap between this group and all other colonial Americans was not only visible, it was both broad and deep. The unequal distribution of wealth was a stark, if un-acknowledged fact.[7] The population (excluding Indians) had grown to just under 2.5 million from approximately 125,000 at the beginning of the century. Of these, only about 435,000 were empowered to hold wealth, the rest of the number being composed of slaves, indentured servants, women, and minors. Over half of the nation's goods was in the hands of 10 percent of the population. Even more forcefully, the top 2 percent controlled about one-quarter of the wealth, and the top 1 percent about 15 percent: in real numbers this boils down to a mere 4,300 who might fit the definition of gentry, and some-thing under ten thousand households that might harbor "expectations." Beneath these, were an-other 34,000 wealthholders whom Bridenbaugh had in mind when he distinguished between "the rich and the very rich."[8] Together with their dependents who shared their lifestyle (if not control of their assets), they made up the finan-cial and social elite of late colonial America. While contemporaries had no exact knowledge of the gradations of wealth, their frequent refer-ences to certain individuals—William Allen of Pennsylvania, Peter Manigault of South Car-olina, or John Hancock of Massachusetts, for example—as "the richest man in the colonies" probably denotes a *de facto* recognition of that top 1 or 2 percent; the discernable American gentry.

The pattern of wealth varied to some extent from region to region. The greatest amount by actual total value occurred in the South; so too did the greatest gaps between rich and poor. Both of these facts are rooted in the widespread adoption of slavery by the beginning of the eigh-teenth century, so that blacks were considered both people and property at the same time. New England, although far poorer in assets than the South, also exhibited a high degree of unequal distribution, owing, in this case to the existence of many more incipient urban areas, where the gap between rich and poor was one of the defin-ing characteristics. In the middle colonies, the total amount of wealth was less than that of the South, more closely approximating New En-gland, but it was somewhat less unequal (more equal would be inaccurate) in its spread. It is interesting to note the way in which modern statistics may confirm contemporary impres-sions: Pennsylvania was, in fact as well as ro-mantic vision, the "best poor man's country." In all areas of the colonies, the very richest were gentlemen, esquires, or officials, but in the South *gentleman* implied *plantation owner* while in the two northern regions, it more often stood for *merchant*. In New England alone did the mer-chants exceed all other categories in average wealth.

English disdain for a New World gentry rested on the fact that although the rules for mem-bership in their own gentry were unwritten—as, for that matter, was the British constitution—they were well understood to include qualifica-tions to which colonials had no access: old family and old wealth in the form of a landed estate associated with that family. The only formal dis-tinction conferred by these twin possessions was the right to bear arms and to display the coat of arms that went with the privilege. This right, however, was guarded by the College of Heralds and, as one historian has put it, "was not an empty concept," since it identified the gentry with the upper echelons of nobility and even of royalty and separated them from the middle class, however wealthy and respectable of lin-eage.[9]

The only traditionally acceptable occupation for an English gentleman lay in the management of his estates; the actual dirty work of creating cash from agriculture and land rental was done by his steward or local attorney, while the task of producing income from capital rested on his London men-of-affairs. By the eighteenth cen-

tury, however, he could, without loss of status, enter one of the professions that, in Dorothy Marshall's words, "constituted a kind of hyphen between the gentry and those men whose money had been made in industry and trade."[10] The younger son of a gentry family, following a university education, might be absorbed into the growing royal bureaucracy, be accepted into the Inns of Court, elected a fellow in the Royal College of Physicians, given preference in the church, or granted an officer's commission in the army or navy. Participation in the highest ranks of these professions allowed him to make a considerable fortune while maintaining the pose of acting in the service of others, the traditional gentry view of their roles of political and economic dominance in their own counties. He could not, however, become a country attorney, an apothecary, a curate, a common soldier or sailor, or a serious scholar (dilettantism was acceptable) and retain his place in society.

Most particularly, English gentlemen could not engage in trade, even at the highest levels of international commerce where the merchant princes dwelt. This was hardship indeed, since whatever the trappings of gentility, its real power lay in the wealth that underpinned its position as part of the upper classes and its control of local political, institutional, and social life. The vaunted willingness of the English gentry to accept members of the merchant community—which they regarded as a class rather than an occupational grouping—into their own charmed circle was a practical response to the obvious fact that it was in the growing fields of mercantile and manufacturing pursuits that future fortunes lay. Nor did they make it as easy as Daniel Defoe suggested when he described "the rich Tradesman [who] laid the Tradesman down and commenc'd Gentleman."[11] As Dorothy Marshall noted, ". . . however much they might mingle, might look alike, might talk alike, might dress alike, particularly when the second generation inherited an estate that had been acquired through the profits of successful trade . . . the *true* landowner and the merchant possessing estates could at times diverge sharply, though . . . the possession of land camouflaged the gulf between them to the eye of the casual observer."[12] In 1772 the European traveler P. J. Grosley was typical of those whose vision was blurred by the obvious connections of the English gentry to the worlds of business and professionalism. "The

Gentry do not consider themselves as beings that have nothing in common with the good men," he wrote. "They look upon the wealth that has raised them to that distinction, as the only means of supporting it. . . . They continue to act as merchants, husbandmen, insurers, lawyers, physicians, etc., and in bringing up their children to these professions."[13]

The English themselves knew better, as Jane Austen, always the court of last resort for sorting out the subtleties of the English social system, made clear in *Pride and Prejudice,* written in the last decade of the eighteenth century. When Miss Bingley teased Mr. Darcy on the preposterous notion that he might marry Elizabeth Bennett, whose mother's family was not of the gentry, she alluded to the fact that Elizabeth's uncle was merely a small-town attorney. "Do let the portraits of [her] uncle and aunt Philips be placed in the gallery at Pemberley. Put them next to your great uncle, the Judge. They are in the same profession, you know; only in different lines." Even more pointedly, although her aunt and uncle Gardiner were in all respects so genteel that "the Netherfield ladies would have had difficulty believing that a man who lived by trade, and within view of his own warehouses, could have been so well bred and agreeable," Elizabeth was saved from regretting her refusal of Mr. Darcy's proposal by recollecting that she could never have welcomed the Gardiners to her home. "That could never be," she thought. "My aunt and uncle would have been lost to me; I should not have been allowed to invite them."[14]

Given the emphasis in England on birth, family-descended estates, and occupations that bore no taint of trade, it is not surprising that colonial gentility came to be defined in quite different terms. Birth mattered, but by necessity it was in terms of present and future-oriented family connections rather than those of historical lineage. Important families from New England to South Carolina were united and reunited, but the concerns were economic rather than specifically dynastic in the English fashion. Few, perhaps, stated the reasons as baldly as William Shippen III of Philadelphia when he jotted down his justification for refusing to allow his daughter, Ann, to marry her choice, Louis Otto, and forcing her into a loveless and disastrous union with Colonel Henry Beekman Livingston. "[Ann] loves ye first & only esteems the last. L—— will consumate immediately. O—— not these 2 years. L——

has 12 or 15,000 hard. O—— has nothing now, but honorable expectations hereafter. A Bird in hand is worth 2 in a bush."[15]

Nor is it easy to imagine London newspapers carrying an announcement similar to a typical report in the *Virginia Gazette* in 1738: ". . . on *Thursday,* the 13th Instant, the Rev. Mr. *William Stith* was married to Miss *Judith Randolph* . . . an agreeable Lady, with a very considerable Fortune."[16] Historians have noted that American gentry were more and more inclined to allow their children to make their choices of partners based on love as the eighteenth century wore on, but the social habits of the top families, their continual rounds of parties in each other's homes, and their segregation at exclusive clubs, dancing assemblies, and vacation spots, more or less guaranteed that they would be exposed to appropriate mates.[17] Despite the crass form of the Stith/Randolph wedding announcement, the Reverend Mr. Stith was a suitable husband for Miss Randolph: he was a poor but genteel "connection" of the Randolphs through his mother, who worked as a housekeeper at William and Mary. He eventually became the president of the college.[18]

Permanent association of a family with a special piece of land and a particular neighborhood undoubtedly grew in the colonies, especially in the Chesapeake and in New York, as mansions were built by second- and third-generation heirs, and political and economic hegemony by powerful families was passed from one generation to another. Still, the number and productivity of the acres counted far more than traditional obligations and privileges, since it was wealth and power rather than custom that dictated deference. The laws of primogeniture and entail, while they existed in the colonies, were never rigorously followed and usually related to intestate settlements. They were abolished almost casually within a decade after the adoption of the Constitution. Even in the South, where family pride was just beginning to carry the feudal overtones that marked the nineteenth century, it was far more important to set a son up on land, where he could amass a great fortune, than it was to keep him on the home plantation. Given the nature of tobacco agriculture, this often meant moving him to western soils not yet exhausted by overplanting of the staple.

Finally, it is this underlying assumption that social power ultimately rested on wealth that created a gentry in the colonies whose adherence to the legal definition of a gentleman as "a socially respectable person who has no specific occupation or profession" was unrealistic.[19] Even in England, as we have already seen, by the eighteenth century the rule no longer applied to those engaged in the upper ranks of the professions. But it might be said of those members of the English gentry who actually made money as judges or lawyers or government officials that they were like the Boston ladies of a later century who "didn't buy their hats, they had them." That is, a background of leisured status underlay the current need to work. Historical necessity dictated that this state of affairs was reversed in the colonies. Wealth had to be earned before status could be assured, and the quickest and surest way to economic independence was through trade. This was true not only of northern merchants, but also of southern plantation owners, who were tied to the manufacture and trade of a mass-produced product, whether tobacco, rice, or indigo.[20] Therefore, the occupation of trade in eighteenth-century America, as Bernard Bailyn says, "though it defined an area of common interests for the men engaged in it, did not delimit a stratum of society as it did in England. It was not so much a way of life as a way of making money; not a social condition but an economic activity."[21] It was, in fact, these common interests that turned economic activities into social relationships, so that the grandees of New England were almost universally merchants or professional members of merchant families. It was commonality of economic interest that impelled southerners to include among the participants in their socially restricted horseraces "[leisured] gentlemen, merchants, and creditable Planters" for the purpose of "cultivating Friendship."[22] Richard Henry Lee saw no threat to social status in switching the career plans of his son, Thomas, who had been sent abroad to study for the church—one of the "acceptable" occupations—to learning "commerce, as well the theory as the practical part [since]," he wrote, "There is no doubt but on your return to your Country, you will be so trusted to conduct the business of foreign Merchants, as to be very useful to them, & profitable to yourself."[23] The professions themselves developed differently on the western side of the Atlantic, and while the gentry might send their sons to study law at the Inns of Court or medi-

cine at the University of Edinburgh, when they returned they entered a world where lawyers were lawyers, doctors were doctors, ministers were ministers, and government officials were politicians. The ranks were separated by connections and by success, not by job description.

The Revolution even changed the face of the military. Although the officers of the local militia in the earlier part of the eighteenth century had certainly come from the families of the gentry, the lack of a professional military at the time of the war and the fact that many of the gentry were Tories drew many yeomen and "mechanicks" into ranks reserved in England only for those entitled by the 1689 Act of Settlement "to bear arms . . . suitable to their Conditions and as allowed by Law."[24] The arms in question were swords, and they were powerful symbols of authority in England. Their symbolism was not lost on colonial gentlemen in the eighteenth century who owned, wore, and had their portraits painted with richly ornamented swords, but since the right to these weapons in the colonies was not granted by the College of Heralds but by self-definition, they were owned by many others as well. At least 25 percent of those who died and left inventories in Lancaster County, Virginia, before 1740, listed swords among their possessions, although those listed by poorer yeomen or tenants were clearly functional rather than decorative.[25] The second amendment to the Constitution protecting the right of the "people" to keep and bear arms, descending as it does from the Virginia Bill of Rights, which was written and passed by a legislature filled with powerful gentlemen who would never have been approved for the honor by the College of Heralds, may have had as much to do with swords as it did with muskets.

There were limits, of course, to what was acceptable work for the colonial gentry. The limits were set in two ways: one measured quantity, the other quality. A shopkeeper, peddler, or huckster was really a merchant writ small, but it was the smallness and local nature of his business that precluded him from consideration as a gentleman. Poor country preachers, lawyers, or doctors, unconnected by birth or money to the great merchant or planter families, were not members of the elite despite the potential gentility of their occupations. On the other hand, it was the nature of the work of artisans and craftsmen, those who actually worked on the transfor-

mation of materials with their hands, that caused them, with few exceptions, to be excluded.[26] A Virginia tailor, for example, was fined for entering his horse in a race and wagering two thousand pounds of tobacco on the outcome, although he was clearly of economic means, "it being contrary to Law for a Labourer to make a race, being a sport of Gentlemen." There are even a few rare examples that such occupational distinctions could be heritable, as in 1759 in Boston, when a man is said to have been disqualified from sitting as a justice of the peace because his grandfather had been a bricklayer.[27]

If three generations did not suffice to turn the grandson of a bricklayer into a gentleman by midcentury Boston standards, it was long enough to turn some of the descendants of southern indentured servants, Pennsylvania button makers, and New England fishermen into reasonable facsimiles thereof. If they could not acquire lineage stretching back into the mists of time, they could wheel, deal, and marry their way into the close-knit networks of other self-made families whose wealth and ambition won them gentry status in the fluidity of the colonial context. If they could not inherit broad lands and elegant mansions they could buy and build them. And with equal parts of hard work and hard cash, they could acquire those traits of gentility—"elegance of behavior; gracefulness of mien; [and] nicety of taste"—that Dr. Johnson's *Dictionary* defined as distinguishing the gentry.

Gentility, as a life-style involving the possessions and behavior appropriate to high social station, was to the English gentry what the signs of grace were to Puritans and other believers in predestination. It did not turn them into gentlemen; rather it reified their membership in that exclusive group. Like being of the elect, it was possible to be an English gentleman without any of the outward signs. As Dorothy Marshall has pointed out, "There was little, if anything, that a gentleman could not do. He could make money or be idle, spend his days in strenuous activity or laze them away, observe the conventions of his class or flout them, and still be accepted in the society of his equals."[28] Literary examples of such "ungenteel" gentlemen might include Congreve's Sir Wilful, Fielding's Squire Western, or Goldsmith's characterization of Tony Lumpkin. On the other hand, those who pretended to the signs of gentility and manipulated them without possessing the "right" to do so, met with scorn

and derision. Clothes—not only the richness of their fabric but also the cut and style of the garment—had long been the quickest, most immediate index to social station. So-called sumptuary laws restricting the use of upper-class clothing to upper-class individuals were apt to be dusted off and reemphasized whenever the social order was in a state of transition, from as early as the reigns of Edward II and III. It is not surprising that in the extremely fluid social conditions of seventeenth-century New England, the General Court should express its "utter detestation and dislike that men and women of meane Condition should take upon themselves the Garb of Gentlemen by wearing gold or silver, lace or buttons, or points at their knees or to walk in bootes or women of the same rancke to weare silke or tiffany horlles or scarfes, which though allowable to persons of greater estates, or more liberal education, yet we cannot but judge it intollerable in persons of like condition."[29]

Nor is it surprising that any kind of law that restricted those who could afford to display the "stigmata" of wealth and breeding was bound to rapid oblivion in colonial America. Upwardly mobile, newly wealthy colonials lacking by necessity the reality of dynastic entitlement found that a life of gentility and the proper use of the symbols of rank became the means rather than merely the sign of election. For them, as for the wealthy merchant class in England, adherence to fashionable standards of culture and taste was not merely proof of social superiority, but actually helped to create it. American counterparts of Squire Western who "were capable of a hard day's hunting followed by a night of heavy drinking [and who were] ignorant enough and content only to adorn their walls with indifferent portraits of themselves, their wives and families" could never hope to achieve social standing, however broad their lands or fat their pocketbooks.[30] It was "the distinctive style of life characteristic of the genteel throughout the colonies [that] set off the 'polite part of the world' from the 'meaner sort,'" one American historian has noted.[31]

While distinctive in the New World setting, perhaps, the style adopted by colonial gentry was part of the cosmpolitan and largely urban way of life that marked the European elite in general. It was clearly intended to identify these provincial Johnny-come-latelies with the real power and prestige that emanated from the home country. There is anxious concern for status in the way that a Virginia gentleman in the 1720s informed his overseas contact that Williamsburg gentlemen "live in the same neat manner, dress after the same modes, and behave exactly as the gentry do in London."[32] Not satisfied with the common flow of imported goods, however much they improved in quality and style throughout the century, and aware that the English gentry was used to having its possessions "made to order," colonial gentlemen entrusted their English contacts with orders for everything from wine to chairs, from fabric for clothing and household use, to coaches and livery for the servants who attended them. Insecurity about their own ability to understand the nuances of style and taste showed clearly in a willingness to leave the final choice up to their correspondents. While an occasional gentleman specified the color of the upholstery of his coach or the carving design for his dining chairs, most contented themselves with stipulating that the items be "of the best sort"—code for "spare no expense"—and in the "latest fashion"—that is, what was currently the rage in London.

The emphasis on owning the "right" sort of luxuries and using them "properly" indicated a lively understanding by the colonial gentry of the part that goods played in defining their position in the world. A "consumer revolution" marked by a huge proliferation of domestic goods and their use as communicators of status was already well underway in England by the time much of colonial America came to be settled.[33] It was not until the beginning of the eighteenth century, however, that capital and population reached a critical mass in the New World, allowing the American gentry to play the consumer game on more than an individual and occasional basis. By that time Boston merchants and southern gentleman planters (as distinguished from common planters who worked with their own hands) had already developed intricate networks of kinship and personal communication at home and abroad that made participation in the international world of goods easy.[34] Although Philadelphia was not founded until the end of the seventeenth century, the lives of its gentry quickly became among the most "cultivated" of any of the colonists. By the 1730s at the latest, the material possessions of the gentry and the lifestyles they engendered had become different not only in degree but in

kind from those around them.[35]

Most conspicuously, the town houses of the gentry resembled newly rising public buildings in material and architectural feature more than they did the homes of the rest of society.[36] On their visible façades, they exhibited the regularity of the Georgian style—intellectually and ideologically related to concepts of order and balance. A second home in the country was of prime importance in establishing the right to genteel status, and these country houses, too, were markedly different from those of their rich but provincial neighbors. They varied in their location on their sites for grandeur rather than convenience; in the use of brick and stone, rather than wood as a building material; and in the appearance of country translations of town house elegance. In the South, of course, the order was usually reversed, and it was the country house that was used as a primary residence, where company was most frequently entertained, and therefore where the best furniture and richest objects were assembled and displayed.

The organization of the interiors of gentry houses, city and country, also widened the gap between "the best and the rest." Increasing social distance from servants—whether black slaves in the South, German and Irish indentured servants in the middle colonies, or native sons and daughters of the "lower sort" in New England—was objectified in the removal of their tasks and persons from the family space. In the homes of the gentry, hearths in the rooms where the family gathered were elegantly dressed in marble or tile surrounds and carved mantles, and were used only for heat and light: cooking, and those who did it, were relegated to a separate kitchen, which, in the South, was actually detatched from the main body of any house not to be thought of as "meane" or "little." The use of a center hall and regular doorways into the rooms on either side not only satisfied the style concept of balance, but enhanced the development of privacy. Mrs. Benjamin Harrison underscored the reality of the meaning behind the symbol in the early eighteenth century when she "feigned to faint" at the appearance of an ordinary farmer in the parlor.[37]

Playing the consumer game as a means of social election involved the colonial gentry in a continual spiral of "keeping ahead of the Joneses." As the accumulation of consumer goods rose among all colonials during the eighteenth century and particularly among those who lived in urban areas, mere ownership of some special piece of household furnishing or accessory was no longer enough to distinguish the elite from their common neighbors. In the seventeenth century, when most Americans sat on stools and benches or squatted and leaned, possession of a chair or two was enough to set the gentry apart. By 1700, however, a few chairs began to appear regularly in ordinary houses, along with an occasional case piece or looking glass. At this stage it was possible to maintain consumer superiority through a multiplication process; genteel could be defined as several "setts" of chairs, a number of case pieces, and more than one looking glass. After midcentury these items, once considered luxuries, had become so common not only among the middling sort but even in the cramped rooms of the barely sufficient that gentility scarcely resided in these utilitarian forms at all, unless they were elaborated in quality as well as quantity—intricately carved, of the finest wood, and made-to-order by the most highly regarded London or urban colonial craftsman.[38] Possession of tea equipage and an understanding of the proper code for its use was no guarantee of gentility. The service itself had to be silver, the cups in matched sets of fine porcelain, perhaps with a personal design such as the family crest indicating its custom-made exclusivity. Newly invented or recently "discovered" family crests and shields were, in fact, the most impressive way to increase the qualitative status of an item, since they not only promised uniqueness, but quite blatantly hinted at association with English nobility and gentry. By the time of the Revolution they appeared on a wide constellation of high-end consumer goods from silver tankards and fine ceramic teapots through carriages and servants' livery to the decorative relief over doors and on ceilings.[39]

There were only a few objects whose forms alone continued to announce their importance; second homes, carriages, and portraits, particularly if done by a fashionable painter who had studied abroad. Even desks, once the sure sign of wealth and power, had become available on a wide scale and required special decoration to serve as status symbols. It goes without saying that the necessities of life—food and clothing—were endlessly elaborated, embellished, and enriched. Food was not only the object of highly

formalized ritual, presented and consumed with the use of highly specialized artifacts, it was also wasted; quantities beyond the capacity of the most ravenous appetites regularly adorned the banquet tables of the gentry. Drink, of course, followed the same pattern. People stocked cellars with imported wines and brandies, purchased matched sets of wine glasses to drink them from, mastered an elaborate code of toasts and mannerisms that showed up the uninitiated, and, above all, developed an ability to consume.[40] It was admiringly noted that the well-known Boston patrician, Elisha Cooke, Jr., was "genial; generous to needy people of all classes, and a drinking man without equal."[41]

The social statement made by fashionable clothing had become less important by the eighteenth century since it was available to a much larger range of people than most other artifacts, extending to the lowest classes in urban areas like London and Boston, where second-hand dealers flourished.[42] Sumptuary laws had long since been found ineffective as barriers against the blurring of the ranks of society, and the only real security against "leveling" was to make sure that one's clothes were in the most immediate style of the international elite, setting those with city connections apart from their country cousins, as well as from those beneath them on the social scale. In a sense clothes provided a negative reference: to be dressed properly might not signify gentility, but to be dressed improperly surely indicated lack of status. Certainly no gentleman wore the cobbler's blackened leather apron, the sailor's knitted cap and tarred trousers, or the butcher's blue apron and protective sleeves with knives and sharpener secured at the waist. Nor would a gentleman appear in anything old or worn, as a London friend warned the botanist John Bartram, when he advised him to purchase a new suit before traveling to Virginia from his home in Pennsylvania: "For though I should not esteem thee less, to come to me in what dress thou will,—yet these Virginians are a very gentle, well-dressed people— and look, perhaps, more at a man's outside than his inside."[43] On the other hand, certain articles of clothing traditional with the gentry became an easy focal point for the republican spirit engendered by the Revolution. Fancy uniforms, for example, came under attack in a letter to the associators [militia] of the City of Philadelphia in the spring of 1775, when the author suggested

the adoption of the hunting shirt as the uniform, not only because it would be "within the compass of almost every person's ability, not costing at the utmost above ten shillings," but more significantly, since it "will level all distinctions."[44] Wigs, along with swords, were the most symbolically loaded of all personal adornments, but their meanings involved a great deal more than simple indications of gentility. At the beginning of the century, refusal to wear a wig on the part of a gentleman made a moral statement, by the time of the Revolution, such a decision was part of republican rhetoric as well. Wearing a wig properly implied not only money and fashion, but enough training in the social graces to know how to manage it without appearing ridiculous. A gentleman had to be taught to carry himself erect and to avoid stooping unconsciously under its weight. He also had to learn to move slowly and gracefully, since abrupt or violent motion could dislodge the wig itself, or spray the powder with which it was liberally covered, over himself, his companions, or the furniture around him.[45]

Clearly clothes alone did not make the man. Natural physical endowments, personal habits, manners, and cultural attainments all played their parts. The general Enlightenment aesthetic that located beauty in the golden mean and philosophy in rational restraint and moderation extended these values to social expression as well. Although earlier periods allowed for a portly gentility, descriptions of eighteenth-century gentlemen usually focused on a slimmer ideal: "his countenance beautiful; his limbs genteel and slender," wrote the philosopher David Hume. Jane Austen, as usual, put her finger on the essence of what was wrong with being fat: it was immoderate and therefore ridiculous. "Personal size and mental sorrow have certainly no necessary proportions," she wrote in *Persuasion* of a mother who grieved over a lost son. "A large bulky figure has as good a right to be in deep affliction as the most graceful set of limbs in the world. But fair or not fair, there are unbecoming conjunctions, which reason will patronize in vain,—which taste cannot tolerate,—which ridicule will seize."[46]

The budding interest in the grotesque as part of the romantic ideal of beauty did not extend to the human face, although being "plain" was acceptable if the "expression" was genteel, the "carriage" dignified. Awkwardness in physical

movement, speech, or written expression was an indication that a person did not come from a genteel home where the advantages of dancing master, fencing master, writing master, and first-rate tutor would have corrected the defects. Among colonials, fear that one or another regional accent would doom their sons to mediocre status led them to search for teachers who could "pronounce English articulately, and read with emphasis, accent, quantity, and pauses."[47] Enthusiasm in religion or in scholarship as a form of immoderation was also suspect, although a smattering of knowledge and taste relating to international art, culture, and ideas was absolutely essential. It was enhanced if it was acquired on a Grand Tour of the cultural centers of Europe.

The ideal was best expressed by Elizabeth Powel of Philadelphia in a letter to her nephew at the turn of the century: "Physical strength, and vehement passions are the characteristicks of a Savage—regulated passions, improved intellect, cultivated taste, a love of Science—the fine arts, and indeed all the embellishments of polished Society,—are the Characteristicks of a Gentleman who wishes to be pre-eminently wise, and virtuous."[48] Many among the gentry did not follow this ideal of gentility. There was an opposing view, an "anti-ideal of decadence, indolence, and arrogance. In England it centered around those whose habits were picked up at court, where fashion and high life marked the acme of social power and prestige. American sons, sent to London to learn ideal manners and accomplishments, frequently spent their time, and their father's money, acquiring those of the "anti-ideal." In such a milieu, a "true gentleman" like John Adams could never shine, since he could not "dance, drink, game, flatter, promise, dress, swear with the gentlemen, and talk small talk and flirt with the Ladys," as Jonathan Sewall remarked.[49]

But was John Adams really a gentleman? He had chosen many of the means of election, particularly those stressing the intellectual attainments, but he deliberately spurned many others, those he described as "the exteriour and superficial Accomplishments of Gentlemen, upon which the World has foolishly set so high a Value."[50] Others, too, picked and chose among the traits of gentility. Since they were to be had for money, in England at least, their association with the traditional class of gentry was loosened.

With an increase in religiosity, character as well as style became a mandatory part of the definition of gentility, and it became more difficult to tell the players without a scorecard. In 1836, Burke's *Genealogical and Heraldic History of the Landed Gentry* was published, indicating a need for the first time to distinguish between those who had a right to the dignity and those who could merely afford its attributes. In America Noah Webster's stridently nationalistic dictionary of 1806 dropped "gentility" entirely. When it reappeared, many editions later, it had dwindled to mere "respectability," no longer a synonym for the behavior of the "gentry," but rather a word associated with those who were attempting to scramble upward on the ladder of social superiority.

Notes

1. *The Oxford Universal Dictionary on Historical Principles*, 3d ed., rev. with addenda (Oxford: Oxford University Press, 1955), 786.

2. This definition appeared in Samuel Johnson, *A Dictionary of the English Language* (1768), and Noah Webster, *A Compendious Dictionary of the English Language* (New Haven and Hartford, 1806).

3. This paper is primarily concerned with male aspects of gentility for two reasons. First of all, whatever genteel traits an eighteenth-century woman possessed, her status was determined by her father before she married and her husband thereafter. While she might be regarded as deserving of her membership in the gentry (or not) according to her appearance, behavior, and ability to manipulate genteel symbols, these were never the real determinants of her position. Second, the feminine traits of "quality" are too frequently regarded as the reverse side of masculine behavior and tacked on to the end of a work about men. They are, in fact, so different in many ways that they deserve investigation and presentation lying outside the scope of this paper.

4. *Puritans and Adventurers: Change and Persistence in Early America* (Oxford: Oxford University Press, 1980), 22.

5. Bernard Bailyn, *The New England Merchants in the Seventeenth Century* (New York: Harper & Row, 1964), 154.

6. Breen, *Puritans and Adventurers*, 153.

7. The numbers in this section are derived from Alice Hanson Jones, *Wealth of a Nation to Be: The American Colonies on the Eve of the Revolution* (New York: Columbia University Press, 1980).

8. Carl Bridenbaugh, *Cities in Revolt: Urban Life in America, 1743–1776* (New York and London: Oxford University Press, 1971), 334.

9. Dorothy Marshall, *English People in the Eighteenth Century* (London and New York: Longmans, Green, 1956), 51–52.

10. Ibid., 52.

11. Quoted in the *Oxford Universal Dictionary*, 786. It appears in a satire, "The True-Born Englishman," published by Defoe in 1701.

12. Marshall, *English People*, 48. Emphasis supplied.

13. P. J. Grosley, *A Tour to London*, trans. T. Nugent

(London, 1772) and quoted in Marshall, *English People*, 56.

14. Jane Austen, "Price and Prejudice," *The Complete Novels of Jane Austen* (New York: Modern Library, 1933), 262, 315, 377.

15. Quoted in Randolph Shirpley Klein, *Portrait of an Early American Family: The Shippens of Pennsylvania Across Five Generations* (Philadelphia: University of Pennsylvania Press, 1975), 195.

16. Quoted in Daniel Blake Smith, *Inside the Great House: Planter Family Life in Eighteenth-Century Chesapeake Society* (Ithaca: Cornell University Press, 1980), 141.

17. See, for example, Philip J. Greven, *The Protestant Temperament; Patterns of Child-Rearing, Religious Experience, and the Self in Early America* (New York: New American Library, 1979) and Smith, *Inside the Great House*. For a rare account of the role played by spas, see Carol Bridenbaugh, *Early Americans* (Oxford: Oxford University Press, 1981), chap. 9, "Baths and Watering Places of Colonial America," 213–38.

18. I am indebted to Thad W. Tate for the biographical information on William Stith in a letter to me, 24 July 1989.

19. *Oxford Universal Dictionary*, 786.

20. There is a large literature on planters as merchants and whether or not this made them capitalists, an issue that is beside the point in this context. Of usefulness in describing the economic totality of the staple-crop plantation are John J. McCusker and Russell R. Menard, *The Economy of British America, 1607–1789* (Chapel Hill: University of North Carolina Press, 1985), esp. chaps. 6 and 8; Aubrey C. Land, "Economic Behavior in a Planting Society: The Eighteenth-Century Chesapeake," *Journal of Southern History* 33 (1967): 469–85; Joyce Oldham Appleby, "Commercial Farming and the 'Agrarian Myth' in the Early Republic," *Journal of American History* 68 (1982): 833–49; Paul G. Clemens, "The Agricultural Transformation of the Northern Chesapeake, 1750–1800," Paper presented at the annual meeting of the American Society for Eighteenth-Century Studies, Washington, D.C., April 1981.

21. Bailyn, *New England Merchants*, 194.

22. Breen, *Puritans and Adventurers*, 156.

23. Quoted in Smith, *Inside the Great House*, 96–97.

24. *Act declaring the Rights and Libertries of the Subject and Setteling the Succession of the Crowne*, 1689 (1 William & Mary, Sess. 2, c. 2).

25. Carter Hudgins, "Exactly as the Gentry do in England: Culture, Aspirations, and Material Things in the Eighteenth-Century Chesapeake," paper delivered at the Forty-fifth Conference on Early American History, Johns Hopkins University, September 1984, 23.

26. Exceptions included crafts where either the capital investment or the materials were unusually expensive, such as milling or silver smithing. Even in these cases, those who aspired to social prestige had passed the stage of doing the actual physical work and spent their time supervising and acting as merchants with connections to the wider world of commerce beyond the immediate neighborhood. For an example, see Cheryl Robertson, "Elias Boudinot: A Case Study in Ethnic Identity and Assimilation," M.A. thesis, University of Delaware, 1980.

27. See J. C. Furnas, *The Americans: A Social History of the United States, 1587–1914* (New York: Putnam, 1969), 63.

28. Marshall, *English People*, 117.

29. Quoted in Gary B. Nash, *The Urban Crucible: Social Change, Political Consciousness, and the Origins of the American Revolution* (Cambridge: Harvard University Press, 1979), 8.

30. Marshall, *English People*, 121.

31. Greven, *The Protestant Temperament*, 321. For a full discussion of the differences between cosmopolitan and local cultures, see Richard L. Bushman, "American High-Style and Vernacular Cultures," in *Colonial British America:*

Essays in the New History of the Early Modern Era, ed. Jack P. Greene and J. R. Pole (Baltimore: Johns Hopkins University Press, 1984), 345–84. The antagonistic nature of the distinction between high-style and vernacular culture in England is explored in E. P. Thompson, "Patrician Society, Plebian Culture," *Journal of Social History* 7 (1974): 382–405.

32. Carter Hudgins, "Exactly as the Gentry do," 2–3.

33. The literature on the consumer revolution both in Europe and America is proliferating at an enormous rate. It begins perhaps with Fernand Braudel, *Capitalism and Material Life, 1400–1800*, trans. Miriam Kochan (New York: Harper & Row, 1973). Its theoretical underpinnings concerning the use of goods as a means of communication are well-explored in Mary Douglas and Baron Isherwood, *The Worlds of Goods: Towards an Anthropology of Consumption* (New York: Basic Books, 1979), esp. 56–71. Developments in England are traced by Neil McKendrick, John Brewer, and J. H. Plumb, *The Birth of a Consumer Society: The Commercialization of Eighteenth-Century England* (London: Europa, 1982). Interpretations and descriptions of consumer patterns form part of almost every "new" social history of early America, although focus on the theory is more recent. For an early example see Lois Green Carr and Lorena S. Walsh, "Changing Life Styles in Colonial St. Mary's County," *Working Papers from the Regional Economic History Research Center* (Wilmington, Del.) 1 (1978): 3, 73–118. Many articles over the last decade in the *Winterthur Portfolio: A Journal of Material Culture* provide both information and bibliography. The newest entry in the field will be a collection of essays, *Of Consuming Interests: The Style of Life in the Eighteenth Century*, edited by Cary Carson, Ronald Hoffman, and Peter J. Albert, to be published in 1992 by the University Press of Virginia for the United States Capitol Historical Society.

34. For a careful distinction between the meanings of *planter*, see Rhys Isaac, *The Transformation of Virginia, 1740–1790* (Chapel Hill: University of North Carolina Press, 1982), 16.

35. See, for example, Jack Michel, " 'In a Manner and Fashion Suitable to Their Degree': A Preliminary Investigation of the Material Culture of Early Rural Pennsylvania," *Working Papers from The Regional Economic History Research Center* 5 (1981): 1–83.

36. See Susan Mackiewicz, " 'Property is the Great Idol of Mankind . . .': The Material Lives of Philadelphia Elites, 1700–1775," paper prepared for the Delaware seminar, University of Delaware, June, 1985. Parts of this paper were further developed in the author's dissertation, "Philadelphia Flourishing; The Material World of Philadelphians, 1682–1760" (Ph.D. diss., University of Delaware, 1988).

37. Hudgins, "Exactly as the Gentry do . . . ," 7–8.

38. The theoretical basis for these three levels on which goods operate within a culture is found in Lewis Binford, "Archeology as Anthropology," *American Antiquity* 28 (Oct. 1962): 217–26. For practical application, see James J. F. Deetz, *In Small Things Forgotten: The Archeology of Early American Life* (Garden City, N.Y.: Anchor Press—Doubleday, 1977). Also, Stephanie Grauman Wolf, "Living It Up in the Eighteenth Century: The Style of Life among the Rich and Famous," paper presented at the conference of the United States Capitol Historical Society, "Of Consuming Interest," March 1986.

39. Mackiewicz, " 'Property is the Great Idol of Mankind,' " 20–21.

40. These rituals are described in detail in Isaac, *Transformation of Virginia*, 77–78.

41. Quoted in Nash, *Urban Crucible*, 440n.

42. On second-hand clothing see Robert A. Guffin, "James Gambell's Clothing," in *A Glimpse into the Shadows: Forgotten People of the Eighteenth Century*, ed. Barbara McLean

Ward (Winterthur, Del.: Henry Francis du Pont Winterthur Museum, 1987), 26–27, published in conjunction with an exhibition held at the Winterthur Museum, 9 March–14 June 1987. See also Marshall, *English People*, 176–77.

43. Breen, *Puritans and Adventurers*, 153–54.

44. 18 May 1775, quoted in Steve Rosswurm, ed., "Equality and Justice: Documents from Philadelphia's Popular Revolution, 1775–1780," *Pennsylvania History* 52 (October 1985): 256.

45. I am indebted for this information to Professor Karin Calvert, American Civilization Department, University of Pennsylvania.

46. Austen, *Persuasion*, 1088–89.

47. An advertisement by David James Dove, a pre-Revolutionary school-teacher in Philadelphia, placed in the *Pennsylvania Gazette*, and quoted in Catherine Drinker Bowen, *Miracle at Philadelphia: The Story of the Constitutional Convention, May to September, 1787* (Boston: Little, Brown, 1966), 161.

48. Greven, *The Protestant Temperament*, 297–98.

49. Ibid., 297.

50. John Adams to Abigail Adams, 4 August 1776, *The Book of Abigail and John: Selected Letters of the Adams Family, 1762–1784*, ed. L. H. Butterfield, Marc Friedlaender, and Mary-Jo Kline (Cambridge: Harvard University Press, 1975), 149.

Colonial American Portraiture: Iconography and Methodology

WAYNE CRAVEN

Portraiture requires a special methodology for art historical analysis because of the very nature of its subject matter. The primary concern of portraiture is, after all, the creation of a visual biography, as the preservation of the likeness of some private individual or as a commemorative image of a great person. In either case, the cardinal rule for analysis is that nothing is included in a portrait by chance or accident, and that every detail bears scrutiny for the potential role it plays in revealing the biography. Study of the biography of the sitter is as important for the full understanding of the portrait as, say, awareness of something like the doctrine of Manifest Destiny or the rise of the science of geology is for the study of nineteenth-century American landscape painting, or a knowledge of Jacksonian democracy is for the interpretation of genre painting in the same period. Formal stylistic analysis will provide important information about matters of aesthetics and connoisseurship, but the ultimate purpose of a portrait was to serve as a permanent mirror reflection of the physical appearance and the spiritual and secular values of the subject in the way that he or she

wished to be remembered. To understand the portrait fully, we must know as much of the subject's biography as surviving documents will permit and take note of every detail in the picture to see how it records that biography. Certainly, portraits such as William Williams's *Deborah Hall* and John Singleton Copley's *Mr. and Mrs. Ralph Izard* intrigue us through the rich paraphernalia that abounds throughout the canvases.

To gain command of a methodology for portraiture we should begin by observing that the components of this type of picture are normally few in number. To identify them we need to ask, what occupies the area of the canvas plane. The answers are the face; hair; costume; attributes such as objects on a table or something held in the hand; and background, which may be either neutral or contain biographical references. Actually the face—so important for recording the individual's personal distinctive appearance—occupies a very small portion of the canvas area; indeed, it is usually the smallest area of all five of the components. The face primarily serves to preserve the likeness, not to tell a history, al-

though it may contribute to that end. The rest of the image, then, is devoted to an elaboration of the subject's biography through a visual language that is understood by the sitter's contemporaries but often has to be decoded or deciphered before later generations are capable of accurate and sensitive translations.

When one recreates a biography several categories seem especially useful: the sitter's socioeconomic status and goals; religious affiliation; political allegiance; cultural concerns; and last, personal interests, vocations, past experiences, and the like. Interestingly enough, it is increasingly evident that artistic style is often arrived at through service to these categories. That is, these social, economic, political, cultural, and personal interests are such powerful forces in a society that they determine not only the iconography of the portrait but also the style used in painting it.[1]

Art historians generally have been slow to take up the study of portraiture, perhaps because they have erroneously assumed that portraits did not offer the intriguing and intellectually fascinating problems found in landscape, genre, or even still life—areas that begin now to become somewhat crowded. Portaiture has always been an important part of American painting, both in quantity and quality: from the seventeenth through the nineteenth centuries, there were probably at least as many portraits painted as all other types combined, and the artists were fairly competent, particularly when one speaks of a Copley or a Stuart, a Sargent or an Eakins. Portraiture is, in fact, a beckoning frontier for the established scholar and the graduate student, offering the excitement of discovery to the intrepid researcher.

The iconographic pattern for eighteenth-century colonial American portraits was established in the seventeenth century, in paintings such as *Mr. John Freake* and the *Mrs. Elizabeth Freake and Baby Mary,* both by an unidentified artist, known as the Freake Limner, which many would consider the masterpieces of the first century of our history (figs. 26–27). They were painted in Boston about 1671 or 1674, and they are now at the Worcester Art Museum. Here, ostensibly, is the very embodiment of the Puritan colony—the dark, drab colors in Mr. Freake's portrait, the sober, stern ascetic face of Mrs. Freake reeking of austerity and self-denial. How beautifully this interpretation meshes with what we know of

Puritan New England from Nathaniel Hawthorne's wonderful stories, *The Scarlet Letter* and *The House of Seven Gables.* But Hawthorne was a romantic novelist who wanted to tell a story, and although he located his dramatic tales of religious fanaticism and morality in Salem, he lived there two hundred years after the period of his novels. His purpose was not to give an accurate account of history, but scholars have sometimes used his stories as the basis of their knowledge of seventeenth-century New England society, as, for example, in interpreting portraits such as those of Mr. and Mrs. Freake. The Hawthornian legacy was supported by the circumstance that the two largest bodies of surviving artifacts and documentation are strongly Puritan in nature, being devoted to death and religious faith. These are the gray slate gravestones that populate seventeenth-century burial grounds and the sermons, those endlessly haranguing Puritan intonations of the wickedness of flesh and the evil of pleasure. It all fits so beautifully together—Hawthorne's tales, the gravestones, the sermons, and portraits such as these. Surely the religious convictions of Puritanism must give us the basis for the iconography of the portraits.

But how do we know that John and Elizabeth Freake were Puritans? We have too often assumed that anyone living in seventeenth-century New England was a Puritan, but that is not so. By the end of the century, for example, many were Anglicans, members of the very church that had forced the Puritans to flee their homeland in England to escape religious persecution. Moreover, even within the main Puritan church, the Congregationalist branch, there were many who were devout without being zealots and whose worldly interests were a constant cause for tirades from the pulpit.

Even in the above line of reasoning, however, there is an erroneous assumption—due no doubt to the power that Hawthorne still has on us—that religion was the guiding factor in determining the character of colonial American society, culture, everyday life, and, accordingly, portraiture. It was not, and here is the great error that has clouded the interpretation of early American portraits of the seventeenth century and ultimately of the eighteenth century: it was not Puritan fanaticism that gave direction to the lives of most colonial Americans, but rather the secular, economic ambitions of the middle class. Once we realize this the portraits become inter-

Fig. 26. Unknown American artist, *Mr. John Freake,* c. 1671–74, oil on canvas, 42¼ × 36¾ in. Worcester Art Museum. Gift of Mr. and Mrs. Albert W. Rice.

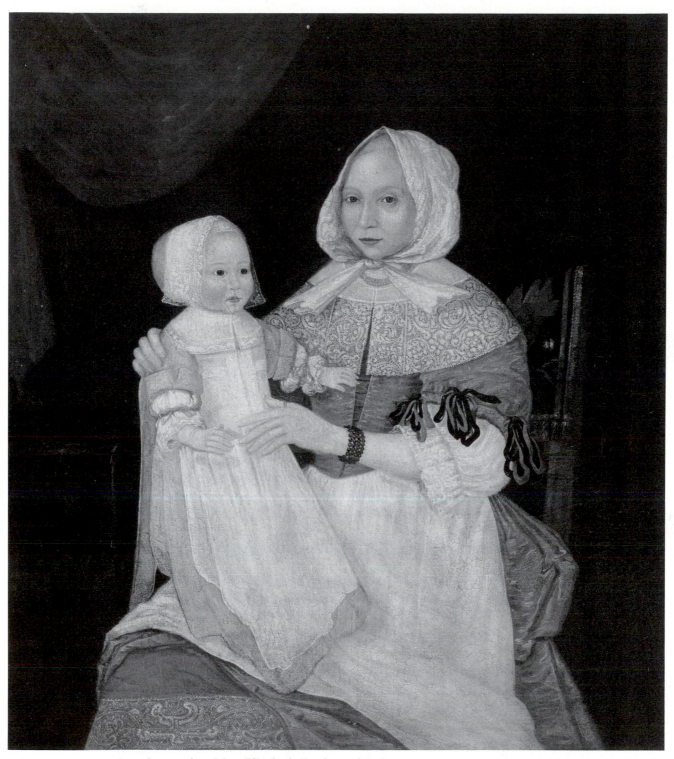

Fig. 27. Unknown American artist, *Mrs. Elizabeth Freake and Baby Mary*, c. 1671–74, 42½ × 36¾ in. Worcester Art Museum. Gift of Mr. and Mrs. Albert W. Rice.

pretable in a way that has not been possible in modern times. As colonial portraits are almost always of middle-class subjects, it is imperative that we recognize and acknowledge the middle class as a phenomenon.

Before the middle class made its appearance in western Europe only the aristocracy and the church were in positions of wealth and governmental power, while the other estate, serfdom, had no authority and existed solely for the support of the other two. But the middle class arose in the waning years of the Middle Ages and the early years of the Renaissance with families like the Medici in Italy and the Fuggers in the north—merchants, manufacturers, and money lenders who turned their capital into one of the most powerful forces within Western civilization. By the seventeenth century, merchants even became the rulers of at least one nation—The Netherlands. Moreover, the mercantilism of the middle class emerged contemporaneously with the schism in the Roman Catholic Church that spawned Protestantism, and in many parts of Europe, Protestantism and the middle class arose together as a single intertwined socio-religio-economic system. It was this interrelationship of social, religious, and economic factors that colonial Americans wanted expressed in their portraits.

The coalescing agent of the social, religious, and economic ambitions of the middle class was Calvinism, which advocated that work at one's secular, earthly calling was more valid in the eyes of God than the monastic withdrawal that was urged by Catholicism. Calvinism was tailor-made for a rising middle class, for it laid God's blessing upon their secular efforts, which were making them wealthy, comfortable, prosperous, and important, and gave them the enjoyable materialism of the temporal life. All of this led to the use of the well-known expression *Protestant work ethic*, a term that has been misapplied because one assumes that its prime motivator is religion. In fact, the moving spirit was the determined temporal drive of the middle class to rise to power through mercantilism and capitalism.[2] This powerful secular motivation required a religion that would accommodate such worldly propensities, and John Calvin became the theorist who codified the Protestant perspective that to prosper one must work hard at one's secular calling and that any resultive prosperity was an overt sign that one stood in God's favor

and enjoyed his blessing. These are the qualities, not Puritan austerity or zealotry, that we see painted into most of the portraits of the colonial era; they establish the foundation upon which the iconography of the portraits is based.

We now see that the portraits of Mr. and Mrs. Freake are not images of Puritan asceticism and austerity; indeed, John Calvin had written that austerity was unnecessary, declaring: "If we consider for what end God created food, we shall find that it was not only for our necessity, but also for our enjoyment and delight. Thus, in clothing, the end was, in addition to necessity, comeliness and honor."[3] In the portrait John Freake's coat is actually brown, not the black that has so often been associated with Puritanism, and it has a rich, bold pattern, probably meant to suggest cut velvet, an expensive and luxurious fabric; it is of a fashionable cut and is trimmed with silver buttons and buttonholes embroidered in silver thread. His lace collar, a handsome specimen that was imported from one of the lace-making centers of Venice, Spain, or Flanders, is similar to a number of surviving examples.[4] Freake calls our attention, with his left hand, to a silver brooch of exceptionally ornate design and splendid craftsmanship, very probably another imported object, and his gold ring is conspicuous. His white muslin shirt has elaborately pleated sleeves and ruffled cuffs, and if all of these items do not convince us that he had achieved gentleman's status, the gloves he holds are unmistakable reminders of the fact. They are similar to a surviving pair that once belonged to Governor Winthrop, founder of Massachusetts Bay Colony in 1630.[5] Gloves were, in fact, a symbol of gentleman status, and in many colonial portraits men wear or hold them for the very purpose of making that point.

Everything in the portrait of John Freake was, it seems, directed to this end—that he be represented as a gentleman—and the portrait thereby becomes an icon in service to the subject's social ambition within his community. No detail of the way Freake presented himself should be overlooked in this respect, and within a portrait, the hair is often of considerable iconographic importance, for the way a man wore his hair in the seventeenth century told much about him.

John Freake's hair tells us that he is of the middle class, that he is a Protestant, that he is an Englishman, and that he is a prosperous gentleman. Long hair, such as we see in contemporary

portraits of aristocracy, cascades in fashionable great curls well down over the shoulders. Lovelocks, they were contempuously called by middle-class Englishmen, and indeed they connoted the promiscuous life-style for which the aristocracy was well known. Moreover, lovelocks originated in Italy—a Roman Catholic country famous for its loose morals—and became popular in lascivious France, whence they entered the English courts of Charles I and Charles II. The controversy assumed nationalistic and patriotic meaning when Thomas Hall wrote the following in his long book, *The Loathsomnesse of Long Haire,* published in London in 1653: "It is not our ancient English fashion, but instead it is a foreign trick, and therefore as unlawful as foreign attire, which God condemns. Our ancient English fashion was to wear short haire."[6] Hall then observed that long hair is "against the modest, civil, and commendable custom of our Nation, till lately that we began to follow the French and Spaniards, who are known Papists and Idolaters."[7] So the long hair—the lovelocks of the cavaliers—would associate one with the lewd, aristocratic sector of society that had betrayed English traditions and manifested sympathies with French, Spanish, and Italian papists and degenerate foreign courts. John Freake, a Protestant, middle-class, English merchant-gentleman, certainly wanted none of that.

On the other hand, further research into the symbolism of hair reveals that short hair would have been equally unthinkable for Freake. Poor men wore their hair short, and they were subject to fines or punishment if they wore it the length of a gentleman's hair. To a man like John Freake, being poor was a sin, for it meant he was idle, did not prosper at his secular calling, and did not enjoy the favor of God. Moreover, Puritans had adopted a roundheaded cut in opposition to the aristocracy with their lovelocks; a favorite expression among seventeenth-century English aristocracy was, "never trust a man if you can see his ears." Now John Freake was no more a Puritan than he was a poor man or an aristocrat, and so he wore his hair a middle length—appropriate for a middle-class, prosperous, mercantile, English gentleman.

There was one other option, of course, and that was to wear a wig. But if Thomas Hall thought long hair was scandalous, the sight of a wig was enough to send him into urgent communication with the Lord. From the pages of his book Hall shouted that wigs were made from the hair of "some harlot who is now in hell."[8] Moreover, Hall proclaimed that Christ had condemned the wearing of wigs—a judgment I have yet to discover in the Bible. If one wears a wig, Hall declares, "What is this but to correct God's handywork, and in the pride of their hearts to think they can make themselves better than God hath made them. . . . It is an odious thing," Hall continues, "for any man or woman to be ashamed of God's workmanship in their own hair, and therefore to beautify their heads with bought hair."[9] John Freake could have afforded a wig, so what does it tell us about him when he chooses not to wear one—and not be shown in one in his portrait? And what does it mean when someone in New England does wear one?

To Judge Samuel Sewell, it was yet another breach in the wall that surrounded the holy city of Boston and protected it from sinners. This relentless denouncer of the periwig recounted in his now-famous diary in June 1701 that Josiah, the son of his minister, the Reverend Samuel Willard, had shaved his head and had the audacity to wear a wig to church meeting. Judge Sewall visited the young man, lectured him sternly on the evil he had taken upon himself, and to demonstrate his disapproval publicly, ceased attending the Reverend Willard's services and joined instead the rival church of the Reverend Benjamin Colman.[10] The wearing of a wig clearly had specific meanings to both young Josiah Willard and old Judge Sewall: essentially it signified a break with the traditions of the Puritan old guard and a desire to lead a more fashionable, refined life-style in a modest imitation of the aristocracy. The Anglican church was more tolerant of such practices than was the Congregational, and many a prospering merchant left the latter to join the former because of its more liberal attitude toward social and cultural ambitions. When a wig is seen upon a man's head in a New England portrait of the late seventeenth or early eighteenth century, it indicates much about his economic and social status, his religious affiliation, perhaps even his nationalistic commitments.

Mrs. Freake is plain of feature, but her face is not dour; there is, in fact, as in the face of her husband, a promise of a good-natured smile upon her lips. Her hair is "bound up," to use a contemporary expression, hidden by a white lace cap. Thomas Hall was specific on this matter

as well, warning women that "It is an abuse of the haire, when the locks are hung out to be seen by others; a modest matron hides them. Thy haire should be bound up like modest matrons, and not lasciviously hung out."[11] So hair, even when it is not seen, may assume iconographic significance in a portrait.

Elizabeth Freake's attire expresses the prosperity she enjoyed. Her gown suggests anything but Puritan austerity, for the material is a handsome taffeta decorated with red and black ribbons and adorned with a broad, lace collar of beautiful workmanship; her dress is arranged to display a bright red-orange underskirt that is banded with an ornate brocade. All of these materials are imported, as are the several items of jewelry that Mrs. Freake wears—the triple strand of pearls from the Orient, for example, or the bracelet made of garnets that probably came from South America.

Mrs. Freake sits in a Turkey-work chair, a status symbol in itself in its day, and the inventory taken at the time of her husband's death informs us that the Freake household contained fourteen such chairs.[12] In style the chair in the picture is similar to a couch of the 1690s that is preserved at the Essex Institute in Salem (fig. 28). Indeed, a seventeenth-century parlor filled with fourteen such brightly colorful chairs is hardly convincing of Puritan austerity. Even this early, in the 1670s, the colonial painter inserted into his portraits some fashionable, expensive, and well-crafted specimens of household furnishings. The purpose was, as with the clothing and hair style, to expand the visual biography by telling us of the subjects' stations in life and the extent of their prosperity through some reference to the level of refinement of their homes. The pattern for the iconography of the colonial American portrait is effectively established here in the 1670s, for even

Fig. 28. **Turkey-Work Couch, c. 1698, 46¼ inches in height, 59⅝ inches wide, 20¼ inches deep, acc. no. 107,548. Courtesy Essex Institute, Salem, Mass.**

Fig. 29. John Singleton Copley, *Mrs. Thomas Boylston,* **1766, oil on canvas, 129.5 × 102 cm. Courtesy of the Harvard University Portrait Collection, Harvard University. Bequest of Ward Nicholas Boylston, 1828.**

in the portraits by John Singleton Copley and Charles Willson Peale at the other end of the period, we find the same system being followed. Colonial images of merchants or of merchants' wives do indeed extol the doctrine of prosperity, so dear to the upwardly mobile middle-class aristocracy of America, through the imagery of fine clothing and handsome household furnishings

subtly introduced. Again note that the face in a portrait occupies only a small percentage of the total canvas area, leaving the rest of the canvas to tell the story of the subjects' life-style, as in Copley's *Mrs. Thomas Boylston* of 1766 (fig. 29), or in Peale's *The Edward Lloyd Family* of 1771 (fig. 30).

If the methodology presented here is precise

Fig. 30. Charles Willson Peale, *The Edward Lloyd Family,* 1771, oil on canvas, 48 × 57½ in. Courtesy, Henry Francis du Pont Winterthur Museum.

we will be able to observe the important changes that occur in the iconography of both life and art. For example, if the portrait of *Maria Catherine Smith* (fig. 31), painted in Boston about 1690 by an unknown artist, is compared with the *Mrs. Freake,* a new sensuousness and fleshiness is apparent in the Smith woman's image; also, the gown is cut low, like those of the English court, and the hair is "hung out," curling suggestively over a bare shoulder. Surely Maria Catherine Smith was prepared to withstand the rage of old-guard Puritans like Judge Sewall for the sake of joining the more elegant society that was arising in New England by turning more worldly. As early as 1671 another of the ministerial dynasty, the Reverend Eleazer Mather, had preached, "Men, brethren, and fathers, you had once an-

other spirit. A right New England spirit. Is the old zeal, love, heavenly-mindedness that was in your heart twenty, thirty years ago, is it still there? Are you the same men you were? Are you not strangely changed? Have you as much of God as you had? Hath not the world got something [of you]?"[13]

After hearing this exortation from one Mather one is surprised at the well-known image of another, the most famous of all the Mathers, the Reverend Cotton Mather, whose likeness was depicted in the mezzotint made by Peter Pelham in Boston in 1728 (fig. 32). What would his forebears have said, to find their jovial, fleshy descendent wearing a great wig, looking, as one critic has noted, as if someone had dumped a bushel of cotton upon his head. So far has the

Fig. 31. **Unidentified artist,** *Maria Catherine Smith.* **c. 1690, oil on canvas, 27½ × 25½ in. Courtesy, American Antiquarian Society, Worcester, Mass.**

Puritan colony of yore come that now even the august leader of the flock wears something that had been a hated symbol of vanity only a few years before. As early as 1691 Cotton Mather had perturbed some of his parishioners by defending, in a sermon, the wearing of wigs, for on 19 March of that year old Judge Sewall lamented in his diary: "I expected not to hear a vindication of Perriwigs in a Boston Pulpit by Mr. Mather."[14] But times were changing, and change affects the iconography of portraiture.

Dean George Berkeley, an Anglican priest, arrived in New England in 1729, the year after the mezzotint of Cotton Mather was made. Berkeley

Fig. 32. Peter Pelham, *Cotton Mather,* **mezzotint, 1728, 12 × 9¹³⁄₁₆ in. (30.6 × 25 cm). National Portrait Gallery, Smithsonian Institution.**

brought in his entourage a professional portrait painter of London named John Smibert, seen at the far left of his famous picture, *The Bermuda Group* (Yale University Art Gallery), while Dean Berkeley is shown standing at the right. It is interesting to compare the images of Cotton Mather and George Berkeley, the former a New England Congregationalist of Puritan stock, the latter a representative of the high church of England; yet Mather's image is not significantly different from that of his Anglican counterpart, even down to the type of ministerial robes and collars and the type of wig worn by each. The woman seated on the right is Dean Berkeley's wife, and her attire and hair style are interesting, for now even the wife of a minister wears the fashionable low-cut, revealing gown of the court style, and her hair curls sensuously around one shoulder, more in the manner of a Maria Catherine Smith than an Elizabeth Freake.

If one wants to develop a methodology for the interpretation of the iconography of portraits one must begin to look to sources that historians of colonial American art have tended to ignore in the past. There are the courtesy manuals, for instance, which were published by the score to inform an eager, rising middle class how it should behave if it wanted to emulate polite, refined society. We have to remember how unpolished were the manners and social graces of the lower class and even the lower middle class in the seventeenth and eighteenth centuries. Those classes tended to be mean, ignorant, unclean, boorish, and ill-mannered, and for someone who was prospering through his trade or mercantile acumen and wished to shed these loutish ways as he rose in society, the courtesy manual was a primary means for getting rid of the coarser aspects of one's life-style. These fascinating books provide a wonderful service for the art historian, for they explain what may be referred to as the decorum of a portrait—how to sit, how to stand, what to do with one's hands, one's eyes, how to assume a posture of dignity and grace, and so on. It is normal to find one or more of these courtesy manuals listed in the inventories of libraries of colonial American homes, just as most upper-middle-class homes of the late twentieth century have their copies of Emily Post, Amy Vanderbilt, or Judith Martin on etiquette. Children were instructed in words that paraphrase the courtesy manual. When Daniel Parke, whose portrait was painted by John Closterman (fig. 33), wrote to his daughter, Fanny, to give her advice about how to behave in polite society, he sounded like a page from one of the manuals of his library: ". . . do not learn to Romp, but behave y'rself soberly and like a Gentlewoman. . . . Carry y'rself so yt Everyboddy may Respect you. Be calm . . . and when you speak, doe it mildly."[15] Parke had obviously been reading Richard Allestree's *The Ladies Calling*, first published in Oxford in 1673, which contains precisely such advice. One understands portraits of colonial American men and women much better after reading a few of these courtesy manuals.

There are other sources that art historians have too often overlooked, such as dancing manuals that inform the reader how to stand or walk like a gentleperson. François Nivelon, a French dancing master, published a book in 1737 titled *Rudiments of Genteel Behavior*, which was much read. Today we soon see its relationship to colonial American portraits, particularly in the way the figures sit, stand, turn their heads, place their feet, or gesture with their hands.

We have relied too much on the model of the mezzotint to explain the postures in portraits, when in fact we need to be more imaginative and broaden our search. Accepting the mezzotint as the model makes our methodology faulty in two ways. First, it begs the question of why people stand or sit as they do in the mezzotints; and second, it reduces the social or cultural (and hence iconographic) importance expressed through posture by limiting the explanation entirely to a formal matter—that is, artistic tradition. Two books published in England set forth the proper genteel postures: Thomas Page's *The Art of Painting in its Rudiments, Progress, and Perfection*, of 1720, and Gerard de Lairesse's *The Art of Painting in All its Branches*, of 1738. Art historians are currently investigating these and other such sources as they apply to colonial portraiture. But courtesy manuals and books on genteel postures and gestures abounded in the nineteenth century as well, and as far as I know, few attempts have been made to relate their influential dicta to portraiture, although Professor John Stephens Crawford of the University of Delaware has published an article in the *American Art Journal* on the influence of classical rhetorical gesture and posture on nineteenth-century portrait statues.[16] This is an example of the imaginative approach that must be taken for de-

Fig. 33. John Closterman, *Daniel Parke,* **c. 1705, oil on canvas, 50¼ × 40½ in. The Virginia Historical Society, Richmond, Virginia.**

veloping methodologies for the study of portraiture. Art historians have done much better in this regard in other fields such as landscape, history painting, genre, or still life.

Robert Feke's *James Bowdoin II* of 1748 invites us to apply to it the methodology we have been discussing here (see fig. 35). Since the face seems more naturalistic than idealized, we must ponder if this is a stylistic or iconographic matter, or both. In any case, the iconographic factor has seldom been considered. Why—in sociocultural terms—is the style naturalistic? We find interesting possibilities once we start to inquire about the matter. Nearly one hundred years earlier Thomas Hall had denounced artificial beautification of the face, and his words parallel a paint-me-as-I-am theory in portraiture. "The beauty of God's people is an inward beauty," Hall wrote, citing Psalms 45:13, "consisting in holiness, humility, meekness, modesty, mercy, etc., no matter what the skin or outside be. . . . Lying is unlawful; but this [cosmetic] painting and disguising of faces is no better than dissimulation and lying; they teach the face to lye. . . . Let everyone be content with those favors and features which the most wise God hath given them."[17] The implication is that one would have to have the audacity to think that he could improve upon the handiwork of God himself if an ideal were applied to a face or its image. So naturalism is not just a formal, artistic, stylistic matter, but it is iconographic as well. Moreover, James Bowdoin was a man of science, so the question arises, would his interest in the empirical science and philosophy of Isaac Newton, John Locke, and George Berkeley have caused him to prefer a naturalistic style for his portrait? Again picking up the methodology we used in John Freake's portrait, what about James Bowdoin's hair: is it his own, is it a wig, how long is it, what does its style imply in sociocultural terms, why is it dark brown instead of white? What does his posture connote? What about the fabrics and cut of his attire: from what far part of the world did these exquisite materials come and how could their luxuriousness be reconciled with socioreligious mores? Or did they, in fact, imply the blessing of God for secular

work well done—the Doctrine of Prosperity at work among middle-class mercantile society? The search for explanations to questions such as these is what makes portraiture a fascinating field of inquiry.

Notes

1. My own methodology has moved continuously in the direction of a social history of art, though I still believe it is unnecessary, even unwise, to have only one methodology in one's analytical tool kit. But for many years, as I taught my graduate seminars in colonial American painting, I knew a full understanding of the work of art eluded me, and it was not until I took a sociocultural approach that the meaning of the portraits began to emerge more clearly. The introductory chapter of my book *Colonial American Portraiture* (New York and Cambridge: Cambridge University Press, 1986) is titled "To Know the Portraits We Must Know the People," and that system, I believe, is the one that leads to the most complete interpretation of portrait iconography.

2. On this point see Max Weber, *The Protestant Ethic and the Spirit of Capitalism*, trans. Talcott Parsons, foreword by R. T. Tawney (London: Allen & Unwin, 1930); first published in Leipzig, Germany, in 1930. See also Erik Larsen, *Calvinistic Economy and Seventeenth-Century Dutch Art* (Lawrence: University of Kansas Press, 1979).

3. John Calvin, *Institutes of Christian Religion*, trans. Henry Beveridge, 2 vols. (Grand Rapids, Mich.: Erdsmans, 1957), bk. 3, chap. 19, sect. 2.

4. Numerous examples of seventeenth-century lace are illustrated in Francis Morris, *Notes on Lace of the American Colonists* (New York: William Helburn, 1926).

5. Jonathan Fairbanks et al., *New England Begins: The Seventeenth Century*, 3 vols. (exh. cat., Boston: Museum of Fine Art, 1982), 2:347, no. 364.

6. Thomas Hall, *The Loathsomnesse of Long Haire* (London, 1653), 14.

7. Ibid., 26.

8. Ibid., 15.

9. Ibid.

10. M. Halsey Thomas, ed., *The Diary of Samuel Sewall, 1674–1729*, 2 vols. (New York: Farrar, Straus and Giroux, 1973), 1:448.

11. Hall, *Long Haire*, 56–57.

12. Suffolk County Probate Records, Court of Probate, Boston, Massachusetts, 5:294. Fairbanks et al., *New England Begins* 3:442 and 535.

13. Eleazer Mather, *A Serious Exhortation to the Present and Succeeding Generation in New-England* (Cambridge, Mass., 1671), 21.

14. *The Diary of Samuel Sewall* 1:276.

15. Daniel Parke to Frances Parke, n.d., quoted in "Virginia Gleanings in England," *Virginia Magazine of History and Biography* 20 (October 1912): 375n.

16. John Stephens Crawford, "The Classical Orator in Nineteenth-Century American Sculpture," *American Art Journal* 6 (November 1974): 56–72.

17. Hall, *Loathsomnesse of Long Haire*, 102–3.

Gentlemen Prefer Swords: Style and Status in the Eighteenth-Century Portrait

ROBERT A. GROSS

In the winter of 1787, as popular protest reverberated across the Massachusetts countryside and the Commonwealth appeared to be on the brink of civil war, the Boston press began to spread rumors about the supposed leader of the backcountry rebellion, Captain Daniel Shays.

One of the principal anecdotes involved Shays and the Marquis de Lafayette's sword. It seems that General Lafayette carried with him to America a considerable number of ornamental swords to bestow upon fellow officers as marks of his personal esteem. In 1780 he presented these swords to the Continental army officers under his immediate command. Captain Daniel Shays was one of the lucky few. But did Shays treasure this gift, this "elegant sword" as a "pledge of [Lafayette's] affection, which a man of honour and spirit would have sacredly preserved, and handed down to his posterity as a jewel of high price"? Not at all. He already had a sword that he liked; so, he sold Lafayette's gift for "a trifling consideration," a measly few dollars.

The sum was little enough, though we may guess that Shays needed the money. But it was sufficient to cause a scandal in the Continental officer corps. His comrades, the story goes, were disgraced by Shays's act and bluntly told him so. He, in turn, was bitter about the criticism and quit the army in disgust. So closed Shays's military career three years before the end of the war. The man and the scandal were pretty well forgotten until 1786. Then Shays's name became identified with insurgency in western Massachusetts. At the height of his notoriety, opponents of the rebellion resurrected the story about the sword and gleefully retailed it in the press.[1]

Why should anyone have cared what Daniel Shays did with Lafayette's sword? And why was it important to repeat the anecdote as a way to attack the rebellion? Such questions bear directly upon the central theme of this volume: the problem of gentility in the new republic.

116

The simple answer is that the critics of Shays were determined to discredit his personal standing among the people. That a former captain in the Continental army was leading the insurgents conferred instant legitimacy upon their cause. It was not simply that Shays had commanded a company in the Revolution, had fought bravely as a patriot, was wounded in his country's service. Equally important was that as a captain, he was considered a gentleman—a man of rank whose position in society entitled him to deference from ordinary folk and whose ideas could rightly claim a hearing in leading circles. It was in recognition of that distinctive status that Lafayette had made his gift to Shays and the others back in 1780: only gentlemen, as Stephanie Wolf notes, carried swords.

In selling that token of status and esteem, his critics believed, Shays betrayed all claim to be a "man of honour." Born poor, he had climbed rapidly up the social ladder without acquiring any "politeness" along the way. Other stories were told to prove that Shays was merely a "mushroom General," sprung up overnight in the dark soil of rebellion. It was said that he had gotten his officer's rank by "duplicity," recruiting men for the Continental army on the condition that he should be their captain. And then there was the degraded style in which he lived. A former comrade in the Continental army paid a visit on Shays at his farm in Pelham, Massachusetts, and was appalled to discover, as he reported to the *Massachusetts Centinel* in January 1787, that his house was "a stye, it having much more the appearance of a den for brutes, than a habitation for men. . . ."[2]

In short, everything about Shays attested to the fact that Shays belonged where he was born: at the bottom of the heap. And if Shays were not truly a gentleman, if he had attained high rank only by practicing the low arts of a popularity-seeker and intriguer for office, then it was easy to explain the spread of insurgency among the people: Shays and his crew were once again stirring up the people for their own selfish purposes. The people themselves were honest but easily deceived and misled. Since they had been trained to defer to gentlemen, they naturally listened to such "adventurers" as Captain Shays and did their bidding. Discredit Shays and peace would return to the state.

Gentility, then, was a crucial value in the social order of eighteenth-century Massachusetts,

Fig. 34. Unidentified artist, *Daniel Shays and Job Shattuck*, 1787, relief cut, 3½ × 5⅛ in. (8.7 × 13 cm); published in *Bickerstaff's Boston Almanack for 1787*, 3d ed., Boston. National Portrait Gallery, Smithsonian Institution.

proudly displayed by claimants to "gentle" status in every aspect of their lives, from the houses they built and the clothes they wore to the books they read and the portraits they hung on their walls. It is fitting that we have no formal portraits of Daniel Shays; the only visual image of the "Generalissimo" of the rebellion is a crude woodcut, published on the cover of a 1787 Boston almanac (fig. 34). By contrast, elegant portraits of his enemies abound, of which the most striking example, painted by Robert Feke in 1748, is the splendid likeness of James Bowdoin II, the enlightened merchant-prince, who as governor of Massachusetts in 1787 sternly suppressed the insurrection (fig. 35).[3]

Yet for all the badges of gentility, it was not so easy to tell the true men of honor from the false. Even in his woodcut, Daniel Shays brandished a sword. There were, after all, no sumptuary laws in the republic, no arbitrary titles or barriers to exclude men officially from the upper class. And in the course of the Revolution, the problem of imposture deepened, as people scrambled for status, rising from day-laborers to army captains and from common seamen to wealthy privateers overnight. The Massachusetts politician James Warren, a self-styled apostle of virtue, complained to his good friend John Adams in 1779 that even "as I am still drudging at the Navy Board for a morsel of Bread . . . others, and among them fellows who would have cleaned

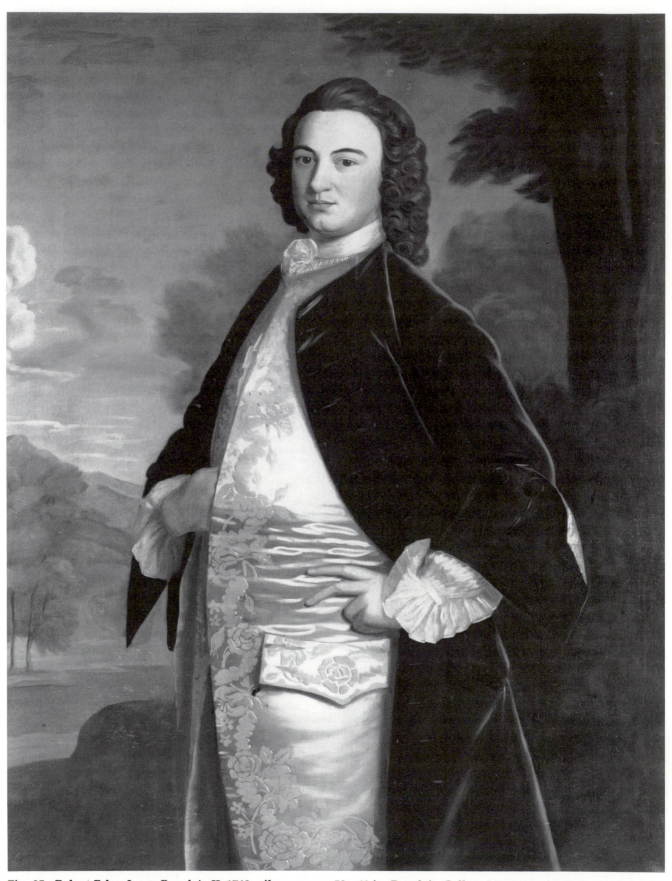

Fig. 35. Robert Feke, *James Bowdoin II*, 1748, oil on canvas, 50 × 40 in. Bowdoin College Museum of Art, Brunswick, Me.

my shoes five years ago, have amassed fortunes, and are riding in chariots. Were you to be set down here you . . . would think you was upon enchanted Ground in a world turned topsy turvy, beyond the description of Hogarths humourous pencil or Churchills Satyr [satire]."[4]

In this light, the issue of portraiture is telling for any historian of society and culture in the era of the American Revolution and Constitution. For how better to pose as a gentleman or lady than on an ornate canvas, depicted in gracious splendor, amid costly possessions and the emblems of rank? Whatever the reality, through an expensive portrait a social climber could invent a persona and assert his claims to acceptance at the tea assemblies and the country houses of America's elite. Portraits, as both Stephanie Wolf and Wayne Craven neatly tell us, are not merely signs but acts of gentility: social statements about the status and cultural identity of the sitters. To read these statements, then, it is imperative to know the precise resonances of every detail—as Craven shows us in his careful explication of the portraits of John Freake and his wife, Elizabeth. Through his middle-length hair, expensive, imported clothes, silver brooch, and gloves, Freake proudly announces himself a prosperous, Protestant prince of the middle class, secure in his worldly accomplishments, No anxiety here about salvation, spiritual or secular, Freake was sure of his election to the gentlemanly elite.

And yet there is a troubling problem that Wolf's fine essay forces us to consider. In eighteenth-century England, to be a gentleman was to rise about economic necessity, to live grandly without ever having to labor. "Whosoever studieth the laws of the realme," Sir Thomas Smith declared in *De Republica Anglorum* in 1583, "who studieth in the universities, who professeth liberal sciences, and to be shorte, who can live idly and without manuall labor, and will beare the port, charge, and countenaunce of a gentleman, he shall be called master . . . and shall be taken for a gentleman." Education, idleness, luxury: gentlemen were, by definition, a leisure class, whose legitimacy ultimately derived from old family and ancient landed estates.[5]

But, as Wolf observes, nobody in the elites of colonial America could really claim such rank, in part because their origins were too recent, and even more because few could afford to get by without working. In that case, what did it mean

to be an American gentleman? And how do we interpret the signs within the portraits of men like John Freake and James Bowdoin? A great many merchant princes, we should note, are happily portrayed against that familiar backdrop of their calling: ships sailing the oceans to distant ports. Such display is surely remarkable, in light of the conviction in the English upper class that a gentleman did not engage in trade. Did colonial and revolutionary Americans mean to assert an alternative scale of values? Were they challenging the norm of genteel idleness with a middle-class notion of utility?

Such questions go to the heart of the fundamental paradox of the early American elite, which combined middle-class occupations with a gentlemanly ideal. Inevitably that ideal would be altered in the crossing to the anomalous American setting. Here is where Wolf's essay, I think, makes its greatest contribution. She argues persuasively that in British North America, the trappings of gentility—brick houses, coaches, private libraries, powdered wigs, household servants—took on a new function. Once they were emblems of gentility, the visible signs of social grace. But in America, they became the very means of grace, bestowing upon their owners the status they were supposed merely to display. In effect, material possessions had already taken on their modern role. Instead of evidencing class, as they did in England, consumer goods merely expressed life-style. In consequence, far from affirming the social order, they actually undercut it. Anybody with money, whatever his or her origins or polish, could buy the means for the genteel life-style and parade out into society in a coach—or a BMW. Inevitably the categories and the signs of status became scrambled, yet the importance of material goods inflated still more. Houses, dress, books, manners, speech carried an anxious burden; in a competitive, status-conscious society, to be out of style is to be de-classed.

In the context of social mobility and fluidity in a revolutionary age, I suspect the portrait took on a new meaning, both for the sitters and the artists. Portraits, we might say, were the equivalent of the "Style" section in today's *Washington Post*, presided over by the painterly "Miss Manners" of the day. We may guess that people scrutinized the canvases for the latest emblems of gentility. How did one don a wig? Were satin waistcoats in or out? Was it appropriate for a lady

to wear a low-cut gown? If this speculation is correct, we are entitled to wonder whether the very art of portraiture changed in the process. As the ranks of patrons expanded rapidly in the race for wealth and status, as the potential audience for portraits widened from city to countryside, it is likely that the nature of portraiture underwent significant changes. Certainly, that happened to political rhetoric as it moved beyond the confines of the genteel in the course of mobilizing Americans for revolution. Once embellished with classical learning, directed at a select coterie of educated peers, political speech was dramatically changed as it reached out to a broad audience. Public figures increasingly spoke in the language of the people, illustrating their ideas and drawing their metaphors from the familiar experiences of ordinary life. Did something similar happen to portraiture, as it, too, was popularized among the *nouveau riche*?[6]

Certainly, the rural portraitists, who sprang up throughout New England in the early nineteenth century, took a very different approach to their work than did such colonial masters of the art as John Singleton Copley. They saw themselves as craftsmen and jacks-of-all-trades, painting signs, houses, and people as necessity allowed. Like the new novelists of the middle class, who claimed to provide authentic accounts of everyday life with which readers could identify, the new portraitists advertised their ability to provide "correct likenesses" of common people. "Verisimilitude" was the style of the middle class, and not, we might argue, of the genteel. In that event, the portrait takes on a new history in the nineteenth century, separated by an age of revolution from its colonial origins, even as it owes its functions as social signifier to that past.[7]

Thanks to that transformation, it is nice to reflect, ambitious artist-entrepreneurs like Erastus Field could emerge from the hill towns of western Massachusetts and carve a living and an art from the popular demand for portraits. Out of the social revolution of the eighteenth century, the itinerant portraitists who swarmed across the countryside were no longer confined to the hard scrabble lives and the cultural isolation of the backcountry. Instead of taking up arms with Daniel Shays, they could pick up a palette and brush and paint their way into a new middle class.

Notes

1. I have recounted the full story of this incident in "Daniel Shays and Lafayette's Sword," *OAH Newsletter* 15 (November 1987): 8–9.

2. "Miscellany," *Massachusetts Centinel*, 17 January 1787; "Anecdotes of Daniel Shaise, leader of the Insurgents," *Massachusetts Centinel*, 2 December 1786; Reminiscence of Judge [Samuel] Hinckley, March 1834, in *Selected Papers from the Sylvester Judd Manuscript*, ed. Gregory H. Nobles and Herbert L. Zarov (Northampton, Mass.: Forbes Library, 1976), 581–82; Josiah Gilbert Holland, *History of Western Massachusetts . . .* 2 vols. (Springfield, Mass.: Samuel Bowles and Co., 1855), 1:292–95.

3. Wayne Craven, *Colonial American Portraiture: The Economic, Religious, Social, Cultural, Philosophical, Scientific, and Aesthetic Foundations* (New York and Cambridge: Cambridge University Press, 1986), 287–90.

4. James Warren to John Adams, Boston, 13 June 1779, Massachusetts Historical Society, Boston, *Warren-Adams Letters: Being Chiefly a Correspondence among John Adams, Samuel Adams, and James Warren . . . 1743–1814*, 2 vols. (Boston: Massachusetts Historical Society, 1917–25), 1:105 (*Massachusetts Historical Society . . . Collections*, vols. 72–73).

5. Sir Thomas Smith, quoted in Edwin Harrison Cady, *The Gentleman in America: A Literary Study in American Culture* (Syracuse, N.Y.: Syracuse University Press, 1949), 4.

6. Gordon S. Wood, "The Democratization of Mind in the American Revolution," in Library of Congress Symposia on the American Revolution, *Leadership in the American Revolution* (Third symposium, Washington, D.C.: Library of Congress, 1974), 63–88.

7. David Jaffee, "One of the Primitive Sort: Portrait Makers of the Rural North, 1760–1860," in *The Countryside in the Age of Capitalist Transformation: Essays in the Social History of Rural America*, ed. Steven Hahn and Jonathan Prude (Chapel Hill: University of North Carolina Press, 1985), 103–38.

Part 4
Colonial Portraiture
in Later American
Culture

Survival and Transformation: The Colonial Portrait in the Federal Era

DORINDA EVANS

During the Federal period, from about 1780 to 1815, American artists, for the first time, exhibited two quite different attitudes toward portrait painting: one was consistent with colonial expectations and the other more ambitious and art-historically self-conscious. In New England John Singleton Copley's late colonial portraits from the end of the 1760s and the early 1770s had established a high standard of resemblance that became the late colonial ideal. For decades his paintings inspired emulation and therefore acted, one might argue, as a strong conservative influence. Even at the turn of the century, several fellow New-England artists such as Ralph Earl and John Mason Furness pursued a roughly Copleyesque manner. Similarly in other parts of the country a number of portraitists such as Henry Benbridge and James Earl of Charleston and Charles Willson Peale of Philadelphia painted in a style that basically did not deviate from the aesthetic of the late colonial period. There is no discernible difference in artistic aims, for instance, between Copley's colonial painting of *Mr. and Mrs. Thomas Mifflin* of 1773 (Historical Society of Pennsylvania) and Peale's *Staircase*

Group of 1795 (Philadelphia Museum of Art). A more obvious example of adherence to tradition is Peale's *Mrs. Robert Morris* of about 1782 (Independence National Historical Park Collection). Its essentially linear style, artificial background, and knee-length, standing pose follow prototypes that appeared twenty years earlier. In their preference for portraits that were relatively smoothly finished, clearly defined, mimetic representations of reality, painters such as Peale may be considered traditional at the end of the eighteenth century. They resembled many self-taught Federal artists in that they continued to regard portraiture apparently as little more than the art of taking likenesses. Generally the aim of these artists did not extend beyond achieving a recognizable and possibly flattering portrayal of the sitter, arranged in a composition that recalled earlier European portraits.

In contrast, Gilbert Stuart acted to a large extent as a model for a new group of artists who aspired to be leaders. He returned to the United States from Great Britain in 1793 and brought with him the latest style from the 1780s and 1790s in London, with its emphasis on the aes-

thetic merit of a portrait as a picture. John Vanderlyn, almost the antithesis of Stuart as an artist, rejected Stuart's English precedent of fancy, visible brushwork and rich coloring, but he too can be considered one of the new leaders whose work moved beyond the late colonial portrait type. The crucial link is that he and the others of this group sought to rival European artists and evinced a new concern with the portrait as part of a larger artistic tradition, more than just a likeness. Collectively their work may be considered characteristic of the new Federal period. Theirs was a newly ambitious approach that coexisted and mingled with the older, surviving manner of representation in a portrait. Since the leaders, including John Trumbull and—in their earlier work—Rembrandt Peale and Washington Allston, all studied abroad, the impetus for change clearly came from this experience and undoubtedly from the United States's changed status as a separate country. Because these artists subsequently worked chiefly in the major American cities of Boston, New York, Philadelphia, and Washington, their influence tended to be concentrated in these locations.

The changes that the Federal artists introduced to refashion the colonial prototype may be organized around three major points. In the first place, artists and occasionally patrons showed a new, historically conscious awareness of painting style as an aesthetic element in a picture; second, specific portrait types gained in popularity; and, finally, in certain portraits, a new kind of idealization of the sitter's character appeared.

When portraits by leading artists of the Federal and late colonial periods are compared, such as Stuart's 1807 *Thomas Jefferson* (fig. 36) and Copley's *Paul Revere* (fig. 37) of about 1768, it is clear that a fundamental difference separates them.[1] Copley provides a smoothly painted, carefully defined, palpable image with weight and substance and three-dimensional projection and recession. By modeling with relatively sharp contrasts in light and shade, he intensifies the illusion of a tactile reality. The inclusion of still life, as in the silver teapot, enables Copley to show off his remarkable ability to trick the eye with reflected light and simulated textures. In opposition to this, we are far more aware of the tools of the artist and the presence of the artist in the Jefferson portrait. Stuart provides a suggested rather than defined image, flickering

highlights, a decorative use of color, and visible brushwork such as in the "penciling" in the hair. As we can see, the colonial artist's preoccupation with the accurate depiction of stuffs and props loses its importance with Stuart. Stuart amazed his contemporaries by combining resemblance in his portraits with an artistic display of great spontaneity and technical virtuosity. His sketchy effects and transparent colors make the likeness appear to have been achieved with unusual ease. Strongly influenced by his English contemporaries Thomas Gainsborough and George Romney, Stuart worked toward a greater pictorial harmony and simplification of form than can be found in Copley's work. His painting style was to supersede Copley's in popularity, particularly among the more wealthy and fashion-conscious. As the art critic John Neal remarked in 1829: Copley's work, once so much admired, is now considered to look like so much "coloured porcelain."[2] Earlier in 1816, one painter claimed that Stuart's style "has bewitched all artists." His appeal can be summed up by one of his satisfied Philadelphia sitters, Lady Liston, who wrote of his work: "The pictures, for they are really pictures as well as portraits, are nearly finished."[3]

The brushy celebration of paint as paint, seen in many contemporary European portraits, preceded Stuart's arrival in the United States, but Stuart's highly visible success as a painter of celebrities and his many followers were instrumental in popularizing the new aesthetic. John Johnston's *Man in a Gray Coat* (Museum of Fine Arts, Boston) of about 1788 displays loose brushwork somewhat similar to Stuart's, but Johnston learned to paint this way from the Danish artist Christian Gullager, who worked near him in the Boston area in the late 1780s and early 1790s. When Stuart's work is compared to theirs, we can well understand the reasons for his quick ascendancy. The colors of Johnston and Gullager are not as pure, as transparent, or as decorative as Stuart's; and there is no evidence that their likenesses were considered to be as strong. Whether the sitter was physically attractive or not, the beauty of Stuart's colors—which were not necessarily accurate—the greater subtlety of his suggestive technique, and his more sophisticated drawing ensured a more aesthetically pleasing result.

The same painterly technique can be seen in the productions of other English-trained artists such as John Trumbull who, like Stuart, had

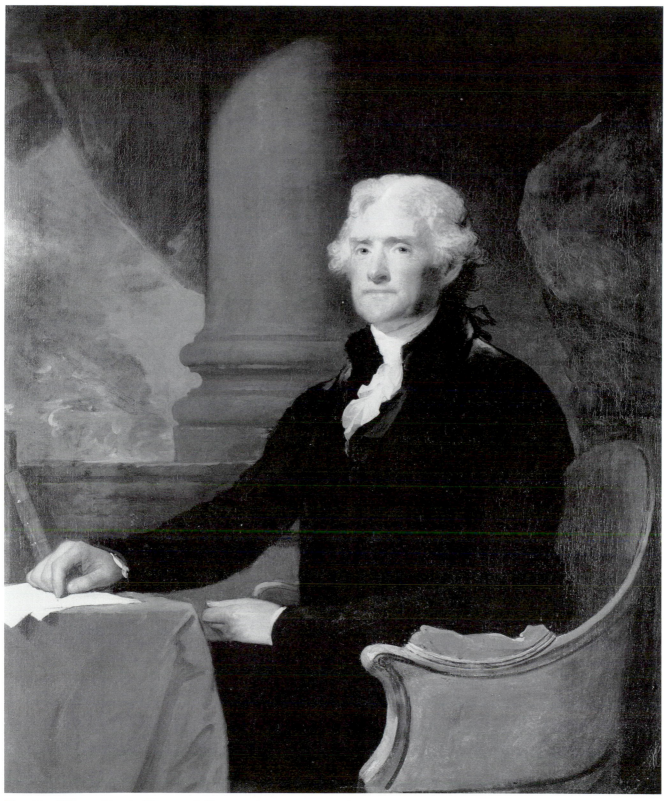

Fig. 36. Gilbert Stuart, *Thomas Jefferson,* 1805–7, oil on canvas, 48⅜ × 39¾ in. (122.7 × 101 cm). Bowdoin College Museum of Art, Brunswick, Me. Bequest of the Honorable James Bowdoin III.

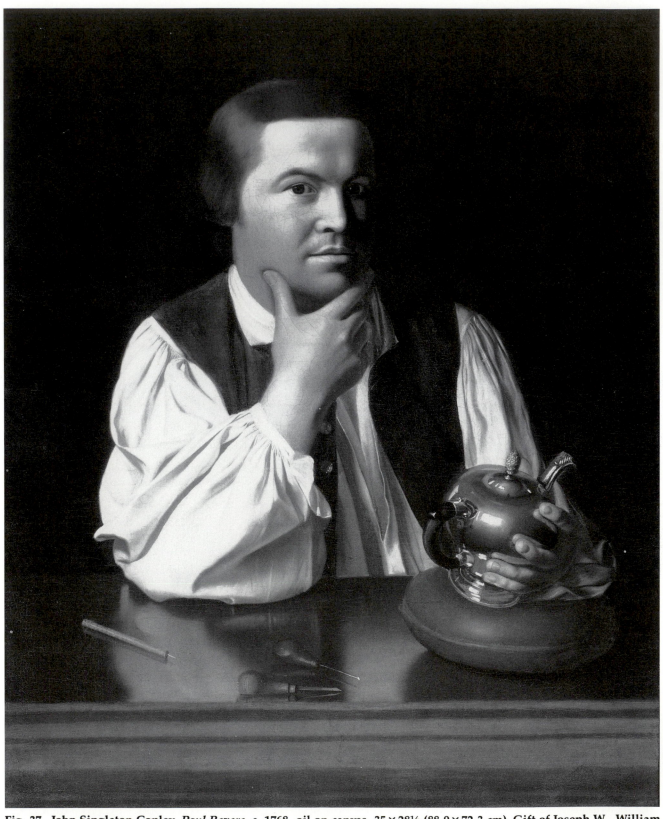

Fig. 37. John Singleton Copley, *Paul Revere,* c. 1768, oil on canvas, 35 × 28½ (88.9 × 72.3 cm). Gift of Joseph W., William B., and Edward H. R. Revere. Courtesy, Museum of Fine Arts, Boston.

been artistically educated in London in the studio of the Anglo-American painter Benjamin West. Influenced chiefly by Stuart and the English artist Sir Joshua Reynolds, Trumbull, while still a student, completed a life-size, knee-length portrait of *Sir John Temple* (1784; Canajoharie, N.Y., Library and Art Gallery) that is coloristically rich and atmospheric, the sort of picture that would be much admired in London, where it was exhibited at the Royal Academy in 1784. Later, after Trumbull had returned to the United States in 1789 with the intention of creating a series of history pictures on the theme of the Revolutionary War, he produced miniature oval portraits in oil on wood, such as the portrait of his niece, *Faith Trumbull* (1791; Yale University Art Gallery), which reveal the same fluid brushwork we have seen before combined with fresher, purer colors, more akin to Stuart's. In fact, Stuart now was the major influence.

Around the end of the eighteenth century, several English artists and a number of Americans studying in London, such as Mather Brown and later Washington Allston, experimented with ways of obtaining richer coloring. The most common method, used by Benjamin West as well, was to glaze the painting—that is, to build up the color in successive, transparent layers.[4] Each layer varied in color, sometimes only slightly, and often incorporated turpentine or perhaps varnish. Some artists, like Reynolds and later the American Thomas Sully, even added wax to their oil paint. With such experimenting relatively common, it is not surprising that after Stuart returned to the United States, Charles Willson Peale and other American painters tried to analyze Stuart's palette and procedure to discover, if possible, any reproducible "tricks." Peale thought perhaps he used wax. Stuart, in turn, scorned this sort of speculation, and even his daughter would not admit that he did glaze.[5] The point is that even in America there was great rivalry in this area and a new consciousness of the precedent of the famous sixteenth-century Venetian colorists. In a change that was characteristic of the time, Peale, who had had problems earlier with fading pigments, began to enrich his colors, especially after 1805. A good example is his portrait of the naturalist William Bartram (1808; Independence National Historical Park Collection).

The new focus on style and technique certainly resulted from the fact that America's artistic leaders in the Federal period had studied abroad and therefore received a more systematic and academic training than their forebears. More significantly, they nearly all trained in England where, instead of stylistic coherence, they found a new appreciation of various past styles. Unlike their colonial counterparts, they also had the opportunity, beginning with the Philadelphia Columbianum in 1795, to exhibit in America in competition with each other, and most had even exhibited in London. With such increased exposure they were understandably more stylistically self-conscious than the colonial artists. They learned from Sir Joshua Reynolds, the first president of the Royal Academy, then the best art school in the English-speaking world, and Benjamin West, the second president of the London academy, that they could improve themselves by copying in combination the finest attributes of the approved old masters. For instance, in addition to working from nature, they might try to combine, in one picture, the grace of Correggio with the subtle coloring of Titian while trying to avoid whatever faults both might have.[6] One result of this exercise was a heightened awareness of differing precedent. Washington Allston was an artist who especially changed during his student years, almost chameleonlike, as he explored different paths taken by his precursors. His early *Romantic Landscape* of about 1803 (Concord Public Library) combines bandittilike figures at the left, inspired by Salvatore Rosa, with a landscape somewhat imitative of work by Claude Lorraine.

Although John Vanderlyn did not study in London, the course of his career reflects the same picture-making consciousness. Having begun as Stuart's pupil, he left New York in 1796 under the advice of his mentor and sponsor Aaron Burr to study in Paris. His mature style, as seen in his portrait of *Mrs. Marinus Willett and Her Son* (Metropolitan Museum of Art) of about 1803, developed under the influence of the French neoclassical artists François André Vincent and Jacques-Louis David. In contrast to the English preference, his colors in this painting are deliberately subdued, the forms subtly modeled and sharply defined, and the brushstrokes almost invisible. As Rembrandt Peale and Abraham Tuthill were to do later, he knowingly rejected the English style and followed the French taste for a dignified restraint. Yet his style was to change gradually before his final return from

Paris in 1815. His portrait of *Zachariah Schoon-maker* (National Gallery of Art, Washington) from about 1816 is more broadly handled and introduces warmer color in the flesh so that the earlier severity is now somewhat softened. Vanderlyn, like Allston, was never merely imitative in the way that, for instance, the much earlier and changeable colonial artist John Hesselius was. Instead Vanderlyn worked out any transitions in style with a high-mindedness and a consciousness of his place in history that was more typical of this later period.[7]

As for the second area of change, portrait types, those seen in the colonial period continued. But the bust and the waist-length replaced in popularity the knee-length and the full-length. Possibly the proliferation of smaller sizes, which cost less, resulted from an increase in middle-class wealth and consequently middle-class patronage after the War of Independence.[8] The bust and the waist-length were also the sizes preferred by Stuart who undeniably set the standard of fashion. The specific bust type popularized by Stuart had appeared in the colonial period and showed the sitter from about the elbows up, with shoulders and head usually turned together to a three-quarter view.[9] As in James Frothingham's portrait of about 1823 of *Mary Ware* (Museum of Fine Arts, Boston), the background was often simply a rich dark color. In contrast, the waist-length comprised a greater variety of poses. One particular pose, again defined by Stuart as in his portrait of *Russell Sturgis* (c. 1820; Worcester Art Museum), conformed to a relatively rigid formula based on a contemporary type seen in London. The type had never been so formularized before, but it allowed Stuart to concentrate on the head, which is what really interested him.[10] In this format he showed the sitter seated as in the bust type, but seen to the waist with, at the bottom of the picture and parallel to the picture plane, bent arms, hands, and part of the chair's armrest. The background was usually a plain dark color, but it might include a red curtain drawn across the base of a classical column—a combination sometimes seen in the colonial period—or, as in his late Boston portraits, a paneled wall with a pilaster. Stuart's waist-length format, sometimes with slight variations, was copied by so many artists—among them, John Trumbull, John Wesley Jarvis, Samuel Lovett Waldo, James Frothingham, and Chester Harding (*Mrs. Mary Martin Kinsley*, fig.

38)—that a convincing argument could be made that it was the most successful, life-size, Federal portrait type.[11]

The standing, knee-length pose so often seen in colonial portraits, as in John Wollaston's *Mrs. Warner Lewis* (c. 1756; College of William and Mary), lost popularity during the late colonial and Federal periods but did appear occasionally. A few artists especially carried on in the earlier tradition. The pose, for instance, recurs in works by Ralph Earl, such as his portrait of *Major-General von Steuben* (c. 1786; Yale University Art Gallery).

So many more miniature portraits survive from the Federal period than from the colonial era that it appears that the demand for the cheaper, small portrait increased. In terms of quality, this might be considered the finest period for American miniatures, painted by artists that include Edward Greene Malbone, Benjamin Trott, James Peale, and Robert Field. The recently invented physiognotrace also made it possible, by mechanical contrivance, to produce accurate, small profile portraits such as the inexpensive silhouettes cut from black paper in Peale's natural history museum in Philadelphia or the more expensive and somewhat larger profiles finished in chalks by hand, with modeling and details added, by James Sharples. The French-born itinerant artist Charles Balthazar Julien Févret de Saint-Mémin was especially successful in mechanically producing profiles in miniature or life-size, as in the *Paul Revere* done in 1800 (Museum of Fine Arts, Boston).

The sudden proliferation of profiles is evidence of a new predilection that also appears in contemporary folk art. One example is Jacob Maentel's small watercolor of about 1812 of *The Daughter of General Schumaker* (National Gallery of Art, Washington, D.C.). The new desire for profiles, not paralleled in the colonial era, is one of the many expressions of the Federal period's infatuation with ancient Rome, for these profile likenesses were often deliberately reminiscent of those found on antique Roman coins and cameos. Stuart's eighteen-inch medallion portrait of Jefferson (1805; Fogg Art Museum) is a case in point. It would seem to be an aberration in his oeuvre, painted as it is in monochromatic gouache to simulate sculptured relief. But this portrait demonstrates the commonly held belief that the new American representative government was the proper heir to early Rome's public-

Fig. 38. Chester Harding, *Mrs. Mary Martin Kinsley,* **c. 1830, oil on canvas, 30 × 25 in. Minneapolis Institute of Arts, Minneapolis, Minn. The William Hood Dunwoody Fund.**

spirited republic. By being portrayed in this way, Jefferson, who was President when this was painted, could be lifted out of time and associated with the immortality of past greatness.

This brings us to a final discernible difference in portraits of the two periods. The Federal artist, usually in certain paintings of patriots, conceptualized the character of the sitter and presented it, in a new way, as a moral ideal. The new form of idealization depended not on props or a symbolic background, but rather on the representation of the head alone. Of all the differences cited so far, this emphasis on the sitter's moral status is the change that most distinctly evokes the end of the eighteenth century.[12] The Federal period was a time of hero-worship: of men such as Charles Willson Peale and Thomas Jefferson collecting portraits of famous men; of proud self-consciousness about the recent victory in the War of Independence; and of an awareness of Reynolds's upgrading of portraiture, especially when it concerned a hero, by defining the special category of "historical portrait." With regard to the last, Reynolds proposed grafting onto the portrait an association with "history painting" or narrative painting with inspirational, moral content. Although we know that colonial portraits of famous men were regarded as enlightening illustrations of virtue, the didactic content of surviving pictures of such men in the Federal period appears to be more focused and therefore frequently more pronounced. Perhaps creating greater difference, there is also a new striving to present readable, moral traits in the face. Possibly the operating influence here, which did not exist in the colonial period, was a widely read book called *Essays on Physiognomy*, written by the Swiss theologian Johann Caspar Lavater and then published in English in several volumes over the years 1789 to 1798. Lavater argued that physiognomy was a science and that one could learn to identify a person's moral character from the bone structure of his face and the permanent lines left by habitual facial expressions.[13] Artists such as Charles Willson Peale and Gilbert Stuart might disagree with Lavater's reading of character, but they evidently did not think the attempt was a futile exercise.[14]

It is instructive to compare Charles Willson Peale's 1768, full-length portrait of the English Parliamentarian William Pitt (fig. 39) with Gilbert Stuart's 1796 full-length of George Washington

Fig. 39. Charles Willson Peale, *William Pitt*, 1768, oil on canvas, 95¾ × 61¼ in. Westmoreland County Museum, Montross, Va.

(fig. 40), the so-called Lansdowne Portrait. Superficially they look very much alike. Both portraits incorporate symbolic references to ancient Rome; both are idealizations and are meant to be seen as examples of heroic virtue. The chief difference is that Stuart's *Washington* is not so much a portrait, with symbols to be read, as it is a personification of abstract ideas. When Peale was unable to obtain sittings with Pitt for his American-commissioned allegorical picture, he carefully copied his likeness from a sculptured bust of Pitt, taken from life (Scottish National Portrait Gallery). Most revealingly, Stuart, in contrast, had obtained a sitting with Washington for the "Vaughan Portrait," his first attempt at a likeness of the President, but afterward obliterated the result and repainted the image without the sitter (fig. 41). According to Stuart's own account relayed through a friend, he so admired Washington that he had insurmountable difficulty in

Fig. 40. Gilbert Stuart, *George Washington (Lansdowne portrait)*, 1796, oil on canvas, 96 × 60 in. National Portrait Gallery, Smithsonian Institution. Lent by Lord Rosebery.

Fig. 41. Gilbert Stuart, *George Washington (Vaughan portrait),* 1795, oil on canvas, 29 × 23¾ in. (73.5 × 60.5 cm). National Gallery of Art, Washington, D.C., Andrew W. Mellon Collection.

expressing "the character of Washington" when confronted with the physical reality. An X-ray of the Vaughan head shows that Stuart "rubbed out" the picture, just as he later claimed, and redid it, apparently from memory and his own imagination.[15] Despite his extra labor, Stuart was dissatisfied with this first effort. In his later full-length "Lansdowne Portrait," painted for Lord Lansdowne in England, he based the likeness primarily on his "Athenaeum Portrait" of Washington, a second head done from life, commissioned by Martha Washington (Museum of Fine Arts, Boston, and the National Portrait Gallery, Washington, D.C.). Contemporaries complained that this second head did not closely resemble the sitter, but the younger artist Washington Allston probably best understood Stuart's intention when he admired the Athenaeum likeness as the "personification of wisdom and goodness."[16] Basically Stuart was again painting not so much the physical Washington as Washington's character. Evidently the artist perceived the task as of immense importance. He was creating an icon for posterity, representing the father of his country and one of the most revered men of the age. Instead of starting with the likeness, as the more literal Peale did, Stuart began with an attempt to convey his preconceived idea of Washington, to interpret the president's face and give the whole image appropriate grandeur.

When one compares the heads by Peale and Stuart, it is clear that Stuart's alone, with its more massive, blocklike form, distant gaze, and glowing flesh colors, conveys an extraordinary spiritual strength, and that this in itself is the essential content of the picture.

Peale gave Pitt an ideal character, in his role as a defender of liberty, by adding readable symbols such as the Roman military dress and the orator's pose. In this same way the late colonial artist was inclined to upgrade the sitter by association, chiefly through the use of borrowed costume and pose.[17] An extreme example might be Copley's *Mrs. Jerathmael Bowers* (Metropolitan Museum of Art), of about 1767, which closely follows the aristocratic image in James McArdell's mezzotint after Reynolds's portrait of Lady Caroline Russell, with the exception of the likeness in the head. Stuart incorporated a few symbols similar to Peale's, such as the classical column, in his full-length of Washington and then, more typically, went beyond them.

Although most portraitists did not follow Stuart's lead in this particular direction, his portraits of Washington were so popular among Federal artists that they are especially representative of the period. In fact, the greater use of the head alone as a vehicle of moral expression is part of an international phenomenon in the late eighteenth century. Several other American painters of this time produced similar idealizations of the head, including John Trumbull and Charles Willson Peale's son, Rembrandt.

Although Stuart's portraits often flattered his patrons and gave them a remarkably apparent "good character," it was only sitters like Washington, whom Stuart personally admired tremendously, that would bring out an extraordinary effort.[18] This was to be nearly always true of Trumbull and Rembrandt Peale as well. Trumbull's bust-portrait of Alexander Hamilton, of about 1792 (fig. 42) has the insubstantial, pictorial quality of much of Stuart's work. But to subtly dramatize the sitter, Trumbull employed an increasingly popular chiaroscuro, ultimately derived from the famous seventeenth-century Rembrandt. Thus the head and shoulders are softly spotlighted from above by a seemingly supernatural light while the sitter looks above us and off into space, apparently lost in his ennobling thoughts. Rather than being psychologically penetrating, this is a generalized, idealized portrait, presented with the dignity and emotional restraint of the period.

In another example, this time a more strongly individualized likeness, the younger Peale used the same unexplained illumination to cast a mysterious light on the head and surrounding darkness in his 1812 portrayal of his father, *Charles Willson Peale* (fig. 43).[19] The effect is to suggest a sentience or life within the sitter. Rembrandt Peale's later "Porthole Portrait" of Washington is a more remote glorification, showing a head sanctified by almost a halo of background light, now combined, for a deifying effect, with the unseeing eyes of a visionary and with direct allusions to Roman greatness (Pennsylvania Academy of the Fine Arts). Produced in the spirit of the Federal age, although it was actually painted in about 1824 (the first of its type having been done in 1823), it was not executed from life and is the result of great agonizing, once again, over how best to convey Washington's virtuous character.[20]

Although Trumbull, Charles Willson Peale, and Stuart were the leading American artists in

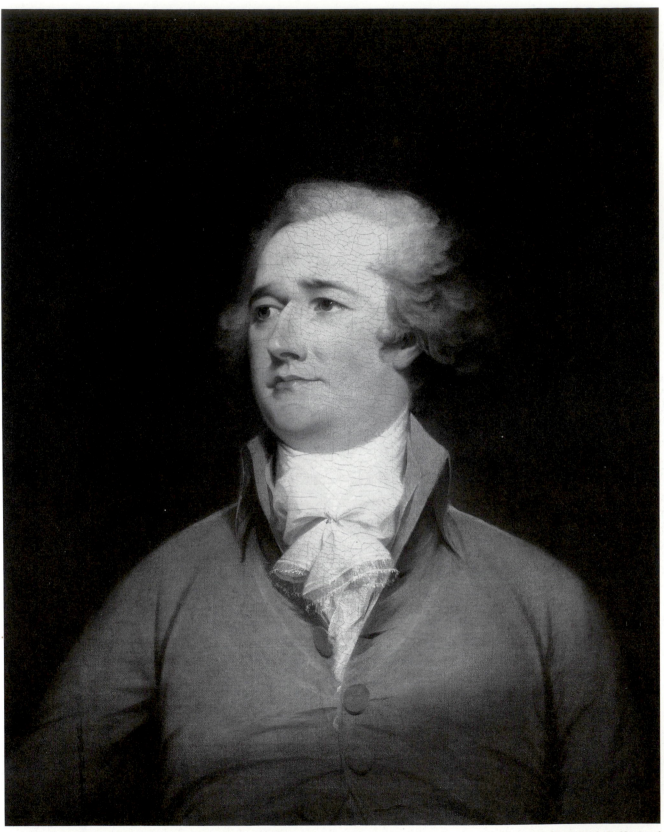

Fig. 42. John Trumbull, *Alexander Hamilton,* **c. 1792, oil on canvas, 30¼ × 24⅛ in. (76.9 × 61.3 cm). National Gallery of Art, Washington, D.C. Gift of the Avalon Foundation.**

Fig. 43. Rembrandt Peale, *Charles Willson Peale*, 1812, oil on canvas, 29¾ × 24½ in. Historical Society of Pennsylvania, Philadelphia.

the United States at the beginning of the nineteenth century, it was Stuart, and secondly Trumbull, who commanded the greatest respect. As the subject of the later painting of 1858 by Carl Schmolze, suggests—*Washington Sitting For His Portrait to Gilbert Stuart* (see fig. 52)—Stuart borrowed stature from the fame of his sitters. Patrons came to him for their portraits, not only because of his ability but also because of his celebrity status. His fame differed from Copley's of an earlier period because in a new nation many of Stuart's sitters were nationally known, and furthermore his reputation, like Trumbull's, was regarded as international. As one art historian aptly observed, Stuart's presence in the United States served to drive a "wedge" between artisan and professional talent.[21] The wedge was driven further by attempts by artists during this period to organize themselves. They hoped to improve their professional status by regularizing public exhibitions of their work and giving better artistic training to beginning artists through such institutions as the 1805 Pennsylvania Academy of the Fine Arts. By about 1815 they had made remarkable strides toward achieving these ends. The Federal period was a time of raised ambition for artists, inspired by the extraordinary success of a few who had proven themselves in a European arena. These few included the expatriate Benjamin West as well as Allston and Vanderlyn, who tended to stay abroad during these years.

The various, most innovative painters during the Federal period demonstrate a fundamental and lasting change in the attitude of influential American artists. There was an acceptance, never seen before, of a European challenge, which was encouraged by a growing sense of pride in nationhood. The adoption, by the most influential artists, of the new, painterly English manner brought with it an emphasis on pictorial qualities such as style, technique, and color. Essentially the conversion to a painterly style, which became increasingly accepted in the early nineteenth century, was symptomatic of a new appreciation of the presence, in a work of art, of the artist's hand, and, consequently, of the artist as an interpreter. This was helped by the general perception of the temperamental Stuart as a genius.[22] Gradually the mimetic, less expressive style of John Singleton Copley receded into the past.

Notes

1. Jules David Prown, in "Style as Evidence," *Winterthur Portfolio* 15 (Autumn 1980): 205, compares artifacts from the two periods, including picture frames, concluding that in contrast to a colonial frame, a Federal frame separates a painting from its surroundings. See his discussion of Copley's portrait of Revere as expressive of "the dominant aesthetic sensibility of the third quarter of the eighteenth century" (200).

2. Harold Edward Dickson, ed., "Observations on American Art, Selections from the Writings of John Neal (1793–1876)," *Pennsylvania State College Bulletin* 37 (5 February 1943): 43.

3. John S. Cogdell in his "Diary," vol. 3, [Sept.] 15, 1816, MSS Collection, Henry Francis du Pont Winterthur Museum; Lady Liston to James Jackson, 8 October 1800, Sir Robert Liston Papers, National Library of Scotland, Edinburgh. Stuart observed, after his return to the United States: "In England my efforts were compared to those of Vandyke, Titian and other great painters—but here! They compare them to the works of the Almighty!" ("American Painters," *American Quarterly Review* 17 [March 1835]: 177). Partly because of him, the Federal period saw a change in this attitude. An instance is Samuel Lovett Waldo's advertisement in the *Charleston Courier* for 18 December 1804: "He flatters himself his work will be satisfactory, no less for the strong likenesses he takes, than his style of painting."

4. Dorinda Evans, *Mather Brown, Early American Artist in England* (Middletown, Conn.: Wesleyan University Press, 1982), 191 n. 39. William H. Gerdts in *"A Man of Genius," The Art of Washington Allston (1779–1843)* (exh. cat., Boston: Museum of Fine Arts, and Philadelphia: Pennsylvania Academy of the Fine Arts, 1979), 32. For West and Trumbull on glazing, see Theodore Sizer, *The Works of Colonel John Trumbull, Artist of the American Revolution* (New Haven: Yale University Press, 1967), 135. For West's interest in a supposed rediscovery of the "Venetian secret," see Helmut von Erffa and Allen Staley, *The Paintings of Benjamin West* (New Haven: Yale University Press, 1986), 134. For Trumbull's experimentation with the "Venetian secret," see Irma B. Jaffe, *John Trumbull, Patriot-Artist of the American Revolution* (Boston: New York Graphic Society, 1975), 209.

5. M. Kirby Talley, Jr., in Nicholas Penny et al., *Reynolds* (exh. cat., London: Royal Academy of Arts, 1986), 63. Sully covered the painted surface of his 1812 portrait of Margaret Siddons (Worcester Art Museum) with a wax mixture before he added a final glaze containing asphaltum, Vandyke brown, and varnish. In his journal "Hints for Pictures," Sully wrote in 1809, "I find wax is sometimes used by the English painters" (typescript copy, MSS Division, New York Public Library, p. 14). Typed transcript of C. W. Peale's diary, vol. 23, 5 November 1818–29 January 1819, p. 25, Peale-Sellers Papers, American Philosophical Society, Philadelphia. All primary sources for Peale in this paper may be found on microfiche (*The Collected Papers of Charles Willson Peale and His Family*, Lillian B. Miller, ed. [Millwood, N.Y.: Kraus Microform, 1980]). Peale also experimented with encaustic (see Charles Coleman Sellers, *Portraits and Miniatures by Charles Willson Peale* [Philadelphia: American Philosophical Society, 1952], 13). On Jane Stuart's denial, see Charles H. Hart's review "Mason's Life of Stuart," *American Art Review* 1 (March 1880): 222.

6. For stylistic variety in England, see Robert R. Wark, *Ten British Pictures, 1740–1840* (San Marino, Calif.: Huntington Library, 1971), 8–12. On Reynolds, see his discourse 6, delivered 10 December 1774, in Sir Joshua Reynolds,

Discourses on Art, ed. Robert R. Wark, 2d ed. (New Haven: Yale University Press, 1975), 113; also see Reynolds's discourses 4 and 5. Draft of Benjamin West's letter, 1808, to Lord Elgin, mss. 36,297f31, The British Library, London.

7. For Vanderlyn's high-mindedness and expressed desire in 1808 to improve his color, see William T. Oedel, "John Vanderlyn: French Neoclassicism and the Search for an American Art," Ph.D. diss., University of Delaware, 1981 (facsimile, University Microfilms International), 442, 447, and 350. As for being typical, one of the most enlightening comments on the period is found in James Jackson Jarvis, *The Art-Idea* (New York: Hurd and Houghton, 1864), 117: "Looking back, we find the American school of painting in its first phase foreign and aristocratic in sentiment. . . . Their lineal successors are our academicians, whom fashion rules instead of the loftier feeling which animated the art of Stuart, Trumbull, and Allston."

8. See Jean Lipman, particularly as to how this affects folk art, in *American Folk Painters of Three Centuries* (New York: Hudson Hills Press for Simon and Schuster, 1980), 15.

9. E. P. Richardson, *Gilbert Stuart: Portraitist of the Young Republic* (exh. cat., Washington, D.C.: National Gallery of Art, and Providence: Museum of Art, Rhode Island School of Design, 1967), 32, is mistaken in implying that Stuart "created" a specific bust-type portrait that is therefore American.

10. The separation of the head, as most important, from the rest of the image (which becomes a formula in Stuart's work) strangely recalls the use of mezzotints for generalized bodies in early colonial portraits. Often the colonial likeness was of special importance for purposes of identification because the rest of the painting was imaginary.

11. Oswald Rodriguez Roque in Helen A. Cooper et al., *John Trumbull: The Hand and Spirit of a Painter* (exh. cat., New Haven: Yale University Art Gallery, 1982), 105, concludes that this formula derived from Trumbull's late portraits, but Stuart established the type earlier. Two examples of this kind of derivative composition by Trumbull are *Christopher Gore*, c. 1801 (Massachusetts Historical Society) and *John M. Trumbull*, c. 1802 (private collection).

12. For "true revolutionaries" as political leaders seeking the "exaltation of spiritual values" in the late eighteenth century, see Neil Harris in Charles F. Montgomery et al., *American Art: 1750–1800; Towards Independence* (Boston: New York Graphic Society, 1976), 29.

13. Johann Caspar Lavater, *Essays on Physiognomy, Designed to Promote the Knowledge and the Love of Mankind . . . translated from the French by Henry Hunter, D.D.* (London, 1789), 1:99.

14. C. W. Peale to Col. Nathaniel Ramsey, 17 March 1805, Letterbook 6, Peale-Sellers Papers, American Philosophical Society; Peale's marginalia in J. C. Lavater's *Aphorisms on Man* (Dublin, 1790). For Stuart, see Henry T. Tuckerman, *Book of the Artists, American Artist Life, Comprising Biographical and Critical Sketches of American Artists* (1867; reprint, New York: James F. Carr, 1966), 117, who quotes Stuart's Lavaterlike analysis of George Washington's head. The same story was published by John Neal in 1823 (Dickson, "Observations," 2). See also Jane Stuart quoted on her father

in George C. Mason, *The Life and Works of Gilbert Stuart* (New York: C. Scribner's Sons, 1879), 37.

15. For more on the rubbing out of the Vaughan portrait and a reproduction of the X-ray, see Dorinda Evans, "Gilbert Stuart: Two Recent Discoveries," *American Art Journal* 16 (Summer 1984): 86–89. For Stuart's attempt to convey Washington's character, see William A. Dunlap, *A History of the Rise and Progress of the Arts of Design in the United States* (1834; reprint, New York: Dover Publications, 1969), 1:197.

16. On the lack of resemblance see Dickson, "Observations," 2. Also see Allston in Dunlap, *A History* 1:221. Tuckerman echoed this view in 1867 when he wrote: "It is acknowledged that [Stuart's] likeness of Washington is the only just representation of a countenance wherein the tranquillity of self-approval blends with wisdom and truth, so as to form a moral ideal in portraiture, as the character was in life" (Tuckerman, *Book of Artists*, 115).

17. The use of accessories as a statement of the sitter's character is recommended by Jonathan Richardson, *An Essay on the Theory of Painting*, 2d ed. (1725; reprint, Menston, Yorkshire: Scolar Press, 1971), 78. See Wayne Craven, *Colonial American Portraiture* (New York and Cambridge: Cambridge University Press, 1986), 339, for Copley's creation of grandeur "through props and setting rather than through a truly noble image of the man himself" in portraits painted before his departure for England in 1774.

18. C. W. Peale to Rembrandt Peale, 23 August 1823, Letterbook 17, Peale-Sellers Papers. Allston, emphasizing the spiritual aspect, called Stuart's late portraits "transient apparitions of the soul" (Dunlap, *A History* 1:223). In support of an international trend, see David Wakefield, *French Eighteenth-Century Painting* (London: Gordon Fraser, 1984), 72.

19. On generalized truth, see Reynolds's Discourse 4, delivered 10 December 1771, and Discourse 9, delivered 16 October 1780, in Reynolds, *Discourses*, 72, 171. David Huntington noticed a similar, supernatural illumination of the sitter in Rembrandt Peale's 1838 *John Calhoun*, which he interpreted as an attempt to "capture the 'soul'" of the sitter. See David C. Huntington, *Art and the Excited Spirit: America in the Romantic Period* (exh. cat., Ann Arbor: University of Michigan Museum of Art, 1972), 7, who develops this theme with some other nineteenth-century examples. Also, for British precedent and the mid-eighteenth-century development of the spotlighted portrait from seventeenth-century work by Rembrandt, see Desmond Shawe-Taylor, *Genial Company, The Theme of Genius in Eighteenth-Century British Portraiture* (exh. cat., Nottingham: Nottingham University Art Gallery and the Scottish National Portrait Gallery, 1987), 50.

20. For identification of the symbolic references, see Carol Eaton Hevner, *Rembrandt Peale, 1778–1860, A Life in the Arts* (exh. cat., Philadelphia: Historical Society of Pennsylvania, 1985), 66.

21. Samuel M. Green, *American Art, A Historical Survey* (New York: Ronald Press, 1966), 162.

22. See Charles Edwards Lester, *The Artists of America: A Series of Biographical Sketches of American Artists* (New York: Baker and Scribner, 1846), 131–32.

The Eighteenth-Century Portrait in American Culture of the Nineteenth and Twentieth Centuries

RICHARD H. SAUNDERS

At the conclusion of the colonial period, the portraits of this era, with the exception of those of loyalists that were destroyed by overzealous patriots, rested calmly on the walls of family residences. A handful of portraits of distinguished leaders of colonial government graced the walls of council chambers throughout the former colonies. During the succeeding sixty years, however, the colonial portrait sank to its lowest point. The portraits, virtually all of which were painted to be accurate likenesses rather than great aesthetic statements, fell from favor. Most colonial portraits languished in bedroom chambers and attics and the names of the artists were largely forgotten. Some colonial portraits fared better. A few of Charles Willson Peale's colonial works were intermingled with those of the Federal period and graced the walls of his museum in Philadelphia up to the 1850s.[1] Also, earlier than one might expect, colonial portraits were donated as curious relics of the past to historical organizations. One example was the anonymous portrait of *Anne Pollard* (1721), acquired for the cabinet of the Massachusetts His-

torical Society in 1834. While John Singleton Copley's portraits, of which well over one hundred were included in the annual exhibitions at the Boston Atheneum between 1827 and 1874,[2] were the most visible evidence during this period of colonial painting, only the occasional portrait by artists such as Joseph Blackburn, John Smibert, Peter Pelham, or John Greenwood could be seen anywhere. Other paintings entered historical collections at educational institutions. Such was the case with Smibert's *Bermuda Group* (1729–31, see fig. 9), purchased by Yale College in 1808, or Smibert's *James Bowdoin* (1736, Bowdoin College Museum of Art), bequeathed to the college in 1826; consequently these paintings received a degree of visibility during much of the nineteenth century that was not afforded most colonial pictures.

Throughout the nineteenth century the impetus for considering colonial portraits was largely historical. Those works that were collected by historical societies or remained on view at educational institutions did so because the sitters, not the artists, were of note. More often than not,

aesthetically pleasing portraits of lesser-known persons were ignored. One exception to this practice was the Bostonian Nathan Appleton's 1853 purchase of Copley's *Mrs. Richard Derby as St. Cecilia,* which he installed with his collections of Old Masters and contemporary American works.[3] Over time, as the period between the colonial era and the present grew, curiosity about the eighteenth century increased. In 1834, when William Dunlap published his history of American painting,[4] much of the information about colonial artists was lost or scattered. In his effort to provide the first comprehensive survey of American art, Dunlap had to satisfy himself with summaries of Copley, Peale, Benjamin West, Smibert, and a handful of others. Artists such as Robert Feke and Blackburn received only passing notice and artists such as Charles Bridges and John Wollaston none at all. How-

ever, by the 1860s articles began to appear slowly, but perceptibly and in ever-increasing numbers, such as William Whitmore's "Early Painters and Engravers of New England," which indicated a desire to know more than was then available about the colonial period.[5] Henry Tuckerman's 1867 work, *The Book of the Artists,* improved what was generally known about several artists including Feke and Matthew Pratt.[6]

Five years later, in 1872, the exhibition of American art by the Brooklyn Art Association brought together 180 works and was the first chronological exhibition of American art (fig. 44).[7] After the publication of Tuckerman's survey, such an exhibition was inevitable since it provided a forum for American art to be seen in its entirety. Included in this event were a handful of colonial paintings, among them Smibert's *Bermuda Group* (fig. 9) and Copley's *Moses Gill,* as

Fig. 44. American paintings on exhibition at the Brooklyn Art Association, from the *Catalogue of the Works of Art, Exhibited at . . . the First Chronological Exhibition of American Art of the Brooklyn Art Association* **(Brooklyn, N.Y., 1972), opp. p. 18. The Brooklyn Historical Society.**

well as five portraits of George Washington. Events of the next two decades, such as the centennial celebration in Philadelphia in 1876 and the centennial exhibition of Washington's inauguration, held at the Metropolitan Opera House in 1887, strengthened a rapidly rising appreciation of historical portraits. Not only had the passing of a century given a sense of historical perspective and appreciation that eluded earlier generations but other factors contributed as well. The rapid growth in the printing industry precipitated numerous periodicals that featured articles illustrated with portraits and historical events. In one form or another, colonial portraits and those from the first years of the Republic were being seen by the American public.

Writers and readers did not make much of the historical distinction between colonial and Federal portraits that we find so useful; they simply referred to this combined group as "early" American.[8] To nineteenth-century eyes the most remarkable of these early artists was Gilbert Stuart, who received the distinction of an 1880 retrospective exhibition at the Museum of Fine Arts, Boston. The earliest nineteenth-century exhibit of colonial portraits was held in 1886 at the Bostonian Society. There were assembled portraits of the Pitts family by Joseph Badger, Smibert, Blackburn, and Copley.[9] Each of the artists was given a degree of recognition that was relatively rare for this period, and the exhibition was commemorated by a lecture, "Provincial Pictures by Brush and Pen."[10]

A far more ambitious event occurred the following year when a loan exhibition of historical portraits, billed as the "first collection of its kind ever brought together in this country," was exhibited at the Pennsylvania Academy of the Fine Arts.[11] Five hundred and three portraits by both colonial and Federal artists were assembled. They included works by Peale, Copley, and Gustavus Hesselius, as well as both Pratt's *American School* and West's *Arthur Middleton Family.* This exhibition was the creation of Charles Henry Hart (1847–1918), at the time a director of the academy and soon to become a virtual dictator in the field of early American portraiture. Hart was a lawyer in Philadelphia who turned to a career in history and art after a railway accident. By the 1890s, as the leading authority on American portraits, he wrote articles that revived such artists as Gustavus Hesselius and

Matthew Pratt.[12] He was able, outspoken, possessed a discerning eye, and was the first scholar to gain national recognition for his expertise in American portraiture.

The year 1887 also helped to touch off a new wave in the "cult of Washington," which had existed almost since his death in 1799. Washington's image symbolized the American spirit in its purest form and it became ever more fashionable among collectors to own at least one portrait of the first President. While these portraits were virtually all painted after the colonial period, they were the force that "primed the pump" for the colonial portrait market beginning in the 1890s. While Washington's portrait was known since childhood to practically every American, few historians were so well-versed that they could distinguish a Gilbert Stuart from a painting by his daughter, Jane Stuart, or for that matter one by Charles Peale Polk. It was for this reason, among others, that Hart in 1889 organized an exhibition of the portraits of Washington.

Before this time, interest in collecting colonial and Federal portraits had been the purview of historical societies. But now, as part of the collecting phenomenon that swept America, there were new art museums and collectors flush with cash; it seemed that almost everyone was collecting something. Typical was the desire of autograph collectors to have a complete set of the signers of the Declaration of Independence or signers of the Constitution. This frenzy spread to portraiture; for instance, in the 1870s, Max Rosenthal (1833–1918), a Philadelphia printmaker and father of Albert Rosenthal (1863–1939), the portrait copyist and art consultant, was commissioned by a group of Philadelphia autograph collectors to make lithographic portraits to accompany autographs of American worthies for whom no engraved portraits existed.[13]

As early as 1867 Tuckerman observed about Copley's portraits that "the possession of one of these ancestral portraits is an American's best title of nobility."[14] During the post-Civil War years, when America became home to many immigrants, this concept was very much in the minds of wealthy Americans. For just as the proliferation of private picture galleries in the 1860s and 1870s were manifestations of one's culture, the ownership of early American portraits provided one more class distinction that served to

reinforce a sense of identity as an American and contributed to a larger notion about nationalism. By 1928 Albert Rosenthal, who by this time was a dealer and consultant, could write:

> the growing estimation of Washington has reached a point that seems to make it necessary for every man of large means to have a Stuart Washington as a household decoration. We might visualize eventually an exclusive social caste based solely on the ownership of a Stuart Washington portrait.[15]

The increased interest in colonial and early Federal portraits in the 1890s also attracted the attention of swindlers. In 1894 Edmund Frossard announced the exhibition in New York of a distinguished collection of 101 drawings of well-known persons by John Trumbull. This included portraits of Washington and his adjutant, Joseph Reed (fig. 45), both bearing inscriptions by the artist.[16] The problem was that the drawings, although similar to legitimate Trumbull drawings, were all forgeries. Suspicions about these drawings grew and one article in *The Nation* (13 September 1894) intimated that the drawings might not be right. Frossard maintained their authenticity despite the fact that they brought only a few dollars each when sold at auction. Lewis Fraser, who worked for the Century Company, wrote Hart in 1899 that "there existed in New York a gang whose business was the manufactory of Washington and other Revolutionary relics and that the head of the gang was one Butler a picture framer and art dealer, that two Trumbull portraits are the work of this gang and that the dealer Frossard who handled these was himself deceived."[17] Whatever the case, the fact was that colonial and Federal portraits were becoming so popular and valuable that they attracted forgers.

Three years after the Frossard scandal the attentions of the art world were turned on Thomas B. Clarke (1849–1931) (fig. 46), a successful dry-goods merchant turned collector and art patron, who sold his enormous collection of contemporary art for $234,000.[18] Less well known is the fact that having sold this collection at considerable gain, he set out to create a collection of colonial and Federal portraits. Clarke was among the first American collectors to aggressively create a sizable collection of such work. While his intentions as a collector have never received much analysis, he apparently hoped to duplicate

Fig. 45. Unidentified artist, *Adjutant General Joseph Reed,* late nineteenth century, pen and ink on inside of book cover, 6⅞ × 5⅛ in. (17.5 × 13 cm.). Yale University Art Gallery, New Haven, Conn., Gift of the Associates in Fine Arts.

Fig. 46. Thomas B. Clarke. Photograph from the *Home Journal,* 10 January 1901. *Scrapbook, 1900–1902,* Thomas B. Clarke Papers, Archives of American Art, Smithsonian Institution, Washington, D.C.

the success of his 1899 sale. We know this because exactly twenty years later he sold his collection of fifty pictures at auction for $78,000 and in the process set several price records, such as the $21,000 paid by the Duveen Brothers for a Stuart portrait of George Washington.[19]

If the 1890s stirred a national interest in collecting great historical portraits, the next two decades shaped the pattern of collecting, both by institutions and private collectors. Before 1900 an occasional colonial and Federal portrait entered the collections of the Metropolitan Museum, the Museum of Fine Arts, Boston, the Wadsworth Atheneum, and other eastern museums, most of which had either been founded recently or, as in the case of the Atheneum, had recently received an influx of new blood and money. The Metropolitan, for example, was given Pratt's *American School* (1765) in 1897,[20] and the Museum of Fine Arts, Boston, received a pair of Copley portraits about the same time. The Atheneum, however, made the bolder move of purchasing its first portrait by a colonial artist in 1901, when it bought Copley's *Mrs. Seymour Fort* (1778), a striking portrait painted after the artist had relocated in London.[21] Institutional collecting of colonial portraits spread; a few years later, the Worcester Art Museum bought Copley's *John Bours* (c. 1758–61) for $3,500.[22]

The interest in the colonial period was given a significant boost in 1909 when the Metropolitan Museum held an exhibit of eighteenth- and nineteenth-century American decorative arts and paintings in conjunction with the Hudson-Fulton Celebration.[23] Both Copley's *Mrs. Seymour Fort* and Pratt's *American School* were prominently displayed. This exhibition was followed in 1912 by one at the Museum of Fine Arts, Boston that was considerably smaller in scale but similar in content.[24] These events, and the institutions' collecting patterns, reflected an increasing desire to be able to exhibit in a coherent historical fashion works by the earliest American artists.

Despite the obvious enthusiasm for early America most collectors possessed a superficial knowledge of the major artists. Even many of those people doing the buying for museums knew relatively little about the individual artists or characteristics of their work. Consider that in 1910 the existing literature on early portraiture, outside of the summary treatment in most surveys, consisted of a handful of chatty but insubstantial books on Copley, West, and Stuart, and

a scattering of rudimentary checklists and articles, such as that by Hart on Gustavus Hesselius. Studies in any form on almost every other colonial artist simply did not exist.

Meanwhile, prices for colonial and early American portraits were rocketing skyward. In 1912 Thomas Clarke paid over sixteen thousand dollars for a Stuart portrait of Washington, the highest price ever paid to that point for an American portrait.[25] And prices such as this seem paltry when compared to the astronomical sums that J. P. Morgan, Henry Clay Frick, and Henry Huntington paid for British portraits by Reynolds, Raeburn, and Romney. It is hard to conceive today, but one dealer remarked in 1919 after a visit to Frick's home that hanging on the walls were two Romneys for which the collector had paid approximately two hundred thousand dollars each,[26] a price that matched or exceeded that of most Old Masters at that time.

The art climate in America could not have been more ripe for what followed: a decade and a half during which literally dozens of British paintings entered American collections as bogus colonial and Federal portraits. Charles Henry Hart sounded the first cry of *caveat emptor* in 1913 with an article titled "Frauds in Historical Portraiture."[27] While his concern was the portraits printed in the 1880s and passed off as legitimate likenesses (such as that of Caesar Rodney, for whom no known portrait existed), the message was clear: the desire by American collectors to acquire portraits of known citizens was being fueled by faked portraits.

At the same time a curious situation developed. The market for portraits had grown so rapidly that there were now numerous institutions and private collectors who desired paintings. But these prospective buyers were generally unable to evaluate them either in terms of authenticity or quality. Since most American museum staffs were in an infantile state, like that of the museum profession itself, they lacked personnel knowledgeable about portraits as well. As a result both private collectors and museums found security in "certificates of authenticity." These were provided by the experts in the field, such as—ironically—Charles Henry Hart, who by this time had become an independent dealer/consultant. These consultants were responsible for what one dealer called "the certified swindle."[28]

In 1917, for example, the Worcester Art Mu-

Fig. 47. Unknown artist, formerly attributed to John Smibert, *Unknown Man, formerly identified as the Reverend George Berkeley,* early eighteenth century, oil on canvas, 30 × 25 in. Worcester Art Museum, Worcester, Mass.

seum bought its first Smibert portrait, or so it thought. The portrait was purported to be George Berkeley (fig. 47). Although offered by a Boston dealer, it had been formerly owned by Hart and came with the following endorsement from him:

> May 1917
> To the Trustees at Worcester. . . . The portrait submitted to you as a portrait of Dean George Berkeley, afterward Bishop of Cloyne painted by John Smibert is in my opinion an original from life. . . . It is also in my opinion a very fine example of the work of John Smibert and a desirable portrait of Bishop Berkeley, his gown and hands, particularly important for being signed and dated.[29]

And when the museum asked for the provenance they were told that "the elderly lady who formerly owned the Smibert Berkeley portrait lives in Waterbury, Connecticut, but will not allow her name to be given."[30] Not until years later, as more was learned about Smibert's style, did it become apparent that this was not by the artist and the signature had been added to an otherwise unidentified eighteenth-century British portrait.

Hart's endorsement might be excused simply as uninformed enthusiasm were it not for the fact that a number of other questionable portraits bearing Hart's stamp of approval were sold by him to at least one other unsuspecting collector. Alexander Smith Cochran, a carpet manufacturer in Yonkers, New York, had at the suggestion of Thomas Clarke decided to create a portrait collection. In 1907 he sought both Clarke's and Hart's advice in the creation of this collection, now exhibited in part at Philipse Manor Hall, Yonkers, which was to include portraits of each of the American presidents, as well as portraits of distinguished colonial patriots.[31] The collection of more than sixty portraits, some of them worthy examples by recognized artists, is also a minefield of overattributions, misidentifications, and some of the most ingenious forgeries of the time. Some practices are excusable, such as assigning to Charles Willson Peale a portrait of George Washington that is now known to be the work of Charles Peale Polk. A more flagrant sleight of hand was the practice of photographing legitimate portraits, touching up the surface with pigment to give it a sense of texture, and then varnishing it. In the case of a self-portrait by Benjamin West (fig. 48), a chromolithograph was so treated and then sold as a legitimate painted portrait.[32] While this seems difficult to fathom today, given our reliance on close scrutiny of the paint surface and advanced conservation techniques, just such a situation did develop because trusting but unknowing collectors placed themselves in the hands of unscrupulous advisors.

All of this begs the question: why would the most respected authority in American portraits be involved in such tawdry activity? In actuality Hart had been an undercover dealer since 1875 and had accepted commissions from dealers on paintings that as a director of the Pennsylvania Academy he urged his institution to buy. He had moved to New York from Philadelphia because of personal and professional crises, married his godmother, and after her death is said to have married an Argentine dancer whose extravagance financially exhausted him.[33]

It was, therefore, not coincidence that Charles Henry Hart and Thomas Clarke cooperated in the formation of the Cochran collection. In reality Thomas Clarke was a Janus-faced figure. If his image, even now, is that of a champion of American artists and a patron of the arts, his unknown side, according to the report by James W. Lane and Anna Wells Rutledge written in 1951–52 for the National Gallery of Art, is that of a charlatan who became a collaborator of Charles Henry Hart. Few of his contemporaries seem to have sensed that there was more at work in Clarke's mind than simple patriotism and philanthropy. While there may have been some surprise when in September 1891 Clarke opened Art House, an establishment that primarily sold Oriental porcelains and Greek antiquities, most people probably perceived this as simply good enterprise. Twenty-five years later, however, Clarke incorporated a second, more malevolent Art House at 12 East Forty-first Street, from which he manipulated the portrait market and flooded it with overrestored and overattributed pictures, as well as outright frauds. Given his motives, it is not surprising that Clarke believed that no portrait was meritorious unless the artist and sitter were identified.[34] Over the remaining years of his life he convinced others of this belief and in so doing was able to pawn off on them portraits that without the identities he provided would be of little monetary value. Art House

Fig. 48. **Unidentified artist after Benjamin West,** *Benjamin West,* chromolithograph on canvas, 29¼ × 24¼ in. New York State Office of Parks, Recreation and Historic Preservation; Philipse Manor Hall State Historic Site, Yonkers, N.Y.

became his conduit. In name it was run by four of his colleagues: Clarence J. Dearden, who was the money handler; Alice T. Bay, who acted as secretary; Thomas B. Clarke, Jr., and Charles X. Harris, a portrait copyist and restorer who had been curator of the Philipse Manor Hall collection from 1911 to 1916. Thomas Clarke, Sr., remained in the background as the principal financier.[35]

The formation of the Cochran collection and other misdeeds by Hart and Clarke were only preamble to the activities of the 1920s, during which over sixty colonial and Federal portraits passed through the hands of other leading dealers to dozens of unsuspecting institutions and private collectors. One dealer who embraced the increasing demand for portraits was Frank Bayley (1863–1932). As proprietor of the Copley Gallery in Boston (fig. 49) he sold a wide variety of work that ranged from that of Winslow Homer to contemporary Boston artists. But his passion

Care and Restoration of Pictures

The care and restoration of pictures is a subject deserving careful attention. We are prepared to give you expert advice as to what is necessary to repair injury, revive color and prevent further disintegration.

Lieut.-Gov. WILLIAM STOUGHTON
By Evert Duyckinck

If valuable pictures are neglected until the paint falls off, as it surely will under certain conditions, restoration not only becomes difficult, but more expensive.

IT IS ADVISABLE TO HAVE YOUR PICTURES EXAMINED FREQUENTLY

Often washing and varnishing, which may be done at your house, is all that is necessary to restore the color and prevent cracking.

COPLEY GALLERY
103 NEWBURY STREET
BOSTON, MASS. F. W. BAYLEY & 'SON

Fig. 49. Copley Gallery advertisement from *Old-Time New England* (1920), inside back cover.

was early American portraits. In 1915 he published a semischolarly work on Copley and in 1918 was coeditor of the revised edition of William Dunlap's history of American art of 1834.[36] He was also responsible for several discoveries, such as bringing to the attention of scholars the signed and dated portrait by Nathaniel Emmons of Andrew Oliver (1728, private collection). He had an excellent local reputation and although in later years he was considered pompous, his opinion was highly valued.[37] Beginning in 1920, however, he began a relationship with Augustus de Forest (d. 1951), a New York dealer, who would bring about Bayley's downfall.

"Gus," as he was known in the trade, was actually Augustus Oberwalder. His father, uncle, and brother were German dealers and restorers of paintings in New York with whom he worked before he set out on his own. In 1918 he changed his name, an understandable occurrence at this time given the anti-German sentiment during the First World War. Although he may well have been associated with Hart and Clarke in the early teens, his first confirmed forgery dates from 1915. That year he sold at auction, under the name of A. W. Oberwalder, a portrait identified as *Alexander Garden*, which bore a fraudulent signature of John Smibert. The portrait passed through several dealers, including Thomas Clarke, before coming to rest in the National Gallery.[38] Two years later he was responsible for the so-called portrait of Berkeley attributed to Smibert that was acquired by the Worcester Art Museum. De Forest, according to the 1951 report, was particularly adept at inscribing the back of canvases with dried, faded ink, or signing them in red paint on the surface. Some of these activities took place at Clarke's Art House.[39]

By 1920 De Forest was beginning to "locate" colonial portraits of highly important New England merchants, governors, and magistrates that he began to offer to many other dealers, among them Walter and Harold Ehrich and Robert Macbeth in New York and Robert Vose in Boston. Bayley's first contact with him was indirect. In 1920 he sold to the Boston Atheneum, on behalf of Vose, a portrait identified as Governor William Stoughton by Evert Duyckinck. This was a portrait in which he took sufficient pride to feature in his advertisements.

What was not realized at the time by either

Bayley or Vose was that the painting was a fake. De Forest had developed the perfect ruse. Assisted by his wife, Rose, and others, he acquired late-eighteenth-century British portraits, gave them the identities of distinguished colonial citizens to make them marketable, and then assigned them to colonial artists whose style was sufficiently unknown to make them difficult to dispute. Such was the case with the so-called *Self-Portrait* of the colonial silversmith Jeremiah Dummer, a painting that confused scholars for years.[40]

When the portrait of Stoughton sold easily, Bayley thirsted for more. Over the next ten years he sold over two dozen portraits supposedly by Smibert, Blackburn, and Feke, among others, that upon more recent scrutiny have turned out to be bogus. Each was accompanied by a certificate detailing the painting's provenance. All of this was creatively compiled by Mrs. de Forest, who specialized in genealogy and who is remembered as a regular visitor to the Frick Art Reference Library and the local history room of the New York Public Library.[41] Over the next ten years Bayley became the primary, but far from exclusive, outlet for spurious portraits put forth by de Forest, who billed himself as a Ph.D. on his letterhead and certainly realized that there was far greater likelihood of his sham New England colonial portraits passing muster if they were laundered by the respected Copley Gallery.

The process was sophisticated and relied on the faker's ability to assess the style of a particular colonial artist. For example, the so-called *Mrs. Oxenbridge Thacher* (private collection), which bears a fake Robert Feke signature, is in many ways superficially similar in palette and costume to legitimate works such as *Mrs. John Bannister* (1748, Detroit Institute of Arts). And the portrait once called *Lieutenant Governor William Tailor* (The Brooklyn Museum) (fig. 50), which bears a fake but believable Smibert signature, is most likely the work of Thomas Gibson (c. 1680–1751). Gibson was Smibert's good friend and London contemporary and his portraits such as *Sir William Pynsent* (private collection), signed and dated 1737, are virtually identical to the Brooklyn picture.[42]

Another example of de Forest's treachery attested to his belief in the simple economic principle of supply and demand. In April 1927 Bayley wrote Harold Ehrich in New York: "Regarding portraits attributed to Peter Pelham, there are very few authentic portraits by Peter Pelham and I know of no one who is competent to decide whether a portrait is or is not by Peter Pelham."[43]

This information reached de Forest, and, as luck would have it, in June, only two months later, de Forest "located" a signed Pelham portrait of *William Greene*, a Massachusetts governor whose portrait was otherwise unknown. Bayley promptly sold it.[44] This scam most likely succeeded far beyond the wildest dreams of de Forest and the others involved. In succession Bayley's trusting clients stepped forward. The list of buyers is a virtual *Who's Who* of institutional and private collectors of colonial portraits.

Henry Wilder Foote[45] and others have suggested, I believe unfairly, that Bayley was entirely cognizant that the de Forest paintings were fraudulent. As any ambitious dealer, Bayley sought works of art that he could sell easily and for significant sums, and he seems to have been less concerned with the origin of these works, as long as they were not stolen. Quite simply, his delight to have portraits of distinguished colonial citizens by identified colonial artists exceeded his desire to study these portraits as closely as he otherwise might have done.

A great handicap under which dealers and collectors operated was their willingness to let a lengthy provenance or "certificate of swindle" obscure the ability to judge a work objectively. Despite great protestations that "the technique style and manners peculiar to the artist is the best of all evidence"[46] in assigning portraits to artists, in reality, Bayley, Vose, Macbeth, Ehrich, and others relied heavily on written evidence rather than visual analysis. What made all of this so digestible was the fact that the dealers who handled these bogus paintings also marketed the best legitimate work. Bayley had sold a number of important early American portraits, including Copley's *Thomas Gage* (1768–69) and even de Forest had sold significant American works such as William Sidney Mount's *The Sportsman's Last Visit* (1835, The Museums at Stony Brook, Stony Brook, L.I.).

On occasion Bayley encouraged the de Forests, as in 1928 when he noted, "I received a call yesterday from a collector who is very anxious to secure portraits of prominent New England people painted before 1700 and if you would keep this in mind, it would be greatly appreciated."[47]

The de Forests did just that, but in so doing they also raised Bayley's suspicions, so that on

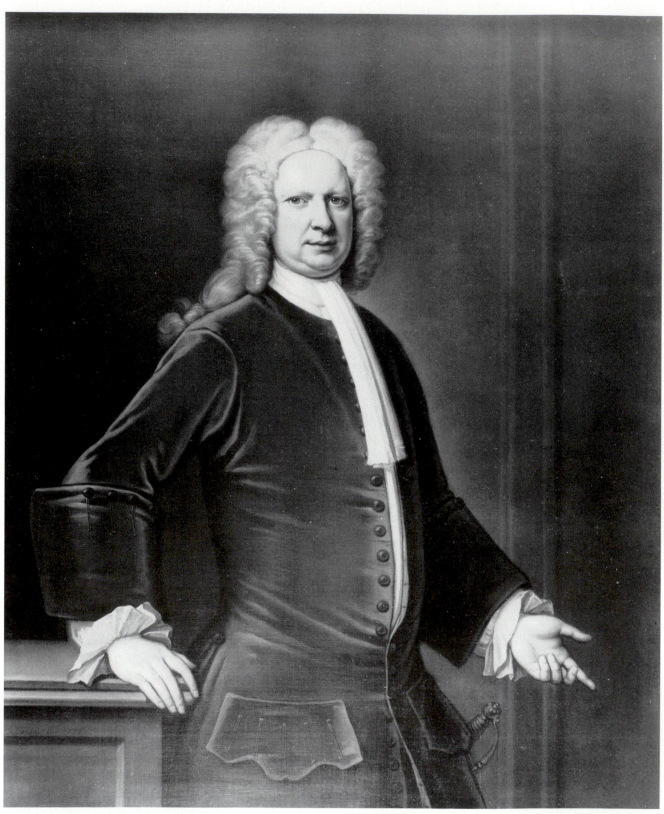

Fig. 50. Thomas Gibson, *Portrait of a Man*, c. 1725–30, oil on canvas, 50½ × 40⅜ in. The Brooklyn Museum, 43.230. Gift of Mr. and Mrs. Luke Vincent Lockwood.

Fig. 51. Unidentified artist after Gilbert Stuart, *George Washington,* **undated, oil on canvas, 30 × 25 in. Unlocated. Reproduced in** *The Boston Herald,* **28 October 1928. Courtesy, American Antiquarian Society, Frank W. Bayley Papers.**

several occasions he wrote:

> It is regarded as almost incredible that so many portraits of early American historical importance should be hidden away in two families and never discovered before. There is no reason why I should not continue to find buyers for you for these early American portraits, except that I must feel confident that statements I may make or histories I may offer can be proven beyond all question as to the personality of subjects.[48]

Ultimately Bayley's own greed consumed him. By 1928 the portrait market was booming; new sales records were being set with virtually every sales season. While this was good news for Bayley, the fact remained that he sold most portraits on consignment at a 20 percent commission and that meant that most of the profit went to someone else. On one fateful occasion, however, Bayley had the opportunity to amass instant wealth. He received a letter from Robert Macbeth (1884–1940), the leading dealer in American art at the time, alerting him to a Washington portrait (fig. 51) that might be by Gilbert Stuart. The portrait came to Macbeth from a person named S. W. Gaines in Fort Worth, Texas, although when reported by *The Boston Herald,* it was falsely said to have come from Charleston, South Carolina, where it had supposedly been for many generations.[49] Largely because the painting did not have a distinguished provenance, it was consigned to Macbeth for the nominal sum of seven hundred dollars. Macbeth invited Bayley to split the profit on it if he would sell it for him.

Although surviving correspondence suggests that Bayley's heart told him the painting was phony, his pocketbook told him to seize the opportunity. After failing to sell the painting to Senator Joseph Frelinghuysen of New Jersey, he succeeded in selling it to Judge Edwin S. Webster, a trustee of the Museum of Fine Arts, Boston. The price was $32,500—almost a 5,000 percent profit.[50]

Within two years, however, Webster had had the painting examined by others and during the process a lining canvas was removed. This revealed a 1928 stamp indicating that the painting had been copied at the Metropolitan Museum of Art from the Vaughan portrait of Washington that Samuel P. Avery had given the museum twenty years earlier.[51] Bayley and Macbeth were forced to return the money and take the painting back. Bayley, as the actual seller, was the figure publicly ridiculed; Macbeth, as the silent partner, avoided the spotlight. Unfortunately this event could not have happened at a worse time, for between the sale to Webster and the discovery of the fake, the stock market crashed and the deflationary cycle that followed ripped the bottom out of a bloated art market. Colonial and Federal portraits that had sold only months before at heady sums could now be had at bargain prices. For example, Copley's portraits of Mr. and Mrs. Joseph Hooper (c. 1770–71, private collection), which sold in 1929 for thirty thousand dollars, were offered unsuccessfully by Bayley in 1932 at half that price.[52]

Bayley's phony Stuart also contributed to the increasing suspicion of earlier portraits that he had sold. Two persons very active in this investigation were John Hill Morgan (1875–1945), a New York lawyer, collector, author, and trustee of the Brooklyn Museum, and Charles K. Bolton, the librarian at the Boston Atheneum. It was Morgan who first sounded the alarm over the bogus Stuart and cautioned Senator Frelinghuysen not to buy it, and it was Bolton who began to look suspiciously at the so-called William Stoughton portrait sold by Bayley in 1920.

In 1931 and 1932, as more and more buyers of de Forest/Bayley portraits began to examine the history of their purchases, they found that a number had the identical provenance, a highly improbable occurrence. One after another they turned to Bayley for explanation, who in desperation and with an increasing sense of persecution turned to de Forest to locate the nonexistent "previous owner." In June 1932 Bayley wrote Walter Ehrich:

> I am in trouble and need your help. In February 1920 I sold a portrait said to be of Governor William Stoughton attributed to Evart Duycking to the Boston Atheneum. I understand that Mr. Vose, for whom I sold it, secured the portrait from you and that you in turn received it from Mr. de Forest. The

portrait is questioned. . . . I must say to you in confidence that this is a very serious matter and hope no specious story on the part of de Forest will deceive you as I must know the truth and nothing but the truth.[53]

By 21 July 1932 Bayley received a letter from C. K. Bolton stating that he

> had not as yet been able to prove correct the evidence which you submitted to us with the so-called Governor William Stoughton portrait. I want to incorporate in the account the whole history of the picture, and am very sorry that I cannot say I feel sure of the authenticity of the evidence. I understand that the Stoughton, the Cony and the Phips [two other paintings sold by Bayley] all came from DeForrest. They seem to stand as genuine or fall as fakes as a group, and for the sake of the history of art I should like to have the whole question settled.[54]

By this point Bayley realized his career was ruined. Rather than face having to take these paintings back, at a time when the art market was in the doldrums, he drove to his summer house at Plum Island on Boston's North Shore and shot himself.[55] Shortly thereafter the gallery closed, leaving a number of creditors unpaid.

Bayley's death and the increased scrutiny of the Bayley/de Forest portraits by Bolton and others effectively brought to a close what Harry McNeil Bland, another New York dealer, referred to in 1939 as "the factory."[56] De Forest, curiously enough, remained in business at several New York addresses during the 1930s, although from this point on he dealt primarily in nineteenth-century pictures. Both de Forest and Clarke had considered themselves immune from detection. Both were also said to indulge in a sense of humor at the expense of the scholar and the museum. As late as 1951, when threatened with exposure, the surviving members of the clique were ready to sue those who dared to impute their reputations.[57] This was sufficient to subdue any open investigation.

The Depression and the cyclical nature of American art also took its toll on interest in colonial and Federal portraits. After selling his first collection of portraits in 1919, Thomas Clarke had, during the 1920s, assembled a second group of 164 portraits.[58] This collection, which included twenty-nine Stuarts, was highly esteemed by the unknowing public and, in fact, were featured as the opening exhibit in 1928 of

the new Philadelphia Museum of Art.[59] Most people did not realize that included in the collection were ninety paintings sanitized by Art House, sixty-two of which had come from de Forest.[60] When Clarke died in 1931 the collection was scheduled for auction. Other dealers were curious about the impact that the sale of so many portraits would have on the market, but they did not have the chance to find out: the sour economy forced an indefinite postponement of the sale. In the next few years the entire collection was sold to Andrew Mellon and ultimately given to the National Gallery, where it still resides. Mr. Mellon, it is said by John Walker, the gallery's first director, knew of the spurious paintings, but felt that since the collection also contained such American icons as Stuart's *Mrs. Richard Yates* and Savage's *The Washington Family*, the latter paintings more than justified its purchase.[61]

The late 1930s was the real watershed period for colonial portraits. The high level of enthusiasm for them, evident in the preceding twenty-five years, was tempered by a new understanding of conservation, a heightened respect for scholarship, and an increased wariness of dubious portraits. While the colonial portrait market has never really regained the height of fashion it experienced earlier in this century, the attention it attracted at this point ultimately had a positive effect. It has, as with other areas of American art, encouraged scholars to be more vigilant and has contributed to the increasing cooperation between the scientist and the art historian. It also has indirectly encouraged museums to rectify the situation in which museum personnel were placed at the mercy of more knowledgeable dealers and collector/dilettantes. Certainly it has led us to where we are today. Portraits have moved far beyond their role as simple monuments to historic people and have provided provocative insight into the colonial period.

Notes

1. Henry T. Tuckerman, *Book of the Artists* (1867; reprint, New York: J. F. Carr, 1966), 30–31.

2. Robert F. Perkins and William J. Gavin III, *The Boston Athenaeum Art Exhibition Index 1827–1874* (Boston: Boston Athenaeum, 1980), 39–41.

3. Ibid., pl. 6, collection of Mrs. Daniel M. Coxe, Drifton, Penn. (1966).

4. William Dunlap, *A History of the Rise and Progress of the Arts of Design in the United States* (New York: G. P. Scott and Co., 1834).

5. William H. Whitmore, "The Early Painters and Engravers of New England," *Massachusetts Historical Society Proceedings* 9 (May 1866): 197–216.

6. Tuckerman, *Book of the Artists*, 8, 47, 48.

7. Kate Nearpass, "The First Chronological Exhibition of American Art, 1872," *Archives of American Art Journal* 23 (1983): 21–30.

8. Tuckerman, *Book of the Artists*, 41.

9. This group of portraits is now owned by the Detroit Institute of Arts.

10. Daniel Goodwin, Jr., *Provincial Pictures by Brush and Pen* (Chicago: Fergus Printing and Co., 1886), 255.

11. Charles Henry Hart, "The Story of a Portrait," *Harper's Weekly,* 16 March 1895, 255.

12. See for example his article "A Limner of Colonial Days," *Harper's Weekly,* 4 July 1896, 665.

13. Albert Rosenthal Papers, film D34, frame 910, Archives of American Art, Smithsonian Institution, Washington, D.C.

14. Tuckerman, *Book of the Artists*, 72.

15. [Albert Rosenthal], "The Hand Portrait of Washington, April 2, 1928," Albert Rosenthal Papers, film NDu3, frame 133.

16. Theodore Sizer, *The Works of Colonel John Trumbull, Artist of the American Revolution* (New Haven: Yale University Press, 1967), 174–179.

17. W. Lewis Fraser to Charles Henry Hart, 31 December 1899, Charles Henry Hart Papers, film 934, frame 1134, Archives of American Art, Smithsonian Institution, Washington, D.C.

18. H. Barbara Weinberg, "Thomas B. Clarke: Foremost Patron of American Art from 1872 to 1899," *American Art Journal* 8 (May 1976): 67.

19. *American Art Annual* (1919): 278. Sold 7 January 1919 at the American Art Association.

20. Albert TenEyck Gardner and Stuart P. Feld, *American Paintings, A Catalogue of the Collection of the Metropolitan Museum of Art, Volume I* (New York: Metropolitan Museum of Art, 1965), 22.

21. *Handbook, Wadsworth Atheneum* (Hartford: Wadsworth Atheneum, 1958), 112.

22. Frank Bayley to William Macbeth, 29 February 1908, film NMc17, frame 522, Macbeth Gallery Papers, Archives of American Art, Smithsonian Institution, Washington, D.C., and Bayley to Macbeth, 23 April 1908, film NMc17, frame 535.

23. *The Hudson-Fulton Celebration: Catalogue of an Exhibition Held in the Metropolitan Museum of Art*, vol. 2 (exh. cat., New York: Metropolitan Museum of Art, 1909).

24. *Museum of Fine Arts Bulletin* 10 (August 1912): 29–31.

25. *Philadelphia Inquirer*, 13 March 1912; clipping in the Thomas Benedict Clarke Papers, film N598, frame 429.

26. René Gimpel, *Diary of an Art Dealer* (New York: Farrar, Straus and Giroux, 1966), 97.

27. Charles Henry Hart, "Frauds in Historical Portraiture, or Spurious Portraits of Historical Personages," *Annual Report of the American Historical Association* (Washington, D.C., 1915), 1:87–99.

28. Gimpel, *Diary,* 352.

29. Charles Henry Hart to the Worcester Art Museum Trustees, May 1917, Charles Henry Hart Papers, film 932, frame 104.

30. Painting file for *George Berkeley* by an unknown American artist, Worcester Art Museum, Worcester, Mass., Registrar's Office.

31. "Cochran Collection of Presidential Portraits Assured of Permanent Home," *Scenic and Historic America* 1 (September 1929): 5–25.

32. Joyce Zucker, Conservator of Paintings, New York

State Office of Parks, Recreation and Historic Preservation, to author, 16 April 1989.

33. James W. Lane and Anna Wells Rutledge, "Background Sketch of Thomas B. Clarke and His Associates," preface to "Report on 110 Paintings in the Clarke Collection," Clarke Collection Files, National Gallery of Art, Washington, D.C., October 1951–52, typescript, 2. Hereafter referred to as Lane/Rutledge Report.

34. Ibid., 14.

35. Ibid., 7.

36. William Dunlap, *A History of the Rise and Progress of the Arts of Design in the United States*, edited with additions by Frank W. Bayley and Charles E. Goodspeed (Boston: C. E. Goodspeed and Co., 1918).

37. Interview with Charles Childs, former Boston art dealer, 16 December 1986.

38. Clarke Collection files, "Alexander Garden," National Gallery of Art, Washington, D.C.

39. Lane/Rutledge Report, 15.

40. Illustrated in Alan Burroughs' *Limners and Likenesses* (Cambridge: Harvard University Press, 1936), pl. 14.

41. Lane/Rutledge Report, 13.

42. See Richard H. Saunders, "A 'Smibert' Portrait Reattributed to Thomas Gibson," *American Art Journal* 21 (1989): 66–75.

43. Frank Bayley to Harold L. Ehrich, 25 April 1927, Frank W. Bayley Papers, box 2, folder 2, American Antiquarian Society, Worcester, Mass.

44. Mrs. [Rose] de Forest to Frank Bayley, 27 June 1927, Bayley Papers, box 1, folder 6.

45. Henry Wilder Foote, *John Smibert, Painter* (Cambridge: Harvard University Press, 1950), 235.

46. Frank Bayley to *The Boston Herald*, 5 March 1928,

Bayley Papers, box 1, folder 3.

47. Frank Bayley to Mrs. Rose de Forest, 19 September 1928, Bayley Papers, box 1, folder 6.

48. Frank Bayley to [Augustus] de Forest [1930?], Bayley Papers, box 1, folder 6.

49. Macbeth Gallery ledger, "Pictures Sold," film NMc17, frame 2823, Macbeth Gallery Papers, Archives of American Art, Smithsonian Institution, Washington, D.C.

50. Ibid.

51. Gardner and Feld, *American Paintings*, 87.

52. Frank Bayley to George A. Cluett, 14 June 1932, box 1, folder 4, Bayley Papers.

53. Frank Bayley to Walter Ehrich, 20 June 1932, box 2, folder 2, Bayley Papers.

54. C. K. Bolton to Frank Bayley, 21 July 1932, film BC1, frame 52, Copley Gallery Papers, Archives of American Art, Smithsonian Institution, Washington, D.C.

55. Interview with Charles Childs, 16 December 1986.

56. John Hill Morgan to Harry McNeil Bland, 6 December 1939, Harry McNeil Bland Papers, Archives of American Art, Smithsonian Institution, Washington, D.C.

57. Lane/Rutledge Report, 26.

58. *Portraits of Early American Artists of The Seventeenth, Eighteenth and Nineteenth Centuries, Collected by Thomas B. Clarke* (exhibition catalogue, Philadelphia: Philadelphia Museum of Art, 1928).

59. *Public Ledger* (Philadelphia), 25 March 1928, clipping in the Thomas Benedict Clarke Papers, film N598, frames 445 and 451, Archives of American Art, Smithsonian Institution, Washington, D.C.

60. Lane/Rutledge Report, 179.

61. John Walker, *Self-Portrait with Donors* (Boston: Little, Brown, 1974), 131.

Commentary

KARAL ANN MARLING

Professor Evans left us with a potboiler—*Washington Sitting for His Portrait to Gilbert Stuart* of 1858 (fig. 52). The picture honors Stuart and the untold difficulties he faced in creating his memorable icon: the sitter's glacial reserve, his disapproval of the light-minded banter that is the stock-in-trade of the society painter, and even his dental distress are cited as points of particular difficulty in capturing the portrait of Washington known as "the Athenaeum." Stories retailed and refined over the next half-century attribute what Washington's contemporaries accounted a remarkable likeness to the fortuitous appearance of a horse outside the window or the cotton wadding Stuart packed over the old gentleman's sore gums. Alternatively, as in the case of the Vaughan portrait, Stuart is supposed to have given up on his first attempt altogether and painted the picture from memory. Thus Professor Evans quite rightly understands Stuart's *Washington* as a painting rather than a mimetic recreation of reality—an icon that, in Washington Allston's telling, was a "personification of wisdom and goodness."[1]

Allston's reaction to the portrait is understandable, given the temper of the times, a period in which American mothers routinely named their babies "Washington." And Washington Allston's generation lived on after the demise of the first President, when the process of transforming person into hero and hero into icon was already far advanced. Quite apart from the aesthetic qualities that supported an understanding of the work as an abstract construction—a thing of paint and canvas, an order of reality at some remove from Washington's flesh-and-blood—by 1806 or so Washington was not real any more. Thanks to John Marshall, Parson Weems, and several hundred doleful eulogists, Washington was Goodness, Sagacity, Forebearance, and Valor. He was a Protestant angel in a three-cornered hat, a collection of virtues attached to a name and to a painting by Gilbert Stuart.

Washington's abstractness—the iconic fixity of the picture—had become irksome to some observers as early as 1823 when John Neal, in his novel *Randolph*, declared that "if George Washington should appear on earth, just as he sat to Stuart, I am sure . . . he would be treated as an imposter, when compared with Stuart's likeness of him, unless he produced his credentials."[2] By midcentury the picture had become not only iconic but unbearable to such commentators as Nathaniel Hawthorne, who thought the prunes-and-prisms likeness trotted out whenever an image of the hero was required had turned Washington into an inhuman wraith, a disembodied portrait head. "Did any body ever see Washington nude?" he asked, with a fine rhetorical flourish in 1853. "It is inconceivable. He had no nakedness, but I imagine he was born with his clothes on and his hair powdered, and made a stately bow on his first appearance in the world."[3] And William Makepeace Thackeray, who had collected Washington pictures in the course of research for his popular historical

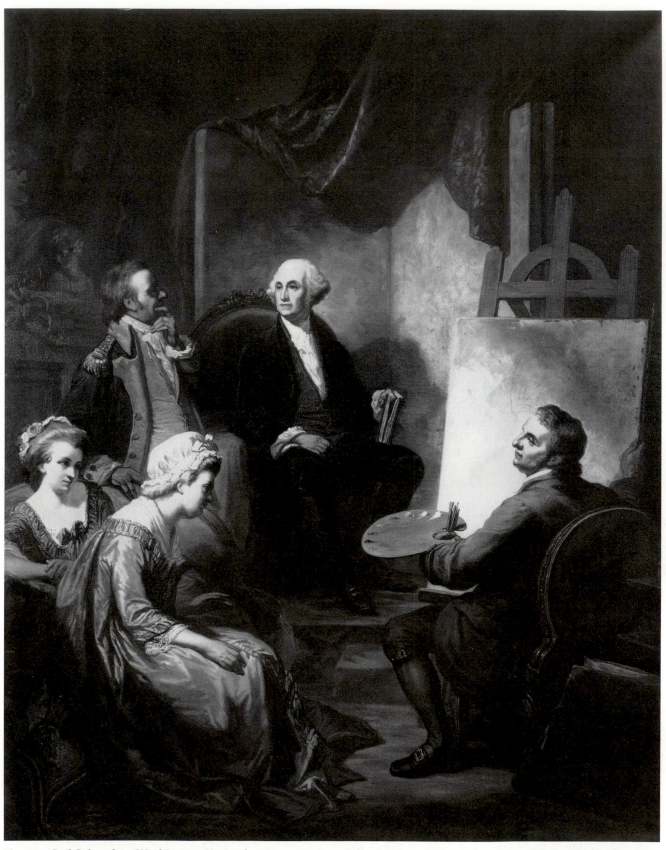

Fig. 52. Carl Schmolze, *Washington Sitting for His Portrait to Gilbert Stuart*, 1858, oil on canvas, 50¾ × 40½ in. Courtesy of the Pennsylvania Academy of the Fine Arts, Philadelphia. Gift of Mrs. John Frederick Lewis (The John Frederick Lewis Memorial Collection).

novel *The Virginians* (serialized in 1857), is said to have shown a copy of the Stuart portrait to his friends, quipping, "Look at him. Does he not look as if he had just said a good, stupid thing."[4]

The wealth of disparaging comment on the Stuart portrait hints at its ubiquity and, in a backhanded way, helps to account for Carl Schmolze's *Washington Sitting for His Portrait to Gilbert Stuart,* one of a surprisingly large number of paintings of the subject done in the second half of the century. But Schmolze's is the definitive treatment of the theme. Washington rigidly faces the painter's left, in canonical Athenaeum fashion, seemingly too uncomfortable to be diverted by Martha, Nelly Custis, and an army officer (probably Henry Knox). Stuart, seated at his easel on the opposite side of the canvas, discusses his plans with Washington's entourage. For all its formal simplicity, however, the painting is a complex cultural statement. As Mark Thistlethwaite has demonstrated, it argues for the prevailing belief in the preeminence of the American artist as a recorder of native history. The homage to Stuart, in other words, implicitly criticizes a recent decision by Congress to commission foreign-born artists, like Costantino Brumidi and Emanuel Leutze of *Washington Crossing the Delaware* fame, to complete a cycle of historical murals in the U.S. Capitol Building.[5]

It is also, of course, an acknowledgment of the preeminent, almost mythic status of Stuart's potent icon and another expression of the desperate veneration for Washington widespread in the years preceding the Civil War, when he came to stand for national identity and unity. Yet above all, the treatment of the subject, with its wealth of genre detail and the assembled cast of witnesses to Stuart's act of observation, stresses faith in the documentary reliability of early American portraiture. In the age of Mathew Brady and photography, it was important for painting to stake its claim to verisimilitude: Stuart, says Schmolze, was really there—believe him! If today on the contrary we prefer to understand the portrait in a different way, it is nonetheless important to remind ourselves that we are not the first to debate the claims of fact versus legend, mimesis versus icon.

My favorite battle over the character of colonial portraiture took place in Washington, D.C., in 1931, as the United States George Washington Bicentennial Commission geared up for the gala celebration of the hero's birth, slated for 1932.

The director of the revels, Representative Sol Bloom of New York, had enjoyed a career as a promoter and understood the value of good graphics. Accordingly the commission's first order of business was selection of the official likeness of George Washington that would serve as the logo and emblem of the festivities. Bloom's minions gathered reproductions of all "the more or less authenticated portraits of Washington," works known or rumored to have been painted from life.[6] Then they called a meeting of the selection panel: a couple of delegates from the Commission of Fine Arts, the chief of the Fine Arts Division of the Library of Congress, two historians who were writing Washington pamphlets for schools and clubs, an academic painter from Virginia, the superintendent of Mount Vernon, and, of course, Mr. Bloom. The memoirs of one of the panelists record the epic conflict that followed.[7]

The artists responsible for the portraits left in the final pool had actually sat in the presence of the living Washington: the committee had hard historical evidence to prove it. Yet their pictures did not agree. By want of skill or honesty, they

Fig. 53. Poster with the official portrait of George Washington designed for the United States George Washington Bicentennial Commission, 1932. Illustrated in the *Final Report of the United States George Washington Bicentennial Commission* (Washington, D.C., 1932), 584.

had apparently failed to record the absolute truth, since no two images matched up exactly. As historical reality, as fact, the painter's art was defective. It was, therefore, unworthy to provide the official U.S. government symbol for the bicentennial.

The solution to the apparently insurmountable problem posed by the hero's failure to survive into the age of the camera was close at hand, however. Bloom had the Houdon bust at Mount Vernon photographed exactly as if it were a living person—a statesman, a tycoon. The official, 1932-moderne George Washington became, then, an actual photo of the deceased worthy (fig. 53), every bit as real as any rotogravure picture of President Roosevelt. Perhaps it was no accident that Eastman Kodak was an "official" sponsor of the Washington Bicentennial!

The great American public, sad to say, was not impressed by Bloom's ingenuity. Although the photo from beyond the grave did grace postage stamps, the commission's letterhead, and the title pages of several obscure academic studies of Washington's blameless life that were released to coincide with the year of tribute, Bloom was eventually forced to print and distribute a million full-color reproductions of the Athenaeum portrait instead. Americans knew what George Washington really looked like, even if the government did not. And Grant Wood's *Parson Weems' Fable* of 1939 (fig. 54) is as much a commentary on the *vox pop* as it is a meditation on the priggishness of the Stuart, the paradoxical truth of legends, and the lie that is art.[8]

So Richard Saunders' fine paper reminds me that the relative popularity of the colonial portrait in modern times has as much to do with the peculiar passions and fads of the moment as with any inherent properties of the works. Like the suit of George Washington's clothes displayed at the Philadelphia Centennial Exposition of 1876, portraits were also relics, albeit sec-

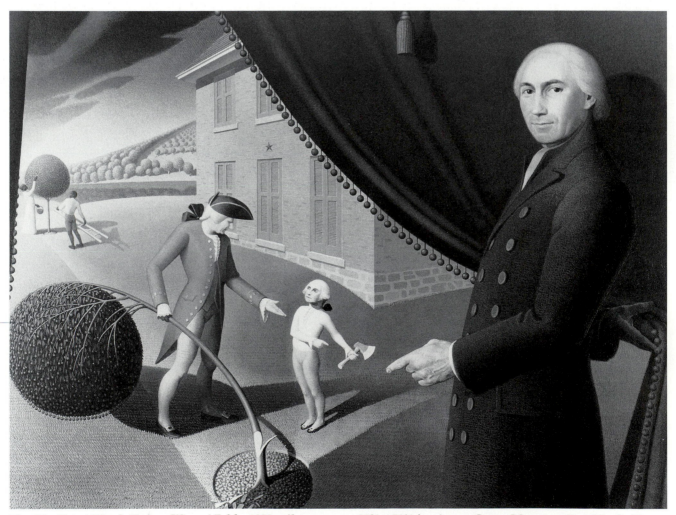

Fig. 54. Grant Wood, *Parson Weems' Fable*, 1939, oil on canvas, 38⅜ × 50⅛ in. Amon Carter Museum, Fort Worth, Texas, 1970.43.

ond- and third-class ones. As such, ownership of antique portraits was closely related to the rise of ancestral societies in the later nineteenth century (a subject to which Grant Wood also turned his attention in the farcical *Daughters of Revolution* of 1932 [Cincinnati Art Museum, Edwin and Virginia Irwin Memorial Fund]) and the sporadic crazes for building and decorating in the colonial manner.

The interior of the Connecticut Cottage at the 1876 Philadelphia Fair created the definitive neo-colonial hearthside ensemble, with a portrait in the position of honor above the mantelpiece. In the construction of such statements of familial integrity and solidarity, it was an advantage that portraits had already become icons, standing for broad concepts of ancestry, order, and position rather than specific historical facts. In the Connecticut Cottage of 1876, "Old Put" hung over the fire—but it could just as well have been George Washington, Lighthorse Harry Lee, or any anonymous worthy except, perhaps, Benedict Arnold. The framed image holds its place above the hearth regardless of who may lurk within the gilded molding.

In the cottages and the colonial kitchens of fair-time America, in the new rash of nineteenth-century historic houses, in the history painting and the pageant, the colonial portrait was—and still is—a part of the décor. But it has also become a kind of strange, new fact: a repository of motifs to be mined by those seeking to recreate and update the past, whether for the souvenir

trade of the 1880s or the Patty Duke-as-Martha Washington television special of the 1980s. As surely as any "munchkin" on a yellow brick road, as surely as any Walt Disney character, the colonial portrait is a part of America's collective fantasy, our national fairy tale of once upon a time.

Notes

1. For the Stuart portrait and nineteenth-century reaction to it, see Karal Ann Marling, *George Washington Slept Here: Colonial Revivals and American Culture, 1876–1986* (Cambridge: Harvard University Press, 1988), 8–13.
2. John Neal, *Conversations on American Art: Selections from the Writings of John Neal*, ed. Harold Edward Dickson, Pennsylvania State College Studies, no. 12 (State College: Council on Research, Pennsylvania State College, 1943), 3 and 73.
3. Quoted in Morton Borden, ed., *George Washington* (Englewood Cliffs, N.J.: Prentice-Hall, 1969), 1.
4. Quoted in William Alfred Bryan, *George Washington in American Literature, 1775–1865* (New York: Columbia University Press, 1952), 235.
5. Mark Edward Thistlethwaite, *The Image of George Washington: Studies in Mid-Nineteenth-Century History Painting* (New York: Garland, 1979), 7.
6. Sol Bloom, quoted in *Special News Releases Relating to the Life and Time of George Washington, as Prepared and Issued by the United States George Washington Bicentennial Commission* (Washington, D.C.: U.S. George Washington Bicentennial Commission, 1932), 67.
7. Marling, *George Washington Slept Here*, 337–41.
8. Karal Ann Marling, "Of Cherry Trees and Ladies' Teas: Grant Wood Looks at Colonial America," in *The Colonial Revival in America*, ed. Alan Axelrod (New York: W. W. Norton, 1985), 294–319.

Contributors

TIMOTHY H. BREEN, William Smith Mason Professor of American History at Northwestern University, received his B.A., M.A., and Ph.D. degrees from Yale University. He is coauthor of *"Myne Owne Ground": Race and Freedom on Virginia's Eastern Shore, 1640–1676* (1980) and author of *Puritans and Adventures; Change and Persistence in Early America* (1980), *Tobacco Culture: The Mentality of the Great Tidewater Planters on the Eve of Revolution* (1985), and *Imagining the Past: East Hampton Histories* (1989), winner of the 1990 book award for the outstanding book in the field of historic preservation, given by the Center for Historic Preservation (Fredericksburg, Va.).

WAYNE CRAVEN received his B.A. and M.A. degrees from Indiana University and his Ph.D. from Columbia University. A member of the faculty of the University of Delaware since 1960, he holds the Henry Francis du Pont Winterthur Professorship in Art History. He is the author of *Sculpture in America* (1968, 1984) and *Colonial American Portraiture* (1986), as well as other books and articles on American art.

DORINDA EVANS, associate professor of Art History at Emory University, received her B.A. from Wheaton College, her M.A. from the University of Pennsylvania, and her Ph.D. from the Courtauld Institute of Art, University of London. She is the author of *Benjamin West and His American Students* (National Portrait Gallery, 1980) and *Mather Brown, Early American Artist in England* (1982). She is currently working on a study of the work of Gilbert Stuart.

ROBERT A. GROSS is director of American Studies and professor of History and American Studies at the College of William and Mary. He received his B.A. from the University of Pennsylvania and his Ph.D. from Columbia University and taught at Amherst College from 1976 to 1988. He is the author of *The Minutemen and Their World* (1976), for which he received the Bancroft Prize in American History and the National Historical Society Prize for the Best First Book in History. Recently he edited an anthology of essays, *In Debt to Shays: The Bicentennial of an Agrarian Rebellion* (forthcoming, University Press of Virginia, Charlottesville, Va.).

JOHN HAYES, director of the National Portrait Gallery, London, since 1974, is a graduate and Honorary Fellow of Keble College, Oxford. He received his Ph.D. from the Courtauld Institute of Art, University of London. Formerly assistant keeper (1954–70) and director (1970–74) of the London Museum (now the Museum of London), he was a visiting professor in the History of Art at Yale University in 1969. The acknowledged expert on Thomas Gainsborough's work, he has published three catalogues raisonné: *The Drawings of Thomas Gainsborough* (1970), *Gainsborough as Printmaker* (1971), and *The Landscape Paintings of Thomas Gainsborough* (1982). He has also written *Gainsborough: Paintings and Drawings* (1975), as well as studies of the work of Thomas Rowlandson and Graham Sutherland, and is engaged on a study of the sketchbooks of Sir Joshua Reynolds. He has recently completed a catalogue of the British Paintings in the National Gallery of Art, Washington, D.C.

GRAHAM HOOD, vice-president and Carlisle H. Humelsine Curator of Colonial Williamsburg, is a graduate of Keble College, Oxford, and the Courtauld Institute of Art, University of London. He was curator of European decorative arts at the Wadsworth Atheneum, associate curator of the Garvan Collection at the Yale University Art Gallery, and curator of the Detroit Institute of Arts before going to Williamsburg in 1971. His publications include *American Silver, Garvan and other Collections in the Yale University Art Gallery* (1970), *American Silver; A History of Style, 1650–1900* (1971), and *Charles Bridges and William Dering: Two Virginia Painters, 1735–1750* (1978).

KARAL ANN MARLING received her Ph.D. from Bryn Mawr College. She teaches art history and American studies at the University of Minnesota. Her books on American popular culture include *Wall-to-Wall America, A Cultural History of Post-Office Murals in the Great Depression* (1982), *The Colossus of Roads* (1984), *Tom Benton and His Drawings* (1985), *George Washington Slept Here: Colonial Revivals and American Culture* (1988), and *Blue Ribbon: A Social and Pictorial History of the Minnesota State Fair* (1990).

ELLEN G. MILES, curator, Department of Painting and Sculpture, National Portrait Gallery, received her B.A. from Bryn Mawr College and her M.Phil. and Ph.D. from Yale University. She has been on the staff of the National Portrait Gallery since 1971. Her publications include, as editor, *Portrait Painting in America: The Nineteenth Century* (1977) and, with Jacob Simon, *Thomas Hudson (1701–1779): Portrait Painter and Collector* (exhibition catalogue, 1979), in addition to the catalogue of the National Portrait Gallery exhibition *American Colonial Portraits: 1700–1776*, with Richard H. Saunders (1987).

JESSIE J. POESCH received an M.A. from the University of Delaware, where she was a Winterthur fellow in Early American Culture, and a Ph.D. from the University of Pennsylvania. She holds the Maxine and Ford Graham Chair in Fine Arts at Newcomb College, Tulane University. She is the author of *Titian Ramsay Peale, 1799–1885, and His Journals of the Wilkes Expedition* (1961), *Early Furniture of Louisiana* (1972), *The Art of the Old South: Painting, Sculpture, Architecture and the Products of Craftsmen 1560–1860* (1983), as well as numerous articles and exhibition catalogues.

RICHARD H. SAUNDERS is director of the Christian A. Johnson Memorial Gallery at Middlebury College. He received his B.A. from Bowdoin College and his Ph.D. in Art History from Yale University. Before his present position he was curator of American paintings at the Wadsworth Atheneum and then was an assistant professor in the Department of Art at the University of Texas at Austin. His publications include *Daniel Wadsworth, Patron of the Arts* (1981) and *Collecting the West: The C. R. Smith Collection of Western American Art* (1988), in addition to the catalogue of the National Portrait Gallery exhibition *American Colonial Portraits: 1700–1776*, with Ellen G. Miles (1987). He is preparing a study of the work of the English and American colonial painter John Smibert (1688–1751).

STEPHANIE GRAUMAN WOLF is a senior fellow at the Philadelphia Center for Early American Studies and visiting associate professor, Department of History, University of Pennsylvania. She received her Ph.D. from Bryn Mawr College in 1973. From 1977 to 1985 she was director of the Winterthur Program in Early American Culture. In addition to *Urban Village: Population, Community, and Family Structure in Germantown, Pennsylvania, 1683–1800* (1976), she is the author of numerous articles and reviews in the field of eighteenth-century American history.

Index